Quest for Real Art:

Challenging Assumptions about Teaching Art

Layman H. Jones Jr.

Buffalo State
State University of New York

Copyright © 2018 Layman H. Jones Jr.

All rights reserved. No part of this book may be reproduced in any form or by any electronic or mechanical means, including information storage and retrieval systems, without permission in writing from the publisher, except by reviewers, who may quote brief passages in a review.

ISBN 9781980662563

Front Cover, the dragon on the cover is from A Handbook for Teachers by Holland, published in London by Macmillan in 1907

Published by Kindle Direct Publishing

laymanhjonesjr@gmail.com

Preface

My book is a series of **allegorical stories** that challenge pervasive ideas about teaching art—students' ideas resulting from their perceptions of how they were taught, as well as teachers' ideas absorbed from the culture of their schools. If left unchallenged, these ideas become taken-for-granted assumptions that are embedded in art programs and resist change, despite the needs for change—needs resulting from changes in students, changes in society, and changes in the art world. Examining these assumptions will free you from the need to develop an art program that simply mirrors current practices.

My first story begins with the tale of an art teacher who has disturbing dreams about fighting a dragon. Ordinary art education books don't have stories about dragons, so why does this one?

The answer is that this dragon invaded the kingdom and stole all the real art. The art teacher dreams that he is a knight on a quest to return real art to the kingdom. If the art teacher had been a real jock, these dreams would have been fun, but the art teacher was a sensitive sort of guy who tried to figure out what the dreams might mean. As he searched for meaning, he began to see parallels between his dreams and his own classroom. It was as though the dragon of his dreams had stolen into his classroom and replaced his students' artworks with **counterfeit art**—though it looked like art, it was only superficial imitations of real art.

Counterfeit art may be difficult to recognize. Even art that looks authentic may be counterfeit, if it is achieved by fraudulent means. Art teachers risk using fraudulent means when their unexamined assumptions are inconsistent with the nature of students, society and the art world.

It is easy to assume that art in schools looks the way it ought to look; but the stories in this book will challenge that assumption; and, as you work your way through the questions at the end of each story, you will become aware of qualities that indicate when student art is not genuine.

The possibility that art in schools might be less than genuine is not unique to me; and the problem is not new. **Manuel Barkan** observed that **much of what art students do is merely busy work** (1966 *Curriculum Problems in art Education*, in Edward l. Mattil, *A Seminar in Art Education Research*, Penn State University.) And, **Arthur Efland** argued **that art students work in a style that has little to do with art outside of schools.** (1976, The school art style: a functional analysis, *Studies in Art Education*, vol.17 no. 2, 37-44.)

Because my stories are allegorical, you may begin to examine your ideas about teaching art. Rather than telling you what to think, my stories prompt you to examine what you think about art and teaching. There are questions at the end of

each story that should stimulate your thinking, and encourage an exchange of ideas in classroom situations.

My allegorical stories were initially inspired by my recollection of *The Saber-Tooth Curriculum* (McGraw-Hill, 1939)—a farce written under the pseudonym, J. Abner Peddiwell. He described how a Paleolithic tribe first developed systematic education. Their curriculum—which focused on providing food and security—included fish-grabbing-with-the-bare-hands, woolly-horse-clubbing, and saber-tooth-tiger-scaring-with-fire. For a time all was well; but then—as the ice age ended—runoff caused the streams to became muddy, so that even experienced fishermen could not find the fish; the wooly-horses migrated north to escape the marshes, the saber-tooth tigers all got pneumonia and died, and they were replaced with ferocious bears that were not afraid of fire. Although intelligent members of the tribe found new techniques to provide food and security, the education of children remained the same; because the wise old men who controlled the schools argued that teaching the new techniques would be "mere training" rather than the fundamentals of learning.

When I became aware of Joseph Campbell's *Hero with a Thousand Faces* (Princeton University Press, 1968), I conceived the notion **that becoming an art teacher was like a hero's journey.** That is, teaching art is not something that you can do perfectly well when you graduate; rather, it is like going on a quest—a quest where you must joust with students, reject advice form false mentors, fight the dragons of self-doubt, and confront challenges that you will overcome only by rethinking your assumptions about teaching art. **The symbol of that quest is the dragon on the cover of this book**. I found it in *A Handbook for Teachers* by Holland, published in London by Macmillan in 1907.

My students find my stories intriguing and I think you will too. Stories permit us to look at situations from a fresh perspective, so that we can think about a situation differently. Stories, unlike lectures or essays, do not tell us what conclusions we should reach. Stories communicate on an emotional level while essays that seem objective may cloak the author's personal feelings in the robes of profound vocabularies. Moreover, we are likely to reject even the soundest reasoning in an essay, if the author's conclusions are not confirmed by our own experience.

When I started to write about issues in art education in allegorical stories, I had no thought that they might be autobiographical. In an early story, "How Arty Cooked his Goose while Grading Art," (Art *Education*, October, 1995), I even tried to deny the possibility of an autobiographical connection. What I wanted to do in my stories was to find a voice that could challenge some pervasive ideas in art education. It was safer to have the characters in my stories say things than to say them myself.

Now I realize that the ideas I decided to criticize were the same ideas that I had once believed in. I share some of the biographical connections with my stories in my **Notes at the end of this book**. My Notes are an example of the kind of self-reflection that I hope the questions at the end of each story will inspire. My notes also explain the literary inspiration for some of the characters in my stories. If my stories seem too removed from real art rooms, my notes will reveal their very real inspiration.

Acknowledgements

George Hole, Chairman of Philosophy at Buffalo State encouraged my efforts to examine ethical issues in my stories. My stories do not provide an unfailing code for you to follow. Rather, I tell stories that dramatize the conflicts between competing philosophies, and leave you to decide.

My wife Dianne is a marvelous story teller. Her stories were the inspiration for some of mine. Additional assistance in developing my allegorical stories came from my son Jeffrey. Those who have read some of my stories and suggested changes include, Kate Hartmen, John Truax, Leanne Peruzzini, Rev. James Monaco, George Hole, and John Siskar. My son Philip was responsible for the publication of this book.

Contents

1: Hero's Journey—An art teacher dreams of a quest to rescue real art............1

2: The Apprentice—A 21st Century student is apprenticed to a 14th Century master............13

3: Art Trickery and Magic Witchery—A king and an enchantress have different conceptions of teaching............25

4: Art and Alienation—A talking crow warns a talented art student that school threatens to alienate him............35

5: The English of Art—An unemployed art teacher uses assumptions about teaching art while substituting in English............47

6: A Dickens of a Christmas Carol—An art teacher is haunted by the ghosts of history, criticism and aesthetics............51

7: The Art of Discipline and the Discipline of Art—A magic pencil comes to the aid of a student teacher............59

8: Prescription for Teaching Art—A medical doctor confronts his daughter's ideas about teaching art............65

9: Popular Teacher Fired by Board—An art teacher, who resembles a Greek philosopher, challenges the politics of assessment............71

10: Winning the Accountability Game—A Superintendent who was once a winning football coach imposes athletic standards of success on the art program............77

11: Heroes and Heroines—This is not a story, rather, it is a challenge for readers to go on a quest............89

Notes on the Stories............93
About the Author............133

1

The Hero's Journey

An art teacher dreams of a quest to rescue real art.

Joseph looked like a typical art teacher in his khaki pants and ill-fitting tweed jacket with paint spatter on the sleeve. He habitually wore the tweed jacket even after his mother gave him a cashmere jacket with a colorful silk lining. When his mother complained, the tone in her voice made him suspect that she wished he could be more like his namesake in the Bible—the Joseph who had a coat of many colors and dreamed of grandeur. But his mother's dreams for him were different from his own.

When Joseph was in high school he had dreamed of going to art school but his mother urged him to go to college in order to have the security of a teaching job. "Why be a starving artist wondering how to buy your next pot of paint, when you can be a teacher with a full belly and have money to buy lots of paint and canvas?" she questioned.

Joseph had no convincing answer, so he entered the college near their home and majored in art education. Joseph liked the studio courses but during the lecture classes he daydreamed of having his own studio in New York City. He envisioned a studio in a loft with a sky light. He would paint each day and wait tables at night. He would meet other young artists in coffee houses and go with them to art openings where he might meet a critic who would discover his work and publish photographs of his paintings in the *New York Times*.

After Joseph graduated he found a teaching position at a junior high school near where he still lived with his mother. It was the same school that he had attended as a student; and the same principal was still there—the one who patrolled the hallways to keep students in line. Though he thought the principal a bully, Joseph had never gotten into trouble as a student and Joseph reasoned that, just the threat of sending a student to the office would be sufficient to keep students in line.

So Joseph had settled in to the routine of teaching at his old school in what should have been his dream job. But as he started the third year, his night-time dreams became so disturbing that he could not sleep. He would wake up at 4:00 in the morning with a start, as though someone was shaking him. Sometimes he was so hot that he got up and went down stairs to stand on the cool tile floor. No matter how he tried he could not go back to sleep. Though he knew that a dream had awakened him, he could never remember the dream.

As Joseph lost more and more sleep it became harder for him to get through the school day. He bought a coffee pot and put it on his desk—something he said he would never do, for it was unfair for teachers to drink in the classroom when it was against the rules for the students. Still he needed the caffeine to push himself through the daily routine.

He tried to muster enthusiasm as he started each new lesson by showing the students a reproduction of a masterpiece. This was one of the few ideas that he had taken from his college theory classes. The actual lessons were tried and true

versions of those he had experienced as a student. As part of each introduction he always demonstrated how to work with the new material. He demonstrated quickly, being careful not to make his artwork too good—he did not want to intimidate his students. At the conclusion of the demonstration he said that students could do much better, if they took their time.

It was easy for Joseph to stay awake when he was introducing lessons, but during successive periods—when the students were just working on their projects—he had to pace around the room to avoid dozing off. Once he sat down to rest while listening to a student explain why he did not hand in his sketchbook assignment. Just as his explanation began to sound depressingly familiar, Joseph opened his eyes to see the student six inches from his face saying, "You're asleep, aren't you?" Joseph stood up quickly, ignored the question and told the student he could bring in the assignment next week.

So Joseph paced around the perimeter of the room, stopping at his desk to sip more coffee. Sometimes he would hesitate in his circuit of the room in order to stare down a spit-ball- thrower or a pencil-tip-smasher. As he approached each table the students' whispers became softer. Students knew that if they became too loud, he would turn off the radio that Joseph kept on his desk. And Joseph knew that the principal often peeked in the art room door to check on the noise level. Joseph found it harder and harder to do what he used to love to do: to go to individual students and tell them how much he liked their artwork. More often, he simply rewarded students' efforts with good grades.

At the end of each period Joseph had the students sit-up straight to see which table would get to line up first. As the students sat-up straight and became very quiet, he wondered, "Why do students always look happiest when it is time for them to go to the next class?"

By the time the last class left the art room, Joseph was ready to collapse, but he had bus duty. It was his responsibility the make the students stand quietly in straight lines until their bus was announced. As he dutifully enforced the Principal's school-bus-rules, he wondered if school was a place designed to imprison students and prevent them from having fun. "Thank God'" he thought, "That the kids can still come to the art room where they can be free."

When he finally got home and sank into his chair he was exhausted and yet fearful of falling asleep and dreaming those dreams that he could not remember. As he tried to rest, he looked at the corner of his room that he called his studio. His sport coat, now spattered with paint, hung from the top of the easel. The paint on his palette had dried and his paint box was covered with a pile of lesson plans for school. Each plan was three pages long and typed in the format that the principal required. Joseph no longer needed plans, because his lessons were now tried and true; but the principal required them, so Joseph complied.

Joseph's mother was alarmed, as she saw Joseph grow increasingly fatigued and pale. "You must take better care of yourself." She urged. "Who will pay the mortgage, if you become too sick to teach?" She urged him to drink warm milk just before bedtime. But he woke up even earlier. She made him Chamomile tea at bedtime, and then she gave him a sleeping remedy the pharmacists recommended. But nothing worked. Finally his mother insisted that he go to the doctor.

Joseph's doctor was advanced in years, wore a starched white jacket and practiced a no-nonsense kind of medicine. He said that interrupted sleep sounded like depression and he asked Joseph, "Is anything bothering you—how are things at school?"

Joseph replied, "I used to love teaching; but since I can't sleep, teaching has become a drag. Still I love the kids and they love me, and the Principal is tolerable."

As the doctor peered over his reading glasses, he asked, "What do you think about the new State Education Department's plan for authentic assessment?" The doctor had read about the plan in the newspaper. It seemed to make sense to him, so he was surprised at Joseph's response.

"It makes no sense! Authentic assessment wants to measure whether students do the things that professional artists do. It's a stupid plan. Children should enjoy being children. We should not make them pretend to be adults."

What Joseph did not tell the doctor was that he feared the plan might also use student achievement as a measure of how well teachers taught. That kind of teacher assessment seemed to threaten the security of tenure—something that Joseph would be eligible for next year.

Unwilling to deal with the thought of losing his job, Joseph told the doctor, "If I judge student work by the standards of professional art, my kids will revolt. They'll know it's an absurd requirement."

The doctor did not respond, instead he moved his stethoscope to the other side of Joseph's chest.

Seeking to justify his position Joseph continued, "The kids love me now, because I praise them for the freedom in their artworks. They won't like me if I am critical. Besides, the things kids make in school are not real art; they are exercises to teach them to appreciate art."

The doctor's apparent response was to ask Joseph to put on his shirt, but after the doctor wrote a prescription he asked, "How can students learn to appreciate real art while they make something that is not real?"

Joseph heard the doctor's question, but thought, "What do doctors know about art?"

After a long pause the doctor added, "Some patients say that these pills give them vivid recall of their dreams. If you can recall you dreams, you should be able to deal with what is keeping you awake."

The Hero's Call

One hour before bedtime Joseph took one of his new pills with a full glass of water, just as the pharmacists had instructed him to do. Once he was in bed he felt strangely relaxed and, as he closed his eyes, he wondered if he might be able to sleep without dreaming.

Despite his hopes, Joseph did dream. He dreamed in 3D and living color. Joseph dreamed that he was Sir Joe, a knight dressed from head to toe in armor— not the shiny armor for parades but the stuff for real jousting.

The castle where Sir Joe lived was no longer a happy place. A dragon had somehow crept into the castle at night and replaced all the real art with counterfeit

art. Paintings sculpture and crafts that had once delighted the King were replaced with tedious reproductions, rude symbols, unfinished scrawls, and pitchers that would not pour.

The King, a robust figure in a purple robe, summonsed Sir Joe and told him he should go on a quest to return the real art. Sir Joe said that it was an honor to be selected but he was much too occupied with instructing the young knights in jousting. "Besides," He said, "My squire is too ill to go on a quest." The King would hear none of it. He summoned the cooking maid to substitute for the squire and showed Sir Joe the dragon's tracks leading from the front gate.

Sir Joe hurried out the gate and down the stone steps, paused to watch the heavy oak doors close behind him, adjusted his armor and looked in the direction of the tracks. The kitchen maid had gone ahead and was making good time, even though she carried Sir Joe's heavy shield. As he tried to catch up with her he called out, "Maid—whatever your name is—you are supposed to follow me." "My name is Bliss," she replied. Then she rested the shield on her toes and waited for Sir Joe.

When Sir Joe caught up to Bliss he turned away from the dragon's tracks and walked in a new direction. Bliss, who was too outspoken to be a humble squire, argued that the only certain way to find the dragon was to follow the tracks. But, Sir Joe was not about to let a lowly kitchen maid tell him how to conduct his quest. Besides, he was certain that he knew where the real art was hidden. So, he led them down the road to a tower that was painted an ivory color.

When they reached the ivory tower, a guard said that the tower did indeed have real art. But, the guard explained that they would need to exchange their money for the coin of the realm before they could purchase any art. So Sir Joe exchanged all his gold for coins called credits and used the credits to buy a thick portfolio filled with new art works.

Because the portfolio was heavy, the journey back to the castle was slow and tiring. As they traveled Bliss argued that he should not take the portfolio back to the castle. "If the King does not like the art, he will be angry that you did not follow the dragon's tracks." But, Sir Joe was confident. Finally at the steps to the castle, in front of the large oak doors, Bliss urged him to look at the art in the portfolio to see if he really wanted to risk showing it to the King. Because he was tired from the trip, and even more tired of Bliss's nagging; Sir Joe gave in and opened the portfolio.

As he unzipped the portfolio three large green scales fell out—the dragon had been there. Inside the portfolio he found no real art—only lifeless drawings of still people, computer generated clip art, and paint-by-number patterns. Sir Joe was outraged at the theft of his art. He threw the portfolio down a well and followed Bliss, who was starting in the direction that the Dragon's tracks had taken.

Joseph woke up. It was 3:30 a.m., and he could not get back to sleep. As he lay there, he was angry that the doctor's pills made him remember his dreams, but did nothing to help him sleep.

At breakfast he told his mother about his dream while she served him oatmeal and raisins. "Could it mean that the art my students make is not good enough?" He asked.

"Nonsense!" his mother answered. "No one works as hard as you do."

"Then how can I get some sleep?" he asked. "The doctor's pills did not help."

"If you remember how blessed you are, you should sleep like a baby. You have a good job, a warm home and a mother who loves you. "Besides," she said, "dreams about knights are a sign of good luck and seeing a king in a dream foretells happiness and prosperity." (His mother knew about the meaning of dreams from a book she had been reading.)

His mother's reassurance made him feel good as he drove to school—he did not even mind the fresh snow. But, as Joseph climbed the stone steps at school and opened the heavy oak door, he noticed how similar the school was to the castle in his dream. His pace quickened as he passed through the darkened hall to the art room. When he unlocked the door a small voice inside him asked, "Has the dragon been here too?" Joseph pinched himself to see if he was awake, and turned on the lights.

His reproductions were in the chalk tray, the students' art works were neatly pinned to the wall where he remembered them, and his visuals were still over the desk. But nothing looked the same. His color wheel, done the year before in construction paper, had faded. His reproductions had also lost their intensity. They had become pale reminders of the paintings he had seen in museums. Student drawings that only yesterday had seemed wondrously free now looked simply naive. The perspective assignment where everyone had followed his directions now looked impersonal and pointless. Paintings based on Seurat's pointillism had become only random color dots with none of the vibrancy of Seurat's colors. "Well," Joseph thought, "the students are only kids and they must first master the basics before attempting serious art. Besides, it is more important for them to appreciate art then to make art."

On the Threshold of Adventure

The next night, as Sir Joe and Bliss wandered about hoping to find fresh dragon tracks, they heard a distressing call from a damsel at the top of a high tower. Bliss cautioned Sir Joe that their quest was not for damsels in distress, but the lady pleaded with Sir Joe to climb the tower and rescue her. So he tried to climb up, but he fell. The lady laughed, but seemed to regain her composure. She called for him to use his creativity and find a better way to reach her window.

Bliss cautioned Sir Joe, "If the lady wants to be rescued, she should throw down her long hair for you to climb up to her." But, Sir Joe only heard that his creativity had been challenged. He was determined to rescue the damsel. So he used his broad sword to fell a tree, leaned it up against the tower wall and climbed up the tower; but as he reached for the windowsill the tree broke and he fell again. The lady applauded his efforts and thanked him for a most entertaining morning. She taunted him, "A real knight would not give up after only two tries." Sir Joe slowly stood up and straightened his armor and said, "I have no time to rescue you until you let down your hair."

Joseph woke up and, although it was 3:00 a.m., he could not go back to sleep. At breakfast he told his mother of the new dream and asked her what he

should do. Again his mother reassured him, "Dreams of falling are common and may indicate fear of job failure, but since you were not injured it indicates that you will triumph over any enemies. Now eat quickly—you don't want to be late."

At school Joseph opened his mail and found a note from the gym teacher thanking him for hand lettering the athletic awards. There was also an envelope from the Principal marked, "Urgent." The envelope contained a distress call for signs to direct traffic during open house that night. As Joseph walked to the Principal's Office, a small voice inside him said, "Painting traffic signs is not your quest—your quest is to teach art." But, Joseph painted the signs during his lunch period.

The First Test

The next night Sir Joe was at an inn with two other knights. An old man at the inn told the three knights about a beast with 30 heads who guarded a nearby bridge. The beast required travelers to answer questions truthfully before permitting them to cross. If a traveler gave a false answer, the beast would spit venom that made horrid warts grow all over the traveler's face. The first knight, trying to look courageous, said that no beast could possibly know as much as he. The second knight, not to be outdone, said that even if he did not know the answer, he could answer with enough authority to fool a beast.

In the morning the three knights approached the bridge. The monster was there with its 30 heads all talking at the same time. The beast became quiet and 60 eyes measured the approach of the first knight. "Stop!" commanded one head. "You may not pass unless you can tell us whether informal balance is better than formal balance." The first knight had taken art appreciation and knew that informal balance was better so he said so. But, all 30 heads shouted, "Wrong!" They all spat on him and large warts instantly grew all over the knight's face. To hide his shame the knight ran away.

When the second knight approached the bridge a different head asked the same question, "Which is better formal balance or informal balance?" The knight responded with real confidence "If informal is wrong, then formal must be correct." But, the 30 heads laughed and spat. The knight tried to wash off the venomous spit by jumped into the river; but—because of his heavy armor—he drowned.

Sir Joe, with Bliss at his side, approached the beast. A new head repeated the question, "Which is better, formal balance or informal balance? You must tell the truth, or you cannot pass."

Sir Joe was speechless. Bliss whispered to him, "Do you know the answer?"

"I don't know," he answered.

"Then that is the truth," she assured him.

Sir Joe looked at the monster and in a shaky voice said, "The truth is I don't know which is better." He paused and waited for the heads to spit. When they did not he gained courage and added, "First one kind of balance is fashionable then the other. Some prefer one, some the other. Perhaps one is better for some kinds of art while the other is best for other kinds of art."

"You have answered well," said the head that had asked the question. The 29 other faces looked disappointed, but the beast opened the gate to the bridge and invited Sir Joe and Bliss to cross.

Joseph woke up and did not try to go back to sleep. When it was finally time to get up he showered, shaved and went downstairs. While his mother boiled the oatmeal he told her his dream and asked her what he should do. Again, his mother comforted him, "Since you crossed the bridge safely, your dream predicts satisfying changes in your life."

At school that morning Joseph had coffee with other teachers in the faculty room. They were discussing how to deal with students who ask teachers preposterous questions. One teacher said it was no problem for he was sure that he knew more than any kid. And then another teacher said that the most important thing was to answer with a tone of real authority in your voice. Joseph became uncomfortable and left, for the teacher's conversation sounded too much like his dream.

During Joseph's first period class Billy, who was usually a troublemaker, asked, "What are the REAL primary colors—the science teacher says they are red, blue and green?"

As Joseph paused to answer, a small voice inside asked, "Do you know whether one color theory is more real than another?" Still, Joseph knew that he had always taught only one color theory, so that he would not confuse the students. Joseph sensed that every student in the class was watching to see how he would answer. There were 30 pairs of eyes on him. So, rather than risk losing face, he called on Mary to answer the question.

Mary answered, "In art we use red, yellow and blue."

"That's right Mary; I can always count on you,"

Though he saw the similarity to what had happened in his dream, he did not expect the students to spit at him. And they did not. "They were happy to be in an art room where he was the source of truth," he thought.

The Second Test

The next night a talking snake approached Sir Joe and Bliss. The snake had a marvelous voice with only a hint of a hiss. The snake offered Sir Joe a magical pair of glasses that would permit him to see what no one could see—he could even see into the future. Sir Joe thought the glasses would be valuable in their quest, so he traded his dagger for the glasses. The snake coiled its body around the handle of the dagger and slithered away.

After the snake left, Sir Joe and Bliss approached a great wall. When Sir Joe put on the glasses he could see through the wall. On the other side he saw a shadow of what must be the dragon. Because the wall was too high to climb, they began to walk around it.

After some time they came to a carnival man who was running a shell game. As the carnival man broke open walnuts for his game, Sir Joe realized that with his glasses he could read tiny writing on each of the shells. The carnival man invited Sir Joe to play, but Bliss warned him that no one ever wins the shell game, "You won't know if the glasses really enable you to see into the future until

the future is history." Still, Sir Joe believed that they must win, because they needed provisions for their trip around the wall.

Sir Joe adjusted his glasses and watched the carnival man put the pea under a shell that was clearly marked, "Personality." So, Sir Joe knew that he could win. Having spent all his gold on credits at the ivory tower, he bet his shield. The carnival man moved the shells quickly and then stopped. Sir Joe read each shell carefully, and pointed to the one marked, "Personality." The carnival man lifted the shell and the pea was not there. Next, Sir Joe wagered his armor. Although he saw the pea go under a shell marked, "Cultural," the pea was not there at the end of the game. Finally he bet his sword. He got very close and saw the pea go under a shell marked, "Academic." But when the game was over the pea was under another shell. Because Sir Joe had nothing left to wager, the carnival man folded up his tent and trudged away.

Sir Joe threw away his glasses and sat down. He was completely discouraged. He had no gold, nothing to fight with, and a great wall between him and the Dragon. Bliss, however, picked up the nutmeats that the carnival man had discarded. She offered them to Sir Joe and they both ate until they were full.

Joseph woke up and went to his mother's room. After his mother heard the dream she consoled him that gambling in dreams requires a contrary interpretation. "If you win, you should be careful in financial ventures," she said. "But losing means you can expect a profitable opportunity." Then they drank coffee until it was time for Joseph to drive to school.

Joseph was glad that it was an in-service day; for he was certain that he was too tired to teach. Joseph went to the auditorium where the other art teachers from his district were to hear lecturers on art education. The moderator introduced the lecturers who had been invited to present their views on curricula design.

The first lecturer advocated lessons that would support personality development. Lessons that started with what students did naturally would not risk denying the students' values. And praise for students' efforts were more important then criticism of results.

The second lecturer advocated lessons that would focus on the art of different cultures. He argued that in our multicultural society, schools have a responsibility to help students appreciate cultures other than their own. The art room, he argued, has a greater potential to bring about changes in attitudes than academic classrooms.

The third lecturer advocated multidisciplinary projects. He argued that art should defend its place in schools by supporting the academic program. He suggested that there are mental abilities in art that have their counterparts in academic studies. And he favored reading and writing assignments as part of the study of art history.

As Joseph walked from the auditorium to the cafeteria he considered the lecturer's ideas. Encouraging students to do what they want to do should minimize some tensions that he was experiencing with some unruly students. The cultural ideas were appealing, for he already had students make African masks. He reasoned that if he could cooperate with some academic teachers, his chances for tenure might be enhanced. But then he sat down at his table and saw that the centerpiece featured a big bowl of nuts. As he looked at the nuts he recalled his

dream and wondered whether personality development, cultural tolerance, and supporting academics should be the meat of art learning.

Confronting the Dragon

That night Sir Joe and Bliss discovered the dragon on their side of the wall. The dragon was sleeping while all around him artists were painting sculpting, and throwing pots. The dragon was as big as a house. Its eyes were as large as windows and its nose puffed smoke like a chimney. Sir Joe trembled, for he had nothing to fight with. He asked Bliss, "What will I do?"

She pressed an amulet shaped like a key into his hand and said, "Hold this next to your heart and you will be able to conquer the dragon from within." Then Bliss disappeared.

While the dragon slept, Sir Joe walked past the artists, right up to the nose of the dragon. The dragon raised its head, and breathed more smoke through its nose. Sir Joe held the amulet close to his heart and told the dragon that he had come to take art back to the King's Castle. The dragon replied that if Sir Joe came closer, he would breathe fire and burn him to charcoal for his artists to use. Clutching the amulet and holding it at arm's length Sir Joe said, "I have a bomb that will explode if it gets hot, so be careful to keep me cool." Then, before the dragon could respond, Sir Joe walked inside the dragon's nose.

Inside the dragon's head he stumbled about in the dark until he found light coming through the dragon's eyes. With the amulet still at arm's length, rather than next to his heart (the way Bliss had told him), he went to the left eye and looked out. From the dragon's eye he could see all the artists' finished artworks. As he looked at their artworks, he was able to judge their quality. These judgments were easy because he could compare each artwork with all the art that the dragon's eye had ever seen.

Next he went to the right eye, looked out and saw the artists at work. From the dragon's right eye, he did not make judgments of quality; he saw only interesting possibilities in each artist's work. He was so intrigued with the evolving process of discovering new possibilities that he walked out of the dragon's head in order to get closer to the artists. Still holding the amulet at arm's length, he warned the dragon to keep cool. As the dragon retreated, Sir Joe walked among the artists and described his intrigue with the emerging possibilities in their works.

Joseph woke up feeling confident in the achievement of his namesake, Sir Joe. Still it was several hours before he could go back to sleep. When he woke again it was noon and his mother told him, "I telephoned the school that you were sick. I knew that you needed the sleep."

Joseph announced that he felt fine now and that he would drive to the city and visit the art galleries—it had been a long time since he had been there. His mother was fearful that someone would see him and know that he should be at work, but Joseph was determined.

So he visited the galleries, talked with a gallery directors, and in the evening he attended an opening. At the opening an artist was so intrigued with Joseph's insight into the possibilities of his work that he invited Joseph to his loft.

There they looked at paintings and talked. At first they talked about the artist's work, but then the artist asked about Joseph's paintings. Joseph described his last painting. It had been several months since he had completed it, but he recalled it vividly. He told of his initial inspiration, his preliminary sketches, his evolving idea of what he wanted to accomplish, and the painting techniques he had used. It made Joseph feel good to talk about his own artwork and the artist seemed really interested. After Joseph finished the artist observed, "It is encouraging to know that, "some of those who CAN, also TEACH." Feeling very good about himself, Joseph fell asleep on the artist's couch.

The Hero's Return

When Bliss returned to Sir Joe she found him on a beach surrounded by artists. The artists worked rapidly, discarding half-finished works in order to explore new possibilities that Sir Joe identified. She confronted Sir Joe, "Why have you not taken the artists back to the castle?"

He replied, "Because I looked through the eye of the dragon I am better able to appreciate the possibilities in their art than anyone in the castle.

Bliss retorted, "If you had held the amulet next to your heart you would have looked through the right eye first and the left eye last. Then you could first see possibilities in process and finally judge quality in finished artworks."

Sir Joe ignored her, but Bliss continued, "Can't you see that what the artists are doing now is no better than what the dragon left at the castle?"

Still Sir Joe seemed not to hear. He was watching his feet. They were turning green and growing scales. "What does this mean?" he asked Bliss.

She answered, "It means that if you don't take real art back to the castle, you will become the dragon." Do you still have the amulet she asked?

"It's on my key ring," he replied.

When Joseph woke up he was clutching his key ring next to his heart. It was still dark in the artist's studio, so Joseph walked quietly to the bathroom and turned on the light. Griping the towel rack to steady his nerves, he inspected his feet for scales. He was relieved when he found none, but he was still troubled by his dream.

Back in bed he wished that his mother could give him a reassuring interpretation of his dream, but she was not there. Then he remembered that she had named him after the Biblical Joseph who was good at interoperating dreams. As he held this thought, he recalled each of his dreams, and he began to ask himself questions:

> "Am I becoming a dragon—keeping real art for myself, while requiring students to do exercises and experiments?
> "Am I more concerned with praising students for the possibilities in their work, rather than judging the quality in their work? If I don't judge their work, are they unlikely to make real progress?
> "What should be the meat of my art curriculum?
> "Are my own paintings more real than the faded reproductions at school?

"Are my quick demonstrations giving students an unreal impression of how artists work? How much might students learn if I take a whole period and show students how I really work?

"If I teach real art, can I be honest with students when I am unsure of an answer?

"If I really teach art, will I have the courage to tell the principal that I have better things to do than paint traffic signs?"

These were not easy questions to deal with. As Joseph pondered them, he wished that he had never taken the doctor's pills that made him remember his dreams. "The doctor was wrong to have given me the pills," he thought. "But was the doctor wrong about authentic assessment?" The Doctor's words, which he had dismissed before, now seemed self evident. "How can students learn to appreciate real art by making something that is not real?"

So Joseph reconsidered all of his questions. When he was comfortable with his answers he fell sound asleep.

Questions

Real art and unreal art: Is the art that you make on your own different from that required in school? Have you experienced art lessons that seemed unreal? How are students' exercises different from the things that artists make? Can well-intended teacher activities increase the probability of unreal student artwork? Is exhibiting unreal student art an attempt to pass it off as genuine? If it is not genuine, is it counterfeit?

Appreciation or production: Can students learn to appreciate real art while making unreal art? Is appreciation used as a goal to justify student art that is less than real?

Truth or theory: Which kinds of information that art teachers teach is real truth, rather than merely theory? If we teach theories, should we include alternative theories?

The Meat or the Shell of Art Curricula: What should be the real meat of an art curriculum? How might multidiscipline projects distract students away from the meat of art? What kinds of academic learning might contribute to the meat of art?
Some art students are self-confident and are good in academics—is art the reason? How might art lessons based on the art of other cultures misrepresent those cultures?

Product or Process: How should teachers deal with judgments of student art? Should students be judged by the standards of artists and critics? Should teachers merely encourage students rather than judge their artworks? Does giving grades require teachers to make judgments?

What kinds of things might well-meaning teachers do that are likely to distract students from making real art: Consider the things that Joseph did in the story. Are these things unique to Joseph?

Goal or Quest: Is teaching art something that you know how to do when you graduate, or is it something that you keep learning about?

Artists or Teacher: What are the emotional consequences of feeling that you have sacrificed the artist within you, in order to achieve the security of teaching? How might the artist within you become an asset in the classroom, and make art more real for students?

2

The Apprentice

A 21st Century student is apprenticed to a 14th Century master.

"Once upon a time," might well be the beginning for the story told by two bundles of letter discovered in a recent estate sale. The letters, tied with green ribbons and secured in a wooden box, are the correspondence of a mother and her daughter. The story they tell is, in several respects, like a fairy tale. In the first place, there is an element of magic in the story, because the correspondence seems to transcend time. That is, while the mother writes from a contemporary context, the daughter writes from a much earlier time. Scientific analysis confirms that the mother's letters are on contemporary bond paper, while the daughter's are on handmade paper that is at least 200 years old. The ink on the daughter's letters is similarly old, but the daughter's vocabulary is definitely contemporary.

In addition to the magical time relationship, the letters have another quality that makes them like a fairy tale. The daughter, who is the heroine in the story, must solve a riddle.

The story begins with a letter from the daughter, a teenager who would have been more at home in an Ivy League College than in the place her mother has sent her.

September 10
Mother,

You have sent me to a dreadful place. Everything here is so primitive. The mud in the streets is ruining my shoes, and I must walk to the fountain twice a day for water. When I am in the streets everyone stares at me. At first I thought it was my jeans—all the women here wear skirts. But I started wearing the dress that you made me bring and they still stare. Perhaps it is my hair, everyone here has long hair.

The boys here tease me, because the dress you gave me is becoming quite stained with pigments. Each day I strain with mortar and pestle to grind pigments into paint that it seems I will never get to use. When I collapse with fatigue, the boys come and use my paint to lay in backgrounds on the Master's paintings.

The Master has not said more than two words to me since the first day I was here. It was the boys, not he, who showed me how to grind the pigments to make paint. The master sleeps late and comes to the studio just as the boys are starting their work. He supervises them, but he now has no time for me.

On the first day I was here the Master seemed interested in me. He told me that he knew that I liked to draw flowers and asked me to draw one for him. He watched quietly as I drew the stem and the leaves and started to draw the petals.

After watching me for some time he asked, "What are your thoughts as you draw?"

I answered honestly, "I am fearful that you will not like my drawing."

He ignored the openness of my answer and asked, "How do you know when your drawing will be finished?"

I looked at my drawing and said, "My flower will be finished when I draw the last petals."

His mood changed as he said, "**You will not touch brush to paint until you know how to think like an artist and until you know when an artwork is truly finished.**"

So, he has invented an impossible riddle that threatens to bind me forever to menial labor. God! I wish I could come home.

If you do not send me money soon, I shall surely die—the food here is unbelievably disgusting. Would you believe that yesterday we had spaghetti sauce made with deer meat—just the thought of eating Bambi turned my stomach.

Your daughter,
Vanity

Sept. 21
Dearest Daughter,
Your letter took so long to reach me. It makes me realize just how far away you are. It seems that we are separated by time as well as by thousands of miles.

As I read your letter, I grieved for the sacrifices that you are making. How I wish that I could have kept you with me and raised you as a lady. You could have painted the flowers you so loved and young men would have praised your artwork just for the chance to be near you. But, your father's untimely departure and the drunken driver that ran me down have forced us both to live in ways that we never expected. The apartment that I have now is a far cry from our house in the suburbs. The bank has reclaimed the Mercedes and the power company is threatening to turn off the electricity.

When the Master agreed to accept you as an apprentice he did so with some reluctance. That reluctance must have been more for fear of how the boys would accept you, rather than for any reservations about your talent. If you can get along with the boys, I am certain the Master will come around.

I do not have the money you requested now, but I will send some when my disability check comes.

With Love,
Mother

October 3
Dear Mom,

Following your advice, I tried to be friendlier to one of the boy named Giovanni. I hoped that he could give me the answers to the Master's questions. Giovanni said that he could not tell me what to think as I drew but he would show me. Then he kissed me—not the way you kiss me—but with his mouth open and he held me very close for a long time. I had never felt so completely alive before. He told me that when I could feel like that as I drew, I would be thinking properly.

Now at night, as I try to draw by candlelight, I think of Giovanni's kiss and I long to feel as I felt then, but I can't. Is it proper for an artist to think that she would rather kiss than draw?

If Giovanni can't tell me how to think as I draw, how did he ever pass the Master's test? It seems that only girls are required to pass the test. It's dreadfully unfair.

Perhaps if you had been kinder to father he would not have disappeared. I used to hear you arguing while you thought that I was asleep.

I hope the money comes soon.
Vanity

October 10
Dearest Daughter

A proper girl will always give her kisses with discretion. It was wrong of Giovanni to trick you. I am certain that he is more concerned with his own pleasures than in telling you how to think as you draw. Protect your purity; once it is lost it cannot be regained. And, do not tell the Master what Giovanni has done. The threat that you might tell, will give you greater power over him than actually telling.

If your father had been as good to me as he was to you, the kind of kindness he wanted would have come easier.

Mother

Ps. Use the enclosed money wisely.

October 18
Dear Mom,

I got the money you sent today and went straight out and bought some Gelato. It was cool and delicious. It is so dry and hot here. The dust from the street has turned the fringe of my skirt a bright orange. The Gelato was so good

that for a time I forgot how everyone about me smelled—have I told you that no one here bathes, so everyone skinks of sweat.

While I was out I bought the boys a bottle of Grappa as a peace offering. They drink it every chance they get and claim that it helps them to think like artists. They promised to share the bottle with me.

Love,
Vanity

October 20
Mom,

I have the most awful headache. And this morning I could not eat. I fear that I have some terrible disease. Adding to my physical distress is the realization that the drawings I did last night look crude and sloppy this morning. That's hard to understand because, I felt so good as I did them. I liked the freedom that I felt as I drew in the night, and I supposed that it was caused by the Grappa. I thought that I was finally thinking with the confidence of an artist, so seeing the drawings this morning was a real disappointment.

Do you still enjoy your Manhattans?

Vanity

October 30
Dearest Daughter,

A hangover is a self-inflicted disease. It is the predictable result of drinking too much. I did not have a Manhattan until after I was 21. Perhaps when you are 21 you will have the good sense to drink responsibility.

Mother

November 19
Dear Mother

Calamity! Last Thursday the Master said that I should do only figure drawings. He gave me a pile of drawings of naked people to draw. You know I hate drawing people. Although I labor to get the lines just right the Master is never pleased. He always tells me to show more volume in my drawings. Is showing volume what artistic thinking is all about? My one pleasure in life was drawing flowers. Now even that is gone.

You need not concern yourself about Giovanni's advances. Although I still think about how I felt when he kissed me, he now seems more interested in other boys than in me.

>Despondently yours,
>Vanity

December 16
Dearest Daughter,

You are too beautiful to worry about the likes of Giovanni. Good riddance.

As for the Master's wish that you draw only nudes; no one should have such power over you, as to control your every moment. You cannot be punished for what you draw in secret—but be very careful.

>Love
>Mother

January 6
Dearest Mother,

Last week it snowed, but it was not like the snows back home—only half an inch and it was gone by noon. While everyone went out to walk in the streets that were momentarily white, I stayed behind. In the garden outside my window I saw a rosebud. At first I thought it miraculous that a rose would bloom in winter but then I thought I might not understand the seasons here.

I went out, picked the rose bud and hid it behind my bed. I had intended to let it dry and keep it to draw, but the next evening the bud had fully opened. I thought roses would not open unless you put them in water. I wondered what my surprising rose was trying to tell me.

While the Master and the boys were lingering over dinner, I secretly did my first drawing of the rose. The experience was a disaster. No, I was not discovered. Rather, I discovered that I could not hide from the Master's voice. I kept hearing him say, "show more volume, show more volume." Now even the fun of drawing flowers is gone. "Volume! Volume! Volume!"

>I wish I could come home.
>Your Daughter

January 18
Dear Daughter,

You should listen to your mother. It is not sensible to talk with, or even listen to, flowers. If you tell anyone that you are talking with flowers, they will think you are crazy.

If you want the Master to be interested in you, you must show that you are interested in him. If you want the Master to like you, you must show that you like him. Now get hold of yourself and remember what I have taught you about dealing with people.

Mother

January 27
Dear Mother,

I tried to show interest in the Master by watching him paint, but he stopped work and stood for a long time while looking at his painting on his easel. Thinking that he was testing my patience, I decided to test him. I asked him to tell me what he was thinking, so that I might learn how to think like an artist. Without turning he said that he was trying to fully see what was there. As he continued to gaze at his painting, I wondered if the Master's eyes were failing. What else could explain why he saw so slowly?

Giovanni let me see the Master's sketches for the painting that they have been working on. The sketches were nothing like the careful drawings he makes me copy. His sketches seemed hurried, with many corrections—more like the drawings I did under the influence of the Grappa.

I wonder how he can paint, if he cannot see and cannot draw. I fear that I will have grave difficulty showing interest in a man for whom I have so little respect.

The hopelessness of my situation here makes me want to cry.

Vanity

February 12
Dear Mother,

I have great news. Well, almost great.

The Master asked to look at my drawings. I opened my portfolio of figure drawings and started to tell him about them, but he said that he wanted to see the drawings that I kept behind my bed. While wondering who had told him of my hiding place I reluctantly showed him my newest flower drawing.

I explained that I had gotten the idea for the drawing while I was in bed. While I was half awake I had seen a rose that was bending its head and shedding dew drops as tears. This was an image that seemed to reflect my own tears. The next morning, while I was grinding pigments, I visualized how I might render the foliage so that even thin leaves might have "volume."

In the afternoon—even though I thought I had a plan for my drawing—I looked at the blank sheet of paper and could not start to draw. Something was not right. The next morning I got up early and went to the garden. I hoped for dew, but there was none; so I got an atomizer and gently sprayed a rose until it bowed under the weight of the mist and began to cry. When I saw the rose crying with the light behind it I knew that it was far more meaningful, for the light coming through the tears transformed them to jewels. As I ground pigments, I wondered how I might render the jewel-like sparkle of the dew in the early light, and I resolved to try to draw the dew first so that the cleanest part of the paper would be the reflection in the dewdrops.

In the afternoon I cut the rose, sprayed it with water, and put it in the window, so that the light just caught the droplets of water. With great anticipation I began to draw.

I apologized to the Master that I did not know what I was thinking as I drew. In a sense I was not thinking at all, although I was acutely aware of everything and I had a sense of really being alive. Then I lost my composure. Tears ran down my face as I looked at the Master. I feared that I would never pass his test—for I did not know how to think as an artist while I drew.

The Master put his hands on my shoulders and explained, "Artistic thinking has more to do with what we think when we are not in the studio. Artistic thinking pervades our every waking moment—and sometimes interrupts our sleep. **Your ability to work without conscious effort is born of the confidence that comes from disciplined preparation." Then he congratulated me for having passed his first test.**

I could not believe what he had said. So, I asked him how I could be thinking properly when I had not followed his instructions to draw only figures. He replied. "Those who only do only what their teachers say are thinking like students, not artists."

I am still in shock.

As I look at my drawing now, I think of the Master's second test. I wish I could know how to judge when my artworks are finished.

I know that things are tight for you, but I hope that you can send me some money for paper. The scraps that I cut from the corners of cartoons are small and I long to do larger drawings.

Love,
Vanity

The discerning reader will have noticed that the relationship between a master and apprentice is not an easy one—especially when that relationship is complicated by a generation gap of several hundred years and a mother who is more concerned with social strategies than artistic values. As

the story continues the already shaky relationship between the Master and Vanity seems to deteriorate, even though Vanity has solved the first part of the riddle.

In the second bundle of letters the setting for Vanity's apprenticeship becomes increasingly clear. Most likely, she is in Siena. That walled city in Italy is consistent with the places that Vanity refers to. And the names of the apprentices—Giovanni and Siomini are the first names of artists who were active in Siena. Moreover, the most famous painter of Siena is remembered simply as Maestà—a name that translates to *Master*.

March 30
Dear Mom,

I'm sorry that I haven't written. It is a strange injustice that the paper that you helped me purchase would make me so involved that I would forget to thank you.

Love,
Vanity

April 13
Dear Mom,

What can I do? I still don't know how to judge when my drawings are finished. The Master—after his moment of kindness when he saw my *Crying Rose* drawing—has returned to his pompous ways. Today, when I was full of the excitement of working on a drawing that I felt was really good, I approached the Master. He was admiring the highlight that he had just painted on the Madonna's nose. He looked really contented, so I said that I now knew how to judge when my drawings are finished. As he turned I said, "They are finished when I feel really good about them." His face turned red, he turned back to his Madonna and said that, if my feelings were such a trustworthy guide to quality, then I had little need of an apprenticeship with him.

Now I am afraid that he will discharge me.

If he does, I am likely to have to survive on the streets until you send me the money to come home.

Fearfully yours,
Vanity

April 21
Dear Vanity,

The mail takes so long that I fear that you may already be on the streets. But if the Master still tolerates your presence, you should use the surest form of flattery. Make your drawings as much like his as possible. Then apologize and say that they are unfinished because they do not yet look as good as the Master's.

Your success in appeasing the Master is imperative—I used the last of our savings on a one-way ticket to send you there. There are no options; you must make amends with the Master.

I anxiously await your next letter.
Mother

April 30
Mother, my Mother,

I tried what you said. I found a painting that was in the back of the studio. It had flowers about the neck of a maiden. I made a very careful copy of the flowers then showed it to the Master. I apologized that it did not look as good as the garland on his maiden. I promised to continue working on it until it was as good as his, then I would know that it was finished. But the Master snarled, "If you want to draw no better than the garlands on that old painting, you have low standards indeed." "That painting is here in the studio because the patron rejected it."

The Master expects too much. He wants me, an apprentice, to be better than he was long after he had his own studio. I should never have tried your silly flattery trick. Giovanni warned me that it was risky.

Still, the Master has not asked me to leave. It may be my fate to always make paint that I will never be allowed to use. Today Giovanni said that I finally got the paint consistency just right. Dear God, is this my calling?

I really miss being at home,
Vanity

May 2
Dear Mom

I have kept my distance from the Master. He seems to have forgotten what he believed to be my indiscretions.

The boys and I have taken to walking through the streets after dinner. Last night we walked from the Porta Camilia to the Piazza del Campo. I feel more

accepted now. I think they see me as a dependable worker and as a contributor to the success of the studio. Certainly they would not be as relaxed when they paint, if their arms cramped from making paint. Simone is now trusted to paint the robes on saints. And Giovanni, who used to do only under coatings, is now doing a sky. While they used to walk arm in arm and leave me to trail behind, the three of us now go arm in arm together.

Giovani says that the Master is negotiating for an important new commission for a "Madonna of the Flowers." How I wish I might do at least part of the flowers that it is likely to require.

Love,
Vanity

June 20
Dear Mom.

Yesterday started marvelously, but ended in disappointment. The Master took me with him when he went to visit Mrs. Fiores to discuss the proposed "Virgin of the Flowers." I wore my dress after I had tried to clean it by rubbing it with a piece of wool. I got everything off except for a little pigment on the front, and I tried to keep it covered with my hand. The Master showed Mrs. Fiores several of my drawings and she agreed that they would be appropriate for her painting.

When we came back the Master said that he hoped that I might paint the flowers as well as draw them, but he still was waiting for my answer to his question: "How should I decide when my artwork is finished?" I could not believe him.

What will I do? I don't know the answer to his riddle. Must I do the cartoons only to let one of the boys do the painting? They have never drawn flowers. Will the Master risk what one of them might do just to adhere to his silly rule? I had thought that I was being accepted as an equal, but it seems the rules are there to insure that art remains in the hands of men.

Disappointedly yours,
Vanity

June 30
Dear Mom,

I haven't heard from you in ages, I hope you are well.

After I wrote you last I went to the Duomo, it was much farther than the Basilica; but I did not want to pray, only to escape. There by chance—or was it divine intervention—I saw a new altarpiece by Ghirlandaio. It had flowers in the

foreground. I studied them closely; they were wonderfully graceful, delightfully rendered with sure strokes. They had just enough detail so that I could recognize each species.

At first I had a vision of how grand those flowers might be in the proposed "Virgin of the Flowers." Then I realized that the flowers were flat. They lacked the feeling of volume that was part of the Master's style, and they did not have as much volume as my latest drawings.

As I came out of the Duomo I met the Master and told him about my reactions to the Ghirlandaio. I explained my vision for flowers that would be better than Ghirlandio's because my flowers would have more volume. The Master listened intently and asked, "If you do paint the flowers, how will you know they are finished?"

I wanted to scream, as I answered, **"I'll know they are finished when they look better than Ghirlandio's**."

"That," he said, "is a proper answer, for we must strive to be better than our competition. Proper judgments must always be based on comparisons with the best painters."

I might not have time to write for some time, as **I will start painting the flowers tomorrow.**

Love,
Your Daughter

If this were an ordinary fairy tale the apprentice would have solved the riddle through her cleverness or because of her virtue. Vanity, however, searched for a solution through trial and error rather than through any kind of cleverness. She was surprised when she happened on to the solution. As for her virtue, the best that can be said is that she became less self-centered. Her passing references to "God" are more like expletives than any evidence of deeply felt religion.

If the Ghirlandio painting that Vanity studied in the Duomo was indeed new, then Vanity must have been writing from Renaissance Italy; but if the painting was simply new to the Duomo, the time of Vanity's letters could have been later. Either time would be inconsistent with when Maestà, the Master of Siena, worked.

The value of the letters, however, is not dependent on their historical feasibility, or on their support for a fairy tale morality. Their value is in their emphasis on the riddles: "How do artist think?" and, "How do artists decide when a painting is finished?" The letters suggest compelling solutions for an earlier time. But the Master's notions of disciplined preparation as a prerequisite for self-confidence, and standards based on competition seem foreign to much of contemporary thinking. Readers must ponder whether the present time is so different, as to require different solutions to the riddles.

Questions

How are your ideas about historical apprenticeships different from typical art instruction today? Were some of your experiences in art like apprenticeships? What might be learned from close association with an artist involved in artmaking? How might art programs be structured more like master-apprenticeships? If art programs move too far from the master-apprentice model, do teachers risk encouraging student art that is les than real?

What is the process of making art? Is the source of a master's ability to be found in the intricacies of the mental side of making art? Can you describe the thought processes that you have experienced in making a recent work of art? If students begin to think like artists, will it make their artwork more real? Is there a danger that art lessons introduced with reproductions of art may encourage emulating the appearance of the reproductions, rather than thinking like artists? Is student artwork, achieved this way, real art or counterfeit art?

How have you judged when an artwork is finished? Have you at times relied on the judgment of teachers or other professionals? Have you used the absence of uncovered canvas as a criterion for being finished? Have you relied on an internal sense of rightness? Have you used similarity to your teacher's artwork (or the teacher's exemplar) as a measure of being finished? Have you experienced trying to make your artwork better than that of a professional? Have you entered competitions with professionals? How might you teach students to make judgments about their own artwork?

Is disciplined preparation the true source of self-confidence? Does the requirement that students start to work quickly limit the possibility that students will mentally prepare for their work? Is praising students a sufficient way to cause self-confidence?

Should student art be judged by comparison with professional art? Can art in schools best be justified by working toward sophistication or preserving naïveté? Is it sufficient to teach students to do what they do naturally?

3

Art Trickery and Magic Witchery

A king and an enchantress have different conceptions of teaching.

Once there was a Prince who, because he had an older brother, never expected to be King. So while his older brother spent his mornings studying politics and fencing, the young Prince sat in his room and read poetry. In the afternoons, while the older brother rode his horse, the younger brother amused himself by working with the gardeners or the cooks. For a time he even worked with the apprentices of the Court Painter while they decorated the throne room with heroic murals. The older brother ridiculed the young Prince for associating with commoners, but the young Prince felt a special kinship with the ordinary people—for he knew that one day his brother would rule over him just as he would rule over the cooks and gardeners.

Then a hunting accident killed both the King and the older brother. As the young Prince followed their caskets to the cemetery beside the cathedral, he grieved for his father and brother. He also grieved for himself, for he was losing his life of freedom—now he must serve the Kingdom.

After the young Prince was crowned King; all the Ministers, Ladies-in-waiting and the Court Wizard gathered in the throne room to see what the young King would do—it was not unusual for Kings at that time to get rid of enemies as soon as they came to power. Would the young King replace the Ministers with the cooks and gardeners and painters who were his friends? The young King sat quietly on the throne for a long time, and then he said, "You know that I have spent more time reading poetry than I have spent learning how to be King, so I will need the help of all of my father's Ministers to govern the Kingdom. But the Court Wizard—whose duty it was to cast spells to protect the King—shall be locked in the dungeon."

Now if the young King had studied politics, he would have known that the usual punishment for an offense that caused the death of a King should have been hanging; but the young King did not know, and because of the kindness of his heart he could not have ordered such a punishment. Hearing his sentence, the wizard tried to run, but soldiers caught him and took him to the dungeon.

The young King continued, "We must find a new wizard who can cast spells to ensure, not only the health of the King, but also the prosperity of the Kingdom." And he directed his Ministers to search for a wizard.

Even though the young King prayed twice each day and went to Mass on Sunday, he still wanted a wizard. It was the custom and he reasoned that he needed all the help he could get, if he was to rule the Kingdom and still have time for his poetry.

Though the Ministers searched for a wizard, they could find none. Finally they brought the King a witch—at least they thought she was a witch. "You don't look like a witch," the young King observed. Indeed, she did not. Her nose was not long, and it had no wart. She had no pointed hat and her golden hair flowed

down over a most beautiful gown. She did, however, have a bewitching smile and a black and white spotted cat.

"How do I know you are a witch?" the King asked.

She responded, "My name is Allure and I am not a witch, but an enchantress. My magic does not depend a black uniform or an ugly face. What my magic requires is the good will that you show me. If you will invite me to eat at your table and promise me a new gown each week, I shall cast spells that will ensure your health and happiness, as well as the prosperity of the Kingdom."

"I can believe that your name is Allure, for you are more beautiful than any of the Ladies-in-waiting, but how can I know that you are able to cast spells?" asked the King.

Allure mumbled a few words and suddenly there appeared a circle of swords around the head of the King. At first the Ministers feared for the King and rushed to defend him, but the swords moved in menacing arcs toward the Ministers and they backed away. As they did, the swords disappeared. "I have already placed a ring of protection about you," Allure said. "The swords will reappear whenever anyone threatens to harm you. Now, will you let me eat at your table and do you promise to give me a new gown each week?

The King agreed.

So, Allure sat at the King's table, and each week the King's tailors presented her with a new gown. She entertained herself by trying on her many wonderful gowns and by playing with her black and white spotted cat. From time to time Allure amused the King by making three-dimensional illusions out of nothing at all—not swords like those she had made to appear around the head of the King—but interesting things like bells, books and candles that would float about the room. She also kept her word and cast spell for the benefit of the King and the Kingdom. The spells were so successful that the King had few problems to deal with, so he read poetry as often as he pleased.

The prosperity of the Kingdom increased until the Minister of Taxation informed the King that there was a huge surplus and asked what should be done with the money. The Minister of Public Works proposed that they build a new palace. The Minister of War wanted to order new cannons. But the young King wanted to give the common people something that would reward them for their hard work. "Gardeners and cooks and laborers and housewives," he thought, "should have the joy of poetry, just as I do." So he decided that everyone in the Kingdom should learn to read. He summoned the Court Poet, appointed him Minister of Education and commanded him to establish schools throughout the Kingdom, so that everyone could learn to read and enjoy poetry. When the Ministers heard the King's plan they complained, "If the adults go to school, they will have no time to work and they will pay no taxes." This observation disappointed the King, but he decided to go ahead with schools for children.

Each week the new Minister of Education reported on the number of new school buildings he had erected, the number of teachers he had hired, and the number of students who were enrolled.

Eventually the King decided to visit the schools, so that he might see how the children were enjoying poetry. But what the King found was students who fell

asleep at their desks and teachers who used switches to make students read their lessons. The only thing the children enjoyed was recess. The young King tried to cheer the students by reading them poems that he had enjoyed as a boy, but the children—though they tried to be courteous, for he was the King—fidgeted, coughed and blew their noses.

The King was distraught. He so wanted the common children to enjoy poetry. "Was their disinterest in school because they were ill?" He reasoned that commoners needed good health and good fortune even more than Kings, and he wished that the children might enjoy the good health and good fortune that he had enjoyed since Allure came to his court. "But how?" How could he find enough enchantresses to protect the health of the whole kingdom? His Ministers had searched for months to find Allure. It would be difficult to find one more enchantress, much less enough to cast spells for everyone in the Kingdom. Finally the solution came to him, "I will have Allure teach the children to cast spells and then there will be enough magic to protect everyone.

So, he appointed Allure the Mistress of Magic Education.

Allure, however, was reluctant to accept the position. She pleaded with the King, "The art of magic is a gift of the spirits. It is likely to anger the spirits, if we indiscriminately give to everyone what the spirits intended for one alone." But, the King was determined, and he threatened to replace Allure with a wizard who would do his bidding.

Because Allure feared the spirits as much as she feared the King, she anxiously paced about the garden and wished for a solution to her dilemma. Seeking a sign, she took some dust from her pocket and threw it near the base of a tree. Instantly the birds roosting in the tree were replaced by the wizards from neighboring Kingdoms.

The wizards listened to Allure's plight. Then they counseled her, "This is a dangerous choice. If you do not teach magic, you will lose your job. And, if you do, all of us are likely to lose our jobs. If everyone can do magic, Kings will not need to hire magicians."

Finally, the oldest wizard suggested a solution, "Teach tricks, but never teach real magic." The other magicians agreed. To enforce their advice, they cast a spell on Allure's magic books that turned them to stone.

The next day Allure told the King that she would become the Mistress of Magic Education. Still, she had one reservation, "Since magic is such a demanding art, it will be necessary to start with instruction in basic tricks." The King agreed, so Allure wrote textbooks on magic tricks. She recruited teachers and instructed them in trickery. They learned to do sleight of hand so that they could cut rope and make it come back together. They also learned to tell what playing cards another person might select. But, they did not learn to cast spells that prevent illness and they did not make three-dimensional illusions out of nothing at all.

The new magic teachers went to schools throughout the Kingdom and taught their curriculum of basic tricks. At first the children loved the tricks. They fooled their parents and they proudly showed their aunts and uncles how the tricks worked. Soon, however, the students became bored. When everyone knew how

tricks worked they could fool no one. So, they complained to the teachers, and the teachers confronted Allure, "The students do not like making tricks." "Can't we teach them some real magic?" they asked.

Allure was troubled with their request. She did not want the King to learn of the student unrest. Yet, she feared what the other magicians would do, if she taught real magic. Because she was anxious, she retreated to her favorite garden. When she got there she picked up some dust and threw it down where it hit a worm. The worm at once became a snake and climbed a tree so that he could better talk with Allure. He seemed to know all about Allure's difficulty and told her that she was confused because she had not considered other alternatives. He said, "The reason the students were unhappy was not, because they could not do real magic. The reason was that they needed a proper appreciation of magic and magicians." This idea was appealing to Allure, because she liked to be appreciated. So, she set to writing new books on magic appreciation. She delivered the finished books to the magic teachers with the admonition, "The purpose of doing tricks is not to do real magic, but to appreciate the greatness of magicians such as Merlin and the witch that King Saul conferred with at Endor."

The new appreciation books pleased the teachers. The students, however, did not like the appreciation lessons any better than learning tricks that fooled no one. Nevertheless, the students studied hard, because the teachers gave tests on magic history.

Everything might have gone well except for some outspoken parents. They noticed that, although their students had been studying magic for years, their families still got sick and they seemed to have no more good fortune than they had before. They complained, "Schools do not need to teach magic appreciation. Real magic has obvious value that holds everyone in awe." What they wanted was real spell-making and less sleight of hand.

When news of the parents' discontent reached the King, he summonsed Allure and reminded her of their agreement that she would teach magic, even though she must start with the basics. Now after years of tricks it was time for real magic. He argued that involvement in real magic was necessary to authenticate the magic curriculum. Besides, he was annoyed at the increasing cost of the apparatus necessary for performing tricks. If they were really cutting rope and putting it back together, why must he continually buy more rope? Finally, because he was displeased, he would grant her no more luxurious gowns until she complied.

Allure dearly loved beautiful gowns, so she resolved to give the students lessons with real magic. She wrote a new Manual on Authentic Assessment of White Magic (Black Magic would not be appropriate for children). The Manual included page after page of assessment tasks that the students were to perform. The tasks listed on the first page were the following: (a) demonstrate morphology by turning a pig into a Prince, (b) show your skill at levitation by making a rock float in water, and (c) make a horse disappear into thin air.

When her Authentic Assessment Manual was finished she visited each school and did real magic herself—she made a three-dimensional illusion appear out of nothing. And then, while Allure watched, the teachers had the students sit in magic circles and chant, "hocus-pocus," until rocks floated in water. Their

chanting did not really work, of course; but Allure whispered an incantation, so that the students thought they had performed magic.

The students were happy, the teachers were happy, the King was happy. But, when the students tried real magic while Allure was not nearby, they were seldom successful. When the students' magical spells did not work, the teachers gave the students failing grades. Since the students knew that they followed the teacher's instructions exactly, they concluded that the teachers were teaching false magic. When the students could stand no more they met at night and burned little straw dolls that looked like the teachers. The spells that they cast on the teachers did not seem to immediately work, but the teachers were afraid and came to Allure. They begged Allure to cast a spell that would protect them from the students.

Allure agreed to protect the teachers, but she did not know what kind of spell to use. She wished she could search for spells in her books, but they were still turned to stone. Wishing for a sign she went to her garden and again threw dust on the ground. The dust turned into a pack of dogs that started to fight with her black and white spotted cat. To stop the fight, Allure quickly turned the dogs into cats. As all the cats came to her and licked her hands, she realized what to do. She would convert the children into a coven of witches and warlocks, so they could do real magic. They could pass the teachers' tests. The students would be happy. The teachers would be safe. And, everyone would adore Allure.

Allure reflected on her own initiation ceremony when she had first received her magical powers. When she was almost certain that she had it right, she gathered the things that she needed: some of the children's text books, and red ribbons nine feet long. She tore pages from the books and cut out paper dolls—one for each student. Next she made the red ribbons into sashes and tied them about the paper dolls' waists. Finally, she recited the magical chant. Because she wanted to get the chant just right, she concentrated so hard that she fell into a deep trance.

When Allure awakened she found that her cashmere gown was filled with mouth holes and she felt strangely old. She looked in a mirror and saw that her blond hair had turned to gray. Alarmed, she ran out of the room. There, beside her door, she found one of her teachers keeping a vigil until Allure should awake; for the teachers again needed help. "What is wrong?" Allure asked. "Did the children do Black magic?" "Did they do dangerous tricks? Did they try to catch cannon balls?"

"Worse than any of those," replied the teacher. "The children do nothing. They imagine that they have the magical power to do anything they wish. They believe that anything they wish for happens; but nothing really changes. The Sheriff's daughter believes that she has turned a pig into a Prince and now she wants to marry the pig. The Sheriff has convinced the people that their children are under a magic spell and they are searching for the witch who is responsible. Several teachers have already been excommunicated and we fear that there may soon be more trials. You must save us," said the teacher.

Allure wanted to help the teachers but since her books had turned to stone everything she tried seemed to make matters worse. Not knowing what to do, she went back to her room.

When the Sheriff heard that Allure had awakened he determined to test her to see whether she was a witch. He summonsed an Inquisitor and together they went to the castle where they confronted Allure. First they required her to recite the Lord's Prayer—a task that most believed witches could not perform. Though they listened closely for any hesitancy in Allure's voice, they heard none. Anxious to justify his suspicion, the Sheriff suggested that she might have the mark of the Devil on her skin. So, they compelled her to take off her clothes and they looked closely for the small red or purple spots that the Devil uses to identify his own. Just as they were about to look under her eyelids the King came in, covered her with his cloak, and forced the Sheriff and the Inquisitor to leave.

Still the Sheriff was determined to revenge the injustice to his daughter. So, he went to the wizard of a neighboring Kingdom to learn how to identify the witch who had cast a spell on the children. Following the wizard's instructions; he collected fingernail clippings from the children, combined the clippings with rye flower and holy water. Next, he baked the mixture into cakes, and fed the cakes to his dogs. According to the wizard, the dogs would attack the one who had cast the spell on the children.

When the King heard that the sheriff was coming to the castle with his dogs, The King was outraged at the hypocrisy of using witchcraft to catch a witch. So much so that he forgot his own anger at Allure for not teaching real magic. Failure to carry out a command of the King should have resulted in a punishment equal to any punishment that the Sheriff and Inquisitor might have wanted. Yet, he went to Allure and told her to flee. He said he would tell the sheriff that she had vanished into a puff of smoke. "You will not need to lie," she said, as she snapped her fingers and smoke filled the room. When the smoke cleared she was gone.

So, Allure vanished, but her students remained. Children believed that there was magic where there was none. Students who were not successful saw good performances as magical. Since they did not have the magic, there was no need to try. Students who were successful believed the spirits favored them, so that real effort was unnecessary. When they left school they seldom worked. And, though they lived in the most despicable circumstances they believed that they had everything that they could wish for.

The King felt miserable that his plan for magic education had come to such an unhappy end, so he collected extra taxes from those who worked, and paid wages to those who did not work. This taxation seemed unfair, but he did not know what else to do.

In time, the King forgot his anger and longed for Allure to return. He wished for the amusement that her three-dimensional illusions had brought to him. He wished for the happiness and prosperity that her spell had brought. But he became depressed when he thought of the harm that magic had done to his Kingdom.

The only activity that seemed to distract the King from his melancholy was painting. Painting was a skill that he had learned as a young Prince while working with the court painter's apprentices. The King became completely absorbed in the craft of painting, so that he painted as long as there was sunlight

to work by and then he spent the evenings drawing by candlelight. The Ministers were concerned that the King spent so much time making art that he had no time for the affairs of the Kingdom.

Finally the ministers persuaded the King to return to the throne room and hear the reports of the Ministers. The Minister of Education reported on the conditions in the schools. "Children do little work. They are not reading as well as they ought and they don't seem to care. They seem to be in a deep melancholy."

The King felt sorry for the children. He so wanted them to be happy. But what was he to do? He wished to escape from the problem and return to his painting. Then he had an idea. "Children," the King said, "can't be expected to work all day at reading spelling and writing. They need a diversion from these activities to rest their minds. The diversion that I most enjoy is painting. Let the children learn to paint. Send artists to the schools so that children can learn the discipline of art. When they make art, they will forget about academic rigors and they will be happy."

The idea appealed to the Minister of Education so he went about the kingdom looking for artists to send to the schools. But all the artists, save one, had fled the Kingdom out of fear of the inquisition. The one artist he found was now retired. The retired painter had been the court painter when the young Prince had worked with his apprentices. The old painter could not possibly travel to all the schools to teach painting, so the Minister decided to have the old artist train teachers to teach painting. The Minister set up a college where the old artist demonstrated the craft of painting. He showed the future art teachers how to draw, and how to transfer the drawing to the wall and how to apply paint. When they perfected their technique the Minister of Education sent them out to the schools to teach art.

The Minister proudly reported the success of his art education program to the King. But when the King visited a school, he was not pleased. The art teacher there neither demonstrated the craft of painting, nor required students to learn the craft. The students did not practice drawing; they did no preliminary plans, so there was no need to know how to transfer drawings to the wall. They worked directly with paint, used their brushes like mops and their colors quickly became muddy. Even though the students did poor work the teacher praised the children's efforts. Curiously the students seemed happy.

When the students had gone the King demanded, "Why do you teach this way? Speak quickly, or I will send you to the dungeon."

The teacher knelt before the King and begged forgiveness. "I was afraid. I knew that you wanted the children to be happy, and I feared that the rigors of mastering the discipline or art would seem more like work rather than fun. Apprentices, after all, work beside their master for years. So I made a pact with the devil. Of course, I did not know that she was the devil. She came to me with a bewitching smile and long gray hair flowing over her stylish gown. She showed me how powers apart from ordinary understanding guide artistic efforts. Even when students appear to succeed it is only because of spiritual intervention. Few

children are blessed by the spirits, so most children will do poor work and they will be unhappy. She offered to make the children happy, if I would teach her curriculum of tricks and fun. If I agreed, she would cast a spell on the children to ensure that the children would be happy even if they were not successful."

What was her name?" the King demanded. But he feared that he already knew the answer.

"Allure," the teacher sobbed, as he collapsed and could say no more.

When the King went to other schools the art lessons were the same. The teachers did not teach the craft of painting, the teachers praised the students even when they did poor work, and each teacher blamed Allure for the way they taught.

The King was distraught with what had become of his efforts to teach painting to children. Still the children were happy. "If painting was only a diversion from the rigors of studying poetry, were tricks an appropriate curriculum? Was Allure using her magic to repay him for helping her to escape the Sheriff?" How the King longed to see Allure again.

When the King returned to the castle he heard that a teacher whom Allure had recently approached was in retreat at an abbey. Because the King hoped to learn where Allure might be; he disguised himself as a Bishop, went to the abbey, and sought out the teacher. "My child you look fatigued from your ordeal," the King said, "pray, sit here and tell me of your encounter with the witch." The King wanted to know whether the teacher had accepted Allure's offer to teach art as magic. So, the King asked, "Did the heavy responsibilities of teaching make the notion of deferring responsibilities to the spirits appealing?"

The teacher replied, "Her personal appeal was very real. And, I have heard other teachers suggest similar ideas. But, the temptation to be lazy was less strong than the need to be moral. It would be immoral to pretend to teach something that was controlled only by supernatural powers."

"Then, can you create art by the strength of your own will?" asked the King. Do you not risk the sin of vanity, if you believe that you alone control your art?"

"God forgive me—I work too hard to discredit myself. Still, there are times when ideas seem to merely appear. But, between the idea and the finished artwork there is much perspiration."

The King pressed the teacher, "It seems unlikely that students will enjoy the kind of work that you connect with art making. Do you not fear confronting the students without Allure's promise to make students happy?" "How will you motivate them?" asked the King.

"Motivation to work comes from high standards. Low standards make work unnecessary, while high standards lead to hard work."

"Will not students be discouraged if they fail to reach your standards?"

"It is proper to reward work," the teacher answered, "Those who work will certainly be discouraged if everyone is rewarded for anything they do. Rewards for everything make work unnecessary. If we are to teach the discipline of art, we must teach the discipline of work. Work is necessary to achieve aesthetic results. It would be a misrepresentation of art history to suggest that master artists achieved quality in their art by tricks, rather than work."

The King objected, "Not all students will become master artists."

"But, every child will become an adult who ought to work," answered the teacher, "and children should learn the joy of work."

The King sat quietly beside the art teacher and considered the teacher's answers. He reflected on the unjust tax that he collected to support adults who did not work. He considered whether it was his complete absorption with the work of painting that made painting a diversion from ruling the kingdom. "Would it be a diversion, if I only played at painting?" he wondered. Completely absorbed in his own thoughts the King forgot to ask the teacher where Allure might be. Finally he remembered that he was pretending to be a Bishop and said, "Bless you, my child, I must go now."

As the King returned to the castle, he reflected on the teacher's dedication to work that had kept him from making a contract with Allure. And then he thought of the other art teachers who were seduced by Allures appeal to teach her curriculum of magic and tricks. Those teachers would certainly need the protection of the spirits, for he had already learned that magic was a dangerous subject to teach in schools.

The King thought about himself. He regretted that his desire for pleasure had tempted him to make his own contract with Allure. He wished that he had dealt with Allure more firmly. "Was he a do-nothing King, just like his subjects who did nothing?

As if awakening to his responsibility to govern the Kingdom, he called his secretary, instructed him to set up appointments with all his ministers so that he could hear detailed reports on their activities. One matter, however, was too urgent to wait for a meeting, so he dictated a letter to the Minister of Education.

> **"Dear Minister: An enchantress is tempting art teachers with false ideas that threaten the fulfillment of my wish to make children happy. These false ideas pervert the disciplined study of art by teaching a curriculum of tricks and trusting in magic to make children happy. Happiness that comes from tricks is likely to be short-lived. Real happiness is more likely to come from the satisfaction with work that is well done.**
>
> **I charge you to find this enchantress and deliver her to a judge, so that she will receive her just punishment. And art teachers enchanted with her ideas must also be held personally accountable for the way they teach art"**

Questions

What experiences have you had that make art seem magical? Does art seem to be the result of talent, or divine intervention? Do good ideas for artworks simply pop into your head, or are you inspired by other artworks? Do articles about art tend to support the viewpoint that artists are very talented people?

What experiences have you had that support the notion that art is the result of work and disciplined judgments? Have you experienced struggling with a painting for a long time before you got it right? Do you get tired while you work on art?

Is the notion of discipline and work at odds with some prevailing practice in art rooms? Are some art lessons more concerned with fun than in learning a discipline? What tricks might art teachers use to ensure that students are happy with their artworks? Are students likely to master a discipline, if they work in a different medium every week? How might art in schools be taught more like a discipline?

Can art teachers use tricks to get students to do the kind of art the teacher wants? For example, do large brushes cause students to do less detailed artwork, even if they don't want to? Does changing the medium frequently ensure a lack of sophistication that may pass for freedom? Do such art teacher tricks—even if they are will-intended—risk perpetuating counterfeit student art?

4

Art and Alienation

A talking crow warns a talented art student that school threatens to alienate him.

Not so long ago, and in a place not so far away, there was a boy named Michael who loved to draw more than anything else in the whole world. What he most liked drawing was people. Sometimes he worked from how-to-draw books, but the book he liked best was a book of old masters drawings.

For the past year Michael had enjoyed working in his own studio. His studio was furnished with a huge drafting table that his father had found in a second hand store, a stool with a swivel top, a small table for his supplies, a goose-neck lamp, and a shelf for his drawing books. The walls were lined with drawings that Michael had finished. Two of the largest ones were framed with moldings that Michael's father had purchased at the lumberyard. Sometimes Michael would sit looking at those framed drawings and think how much more important they looked under glass.

One evening while Michael sat in his studio wondering what to draw, a crow appeared and perched on the top of his drafting table. The crow had shiny black feathers and strutted across the top of the table. When it reached the end of the drafting table, it turned and looked knowingly at Michael.

Michael was not disturbed by the crow, but he wondered how it got in. He swiveled on his stool to check the window. It was closed. He turned back to look at the crow. It was clearly too large to fit through the heat register. He was about to go check the rest of the house to see if a door was open, when the crow surprised him by starting to talk—not the shrieking sounding words you might hear from a parrot, but a voice much more like that of a human. Michael soon recognized the crow's voice. It was the voice of his dead brother, Carl. Since Michael's studio had been Carl's bedroom it seemed that the crow belonged there. So, how the crow got there was unimportant.

Michael told no one about the talking crow with a voice that sounded like his brother Carl. He didn't think that anyone would believe him. They would likely think he had invented the crow as a way of not giving up his big brother. Michel and Carl had been best friends, even after Carl had started attending those political meetings. Besides, if he told anyone, the crow might go away.

One evening, as Michael did his homework for art class, the crow perched at his usual place at the top of the drafting table. Michael paid little attention to the crow, who had become a regular visitor. When Michael stopped to study his drawing; the crow looked at Michael, opened his beak and called, "**Alienation! Alienation! Alienation!**" As Michael looked up, the crow lowered his voice until it sounded more like Carl's and said:

"Homework stinks! It's unnatural to do school work. If you had your way, you would do other things. What teachers want you to do is not like anything in

the real world. If you do what teachers want, you will only be worse off. The reward for doing assignments well is more assignments that are harder."

Michael did not try to answer the crow, because the crow was always saying that sort of thing. Besides, he was enjoying the drawing he was doing now. But, could Carl, the crow, be right? The drawing he was doing now was not what his teacher, Mrs. Prince, had assigned. She had instructed the students to finish the drawings that they had started at school. Michael's eyes turned to the wastebasket that contained the drawing he had started at school, and he recalled the frustration he had felt while he worked on that drawing. Perhaps Carl was right. As he looked back as his new drawing, he thought, "This is really what I want to do. I hope the teacher will see that this drawing is far more personal and give me a good grade."

The crow moved closer to Michael and continued. "It's stupid to work for grades. They are worthless until you get enough of them to buy your freedom from the slavery of school. Teachers use grades to motivate competition that alienate students." Flapping his wings for emphasis the crow said. "School makes you do what you don't want to and makes your friends not like you. School kills your spirit, so that you wish you were dead."

When the crow mentioned, "death," Michael looked up and recalled the day that his brother, Carl, had died. Michael was at school that day. When he heard the siren, he looked out the window of his elementary school, and saw the ambulance stop in front of the middle school. His teacher let him watch until men in white carried out someone on a stretcher. A short time later, Michael was called to the office where his aunt met him and took him to the hospital. At the hospital Michael's father told him that his brother, Carl, was dead. He was the one Michael had seen carried out of the school on the stretcher. Michael could not believe it. Carl had seemed fine that morning. "What was it at school that killed him?"

Michael had heard the crow's speech on alienation many times, but the warning about death continued to unnerve him; for Michael now attended classes in the same building where his brother died. Michael considered asking the crow whether school might also kill him; but the crow never seemed to listen. So Michael put his finished drawing away, found a feather on the floor, put it in his pocket, and left his studio.

On the bus the next morning Michael sat in his usual seat beside his friend, C. J.. They always sat together. While other boys talked on their cell phones, listened to their iPods, or made fun of the girls; Michael and C. J. shared their newest ideas about drawing.

When Michael showed C. J. his homework, J.C. exclaimed, "Wow! That's realistic. Did you work from a photograph?"

"No," answered Michael. "Teacher told us not to. But, I've worked from several of my photographs before. I did this drawing from memory."

While C. J. studied Michael's drawing he said. "I'm glad you threw away the thing you stated in class. This drawing is more personal. Let me show you mine—I started over too. See, it's me as a superhero."

"And," Michael added, "You did it in the comic book style that you usually use. That is really you!"

C. J. seemed not to hear. Instead, he turned around to talk with Yoni and Nodia who had just gotten on the bus. Yoni had recently come to this country from China. She seemed small beside Nodia, who sat looking out the window oblivious to C. J.'s attention.

Focusing on Yani, C. J. asked. "Let me see your drawing, I'll bet you included your monkey. You love your monkey. How many times have you painted your monkey?

"Hundreds, I think," answered Yoni, as she unrolled her drawing. "You know that I paint every day in my father's studio."

"Your drawing's fantastic!" C. J. exclaimed. "The whole picture is just your hand drawing a picture of the monkey. How did you get the idea?"

"I'm most like myself when I paint, but when I paint I sense only my hand and my monkey."

Michael, who had also turned to look, nodded his approval and asked, "Have you seen Nodia's drawing?"

"Yes." Yani answered, "She drew herself riding another of her marvelous horses. No one draws horses as good as hers—such freedom—such understanding of the power of horses." While they talked about her drawing, Nodia continued to look out the window.

After a pause, Yoni questioned, "Will Mrs. Prince like our drawings? They are not much like the drawings we started at school."

Michael, feeling the feather in his pocket, replied: "Our drawings are far more personal than the ones we started in class. Mrs. Prince is an art teacher. She should value our individuality. Besides, fear of what teachers might think will kill our creativity."

While Michael and this friends were still on the bus their art teacher, Mrs. Prince, parked her Chevrolet Impala and walked to the front door of the school. As she walked, she reflected on her assignment and the rubric she would use to grade it. She had assigned a self-expressive portrait and had used a painting by Van Gogh as an exemplar. Her rubric defined three levels of achievement for each of four important qualities in Van Gogh's work. She was confident that she was using the latest assessment theories. In the school office she picked up the 69 copies of her rubric—one for each of her seventh grade students.

Because she was early she stopped at the teachers' lounge. Mrs. Prince sat on the couch and sipped coffee while several teachers at a nearby table tried to console a first-year teacher who was having difficulty controlling students. Mrs. Prince looked up as Mach, the Vice Principal came in and stood beside the teachers at the table. Mach listened as the older teachers tried to help by telling stories about their worst students. When the teachers paused Mach looked directly at the new teacher and told him exactly what he must do:

"Students in the real world are not the angels envisioned by authors of college texts books. Even students, who appear good, will at the slightest opportunity, take advantage of you. Few students want to be good, but none of

them want to be caught being bad. Thus, rewards are less likely to motivate good behavior than the fear of punishment.

"Every teacher must learn to act mean. New teachers should not smile until Christmas. Students will not love you unless they also fear you. It is safer to be feared than to be loved. Love is a fleeting thing. But fear of punishment never fails. It is good to appear to be humanistic, sincere and kind, but when the occasion arises you must be mean."

Mach paused and looked about the room. Mrs. Prince nodded her agreement.

Mach continued, "It is essential to make an example of the first aggressive student who challenges your authority. Any leniency on your part will be seen as a sign of weakness. It is better to be severe with the first offender than to tolerate behaviors that will distract other students from their studies and cause the whole class to suffer.

"Maintaining control is the teacher's primary responsibility, for no teaching is possible until discipline is established. Parents will forgive you for anything that you must do to achieve control, but they will not tolerate a lack of discipline."

Mrs. Prince watched the new teacher's pained reaction to Mach's advice. "That teacher's idealism," she thought, "will be his undoing." Mrs. Prince was confident that she had a more realistic view of students and that discipline was not a problem for her.

Mrs. Prince looked at the clock, picked up her rubrics and walked to her room. Just as she got there the bell rang and students filled the hall. She turned on the lights and stood quietly at the door as students came in and sat down.

Michael, C. J., Yoni and Nodia sat at a table at the back of the room. As the tardy bell rang, Mrs. Prince directed one student from each table to bring the finished expressive self-portraits to her desk. She also had students distribute books to each table and told the class to read the chapter on Cezanné. They were to pay particular attention to his still life paintings, as that was what they would do next.

While the students read Mrs. Prince graded the drawings. She stapled a rubric to each drawing, checked the level of achievement on each criterion and calculated a total grade. When she finished grading she complimented herself, "Expert teachers grade more efficiently than novice teachers." Then she returned a pile of graded drawings to each table.

After Mrs. Prince was back at her desk, Yoni peeked at the rubric on her drawing. She made a face when she saw her grade. She gave Nodia's drawing to her, while Michael and C. J. retrieved theirs. They all looked at each other and held their rubrics so that the others could see their grades. C. J. whispered, "There must be some mistake—we've got to do something." As Michael and Yoni nodded in agreement, C. J. continued, "Let's send Nodia to question her grade. Mrs. Prince must know about her so her grade must be wrong.

Yoni put Nadia's drawing in her hands and gently pointed her toward the front of the room. Nodia walked to the front of the room, laid her drawing on Mrs. Prince's desk, and pointed to the grade on the rubric. Mrs. Prince asked, "Do you

have something to say?" Nodia again pointed to her grade. "What can you say?" Mrs. Prince continued in a voice that carried throughout the room, "You did not follow directions—you did an equestrian, rather than the assigned self-portrait. And, you did not use the expressive qualities that we found in Van Gogh's painting. I was generous to give you some credit for the implied distortion in making the rider on the horse so small. NOW, take your drawing and sit down!" Nodia, who had held her breath while Mrs. Prince spoke, exhaled in a muffled scream as she tore up her drawing, left the pieces in front of the room and stomped back to her seat.

Michael winced, "How could Mrs. Prince not know that Nodia is autistic, spends most of the day in resource rooms, and always draws horses?" When Nodia got back to the table, C. J. touched her hand and whispered, "It was a mistake to send you. I'll talk to Mrs. Prince."

C. J. took his drawing to the front of the room and politely asked, "Mrs. Prince, can you explain my grade? I did my best to follow your directions."

"If you had followed directions," Mrs. Prince answered forcefully, "you would not have made a comic strip character."

"But," C. J. protested, "Comics are the most important thing in my life. I draw them all the time. Nothing is more personal to me."

"YOU are in school so that you can learn to make educated judgments about art qualities. Learned individuals understand that comics are trite subjects often drawn by teenagers, so comics cannot be very personal. Before you sit down, though, I will change your grade. What I first thought was expressive exaggeration, I now see as a close copy of a comic. Your total grade is now one-half grade lower."

C. J. retreated in disbelief.

Back at the table C. J. urged Yoni to take her drawing up and question her grade. "Isn't this drawing as good as the ones you exhibited in China?" He argued.

Yani, however, tightened her lips and breathed, "Too embarrassing."

"Then I'll go," said Michael. And, leaving his drawing at the table, he walked to the front and stopped several feet short of Mrs. Prince's Desk.

"If you want to discuss your grade, bring your drawing to my desk," said Mrs. Prince.

"I don't want to discuss my grade. If you explain my grade using your grading system, my grade is accurate. But, your system is not fair to any student in this room."

Mrs. Prince, sensing that the class was becoming restless, interrupted Michael, "State law will not permit me to discuss with you the grading of other students. Go sit down!"

Michael continued in a firmer voice, "Although you told us to do drawings that really expressed ourselves, you only give us good grades if we use Van Gogh's style."

As Michael spoke, Mrs. Prince got up and advanced toward him and demanded, "Sit down now or you are on report!"

Michael continued, "If Van Gogh truly expressed himself, his style cannot be right for me or for any student in this room. We have not lived 30 years in Europe at the turn of the century. None of us have lived with a prostitute, and

none of us are crazy enough to cut off our ears. His style may have been right for him, but it cannot be right for us."

Mrs. Prince, now inches from Michael's face declared, "You are on report. Now go stand in the supply closet until the end of the period."

Michael sulked in to the supply closet and considered his fate. At first he simply wanted to die, but then he was distracted by the wealth of art materials in the closet. There were also books—a whole library of books. One book on figure drawing caught his attention, for it was filled with pictures of naked ladies. He quickly laid the book face down on the shelf when he heard Mrs. Prince approaching.

"You are on report," Mrs. Prince said, "for disturbing the class, challenging my authority to assign grades, and for refusing to follow a reasonable directive from a teacher. I will telephone your father today and describe your unacceptable behaviors. Now walk swiftly to your next class. I will not give you a pass."

On the bus that afternoon C. J. took a folded drawing from his backpack and showed it first to Michael and then passed it back to the girls. The drawing was of a dragon with a human head. Across the body of the dragon C. J. had lettered, "Art Teacher."

"When did you do this?" Yoni asked.

"I got the idea in study hall. I want Mrs. Prince to like me so that she will recommend me for the Advanced Art class. Unless I am able to take Advanced Art, this class will be my last until high school. So she is the dragon guarding the bridge to the Advanced Art class."

"She will like you even less, if she sees your drawing." Michael suggested. Then he added, "Why did you color her pink? Mrs. Prince usually wears green—aren't dragons usually green?"

"I thought about green." C. J. answered, "but I hoped that she would turn out to be a friendly dragon—pink seemed more friendly than green."

Nodia, while looking out the window, began to chant: "**Dragon Lady, Dragon Lady, Dragon Lady**…"

When Michael got home he sat downstairs, planning how he would explain what Mrs. Prince had done to him and how unfair her grades were. But when his father came home late from work he did not want to hear excuses. Mrs. Prince had telephoned him at work and prevented him from closing an important contract. If his father received another call from Mrs. Prince, he threatened to put a lock on Michael's studio door. Michael was stunned. He had expected his father to take his side for standing up for what was right. Devastated, Michael retreated to his studio.

As Michael sat on his stool and drew, the crow returned. When the crow talked about alienation, Michael paid more attention, for Mrs. Prince's grading system threatened to alienate him from the art that was natural for him.

Then the crow said something that Michael had not heard before, "Teachers alienate students from their parents." As Michael tried not to be mad at his father, Michael feared that the crow was right.

The next morning while Mrs. Prince was having her coffee in the faculty room, the new teacher was still sharing his difficulties. He was concerned about losing face if he changed some of his rules. "They are your rules," the Vice Principal advised. "While consistency is important in enforcing rules, you should never keep a rule that does not work to your advantage. Besides, students are gullible. If you tell them that the change is for their own good, they will praise you for your flexibility. If your old rule gave students a privilege that your new rule takes away, students will work even harder to regain the privilege."

Mrs. Prince considered Mach's new advice while she walked to her room. When her class was seated Mrs. Prince announced some changes in seating assignments. "I am disappointed," she said, "that some students will not be able to keep the seats that they chose on the first day of class. These changes are necessary, because students at one table have difficulty understanding assignments. By moving them to other tables, those students should be able to see what other students are doing and avoid disappointment in their grades." She then directed Michael, Yani and C. J. to exchange seats with students at other tables.

After they moved Mrs. Prince described their next project based on Cezané's still life paintings. She pointed out that objects in still lifes are similar to regular geometric forms. She showed then her example of shaded geometric forms and she emphasized the importance of smooth transitions of shading. Next she called their attention to a still life in the center of the room and lit it with a floodlight so that the shadows would be easier to see. While student monitors distributed paper she admonished students to draw exactly what they saw.

Michael looked at the still life a long time but he did not start to draw.

On the bus ride home Michael asked his friends, "What do you think Mrs. Prince will grade us on?"

C. J. answered, "She will grade how closely our drawings corresponded to our view of the still life—she told us to draw exactly what we saw.

"But," said Michael, "the flood light gives harsh shadows, rather than the smooth transitions she emphasized in her example."

Yani asked, "Does Mrs. Prince want us to work with smooth tones like these in her example?"

"I don't know, said Michael. "The paintings by Cezanné that inspired the lesson were very splotchy—last time Mrs. Prince graded heavily on similarity to Van Gogh."

Despondently, C. J. sighed, "The Dragon Lady is poised to kill again."

That night, as the crow talked to Michael, he repeated his earlier admonitions about alienation at school and added a chorus of, "**Revolution is inevitable. Revolution is inevitable. Revolution is inevitable**."

As Michael went to sleep, he wondered how he might lead a revolt without risking another telephone call from Mrs. Prince.

On the bus the next morning Michael presented his plan for revolution. His idea was for a work slow-down: "Since we can't decide what is required," he argued, "it is to be expected that we will work slowly. It will be hard for Mrs. Prince to punish us for doing nothing. Mrs. Prince will be in a difficult position if no one finishes the assignment. Since we are all at different tables, it will be easy to enlist the other students in our work-action."

Yani objected, "If we do as you want, we will all get low grades."

"If she gives everyone low grades, the Principal is sure to investigate. Anyway, we all got low grades last time. So, we have nothing to lose."

By the time they reached the school they all agreed. "But," C. J. asked, what about the students at Nodia's table?"

I'll find some way to speak to them," Yani said.

While students entered the art room Yoni sat briefly in Nodia's chair and whispered with the students there. When it was time to draw Michael saw his colleagues talking to the students at the other tables. Michael persuaded the students at his table that a slow-down was the only appropriate response to ambiguous assignments and unfair grading.

When Michael looked about the room he tried not to smile, for almost everyone was working very slowly. At the end of the period Mrs. Prince walked about the room, looked at student drawings and observed, "You students have accomplished little today. You must work harder tomorrow, if you are to finish by the deadline."

"It's working," Michael thought, "soon the Dragon Lady will know that she has a real problem."

On the bus Michael told his classmates that Mrs. Prince's threats were only a sign that they were succeeding and that they should rally the students to work even more slowly the next day. They agreed.

From the start of the period Mrs. Prince walked about the room admonishing students to concentrate and to work harder. But most students continued to move at a snail's pace. Michael did nothing on his assignment, but when Mrs. Prince was not looking Michael made sketches of her face.

Halfway through the period Mrs. Prince sat down at her desk. After she was quiet for a while she said in a stern voice, "Michael, come here. There is something going on and you are going to explain it to me."

Michael got up and moved to the front of the room, but he declined to explain saying, "Any explanation might sound like a challenge to your authority and for that I would be put on report."

"My request for an explanation is reasonable," Mrs. Prince said. "If you do not answer, you will be on report for refusing a reasonable directive from a teacher."

So Michael explained that he did not know about other students but he was working slowly because he did not know what to do: "I don't know whether I should make splotchy tones like Cezanne, or smooth tones like in your example. I can't decide whether to draw what I see, the way you told us; or to draw the way

you drew in your example. The work seems easy but the decisions slow me down."

Mrs. Prince pointed to a boy at another table. "You," she said, "Why are you working slowly?" The boy reluctantly answered that he also had difficulty deciding. She pointed to a girl and asked, "Do you also have difficulty deciding?"

The girl nodded her head "Yes."

Mrs. Prince returned her attention to Michael. "You are on report again. Go to the supply closet."

Michael clenched his fists and walked stiffly toward the supply closet. As he went, he heard Mrs. Prince tell the class, "You will have no more class time to waste on this project. It will be due at the start of class tomorrow. If you do not hand in finished work, it will indicate that you are coconspirators with Michael and you will be dealt with appropriately."

Standing in the supply closet Michael thought, "Carl is right, school does make people want to die." Mrs. Prince was sure to telephone his home again and his dad would lock him out of his studio. "Mrs. Prince was totally unfair." he thought. "Carl is right, revolution is inevitable, but how can I revolt without becoming a martyr?" He clenched his fists harder and wished he could hit her; but knowing it would only cause more trouble, he shoved his fists in his pockets. When he did he felt the feather and, as he pinched it between his thumb and his fingers, he had an idea.

When Mrs. Prince walked in and was about to speak, Michael boldly asserted, "You are not going to put me on report and you are not going to call my home. If you do, I'll tell the Principal and the newspapers that you send me in here because you want to fondle my private parts and when I refused you put me on report."

"That is a lie," Mrs. Prince responded.

"The truth doesn't count. What counts is whether you want to risk a public scandal. Decide now, or I will telephone my father and tell him that you wanted me to prostitute my body to avoid being on report."

Mrs. Prince was faced with a difficult situation. She did not want a scandal, but if she let Michael go free it would solidify him as the students' union leader and she could expect more work slow-downs or worse. She considered her options and decided to minimize the potential damage. "I will not put you on report," she said, "if you can guarantee that you will hand in your assignment on time" She knew that would finish him as a student leader.

Michael realized the implications of her proposition, so he hesitated. He desperately wanted to avoid being on report, but he was too proud to cave in completely. If he agreed, he wanted something in return. "I will agree," he said, "if you will give me that book on the shelf." (He pointed to the one he had left face down on his last trip to the supply closet.)

"Agreed," she said without looking at the book. "But be aware that the next time you cross me I will send you to the Principal's office." Michael stuffed the book in his shirt and hurried to his next class.

On the bus Michael told his friends that Mrs. Prince had made him promise to hand in finished work in return for not putting him on report.

"You have betrayed us," sobbed C. J.. "You got us to strike and now you have made a deal with the Dragon Lady to save yourself. This will end our work slow-down and any student who does not get the word will be punished. If we had all stuck together, we'd have had a chance."

Michael did not answer and looked at Yoni for some sign of support. But Yoni screwed up her face and looked away.

That night as Michael tried to finish his drawing; the crow came and repeated his speech on alienation with special emphasis to his warning that, "Teachers use competition for grades to alienate students from students."

Losing his friends made it harder for Michael to concentrate on finishing his assignment. Michael sensed that the Dragon Lady was forcing him to work in an unnatural style—there was nothing about Cezanné that he liked. Apples seemed to be the most boring subject on earth. Besides, he had no assurance that the Dragon Lady would not get him on some trumped up charge—probably for stealing the book he had bargained for. He looked at the book to see if it had any identifying marks and found a sticker inside: "Public School Property." That sticker could mean real trouble.

Not knowing what to do and fearing that any moment the police would come and find him with stolen property, he began to copy one of the drawings. As he drew he began to devise a plan.

On the bus the next morning Michael begged C. J., "Just peek at my assignment. I have a plan that will make us friends again."

C. J. opened the brown envelope that Michael gave him and peeked inside. "Amazing likeness," breathed C. J.. "How'd you do it?"

"The body is from a book and I sketched Mrs. Prince's face in class while she was not looking. The hard part was getting the lighting the same on the head and the body. Finally I used the same kind of light that I had in class on the still life. The background is sketchy because I had to work from my memory of the supply closet."

As Yoni and Nodia got on the bus, Michael hid the drawing.

Immediately after the tardy bell, Mrs. Prince went from table to table collecting the assignments. She came to Michael's table last. Michael left his drawing in its brown envelope and put it on top of the pile. Mrs. Prince wanted to make certain that Michael had honored their agreement, so she peeked inside the envelope and then quickly closed it. Back at her desk she opened the envelope again—just enough to read a note on the back of the drawing. "This is a memento of our time together in the supply closet." She did not grade their assignments during class, the way she usually did. Instead, she paced about the room, while students read about African masks. After the bell rang, Michael was the last to

leave the room. "When you grade the work of my friends," he said, "I hope you will remember that I have more drawings like the one I handed in today."

The rest of the term passed without incident. Michael amused himself in class by sketching classmates and, while Mrs. Prince was not looking, sketching her. Each time that an assignment was due, Michael delivered his in a brown envelope. Mrs. Prince gave Michael good grades, but never returned his drawings. C. J. and Yoni completed each assignment and began to get good grades. Nodia, however, sat in class and did nothing and had nothing to hand in. Eventually C. J. told Yani what Michael was putting in the brown envelopes and that Mrs. Prince would be reluctant to confront any of them again. He hoped that Yani could persuade Nodia to draw again. Yani tried, but Nodia continued to do nothing.

At the end of the term C. J. was upset over a note attached to his grade card. He showed his friends the note while they waited for the bus. The note said that he was not accepted for the Advanced Art Class. Michael tried to console him, "It's not your fault that the Dragon Lady did not see the potential in your artwork. Besides, I won't be in Advanced Art either."

"Why not?" C. J. asked. "Didn't you apply?"

"No," Michael answered. "I was afraid that Mrs. Prince would teach Advanced Art. And I knew that I could not go on doing what I was doing on each assignment. At first it was challenging, but it began to feel just as unnatural as what she made the rest of you do—torn paper collages, African masks, and coil pots. What do they have to do with art that is natural for us? At first I thought I was controlling her, but eventually I realized that I was still not free to do what I really wanted to do. While you were sacrificing your own style for grades, I was doing the same to stay out of trouble. Anyway, my father has promised to send me to a museum school this summer where the classes are taught by real artists."

C. J. turned to Yoni and asked, "Did you apply?"

"No," Yoni answered, "School is school and art is art. I do art at home with my father. He is planning another exhibition for me. I will give him all the credit and I will not mention my school art teacher."

Michael asked Yoni, "What will Nodia do?"

"Her mom said she has stopped drawing and wants to concentrate on her academics,"

"That makes no sense," said Michael. "Why should she give up what she is really good at and try to do what is hard for her?" It was an impossible question, so no one had an answer. Michael wondered what part the Dragon Lady had played in Nodia's decision.

Finally C. J. broke the silence as he pointed to Mrs. Prince getting into a car with the Vice Principal. "He does not look like the picture on Mrs. Prince's desk," C. J exclaimed. "I wonder what that means?"

The next day teachers were expected to straighten their rooms, but Mrs. Prince's room was already straight. So, she sat in the teachers lounge alone drinking coffee. As she sat, she reflected on the last term. "I was right to make the bargain with Michael," she thought. "Dealing with his false accusations would

have distracted students from their work for the rest of the term. He kept his word, handed in his assignment on time, and that ended his revolt. Moreover, a few generous grades for his friends were more than justified to ensure that he would not again disrupt the class. After that incident Michael's class was well behaved and I was able to select students for Advanced Art that were most able to do what I expect."

She sat quietly for a while, content with herself. After her third cup of coffee she got up and walked to her room. Once inside she locked the door, and went to the supply closet where she had hidden Michael's drawings. She sat on the floor, opened the brown envelopes and spread the drawings before her. As she admired the images of herself, she thought, "It is not unlikely that a teenage boy might have fantasies about me. The drawings though, are not like those of a teenager—the line quality reminds me of Michelangelo's drawings. But, my Michael is no angel—he has the devil in him. With all his raw ability it is a shame that he would not let me teach him. I wonder why?"

Questions

What conditions in schools tend to alienate students? What makes Mach's attitude toward classroom control so seductive? What are the likely results of applying his kind of controls to student artworks as well as to student decorum? How are the conditions in schools similar to the political conditions that inspired the political views of Karl Marx? How might the art room avoid those alienating conditions?

What common conditions in art rooms may inhibit the most talented students? How is the practice of basing lessons on different artists' styles, likely to be at odds with the already emerging styles of talented students? Do talented students have such strong personalities that they can survive anything? If everyone must start the same lessons and finish at the same time, how is individuality to be encouraged? What kind of curricular or instructional designs might value student artworks that diverge from assignments? If teachers require conformity, will they thwart talented students' journey toward real art? Are conditions that thwart talented students also inhabiting for other students?

If assignments are not carefully aligned with visuals and demonstrations, are students likely to be confused? Have any of your art teachers given you assignments that seemed ambiguous? If so, how did you figure out what to do? Have you received grades in art that you felt were unfair? Are exceptional students most likely to suffer when assignments are unclear or ambiguous? How might ambiguous assignments cause students to make art that is less than genuine?

5

The English of Art

An unemployed art teacher uses assumptions about teaching art while substituting in English.

Once there was an art teacher named Earnest. At least he had been an art teacher for a year, but when his contract was not renewed, he sought work as a substitute. Since his State did not have specific subject certification for grades K through 6, he was not surprised when he was called to substitute for an English teacher who was on maternity leave. Earnest looked forward to doing some things with the students that would be more interesting than the English assignments he had endured as an elementary student. It seemed to him that, with some effort, English might become as interesting as art.

When Earnest studied in college, he learned about the importance of integrating art history with studio lessons, so he decided to do the same with English. The students' textbook, however, seemed to have been written by educators more intent on introducing a predetermined list of vocabulary words than in writing anything with literature quality. So Earnest decided to introduce the history of real literature. He brought in excerpts from Hemingway, Joyce and Thoreau. He read the excerpts to the class and explained how each writer's work grew out of the author's own experiences. To help the students become more sensitive to how each author used words to portray their characters, Earnest had each student copy an excerpt from an author of their choice. Students worked intently and then brought their finished papers to Earnest. As he stapled their papers to a piece of colored construction paper, he asked each student what they liked about the way their author developed their characters. At the end of the day, Earnest hung his students' papers in the hallway.

The next morning Earnest saw the Principal, Mr. Frank, with several of the other teachers. They were in the hallway just beyond where he had hung his students' papers. Earnest thought to join them, but the early bell rang, so he turned into his classroom. Two minutes later the Principal put his head in the door and asked Earnest to meet him in the office during the lunch hour.

When Earnest got to the office, Mr. Frank said that other teachers in the school were concerned about the quality of his students' papers. "The writing was obviously not the work of children. Everything about the writing was much too sophisticated to believe. Moreover several of the students seem to have plagiarized the writing of well-known authors."

Earnest defend his lesson: "All the students' papers were from well-known authors—I am surprised that the teachers did not recognize all of them. The lesson was not a writing lesson. It was an appreciation lesson. Students copied well-known authors so that they might better understand their style. Moreover, much of language learning occurs through copying. I had students copying real literature

as a way of raising their standards above the juvenile stuff in their readers. If students aren't exposed to sophisticated writing, how can they aspire to it?"

Mr. Frank was not impressed. "Sophisticated writers cite their sources. Moreover, there is little evidence that your students experienced anything beyond some penmanship practice that would have been more appropriate in an earlier grade. Presenting copying as learning in English makes no more sense than having students copy one of Einstein's formulas and calling it science. Our elementary writing program should develop student individuality.

After a long pause, Earnest thanked Mr. Frank for sharing the reaction of the teachers and promised that he would take more care in the way he exhibited his students' work. Earnest wanted to tell the Principal of the tradition of copying as a way of learning in art, but the Principal seemed unlikely to understand. It seemed wiser to tactfully accept the Principal's criticism; because a personality conflict with the administration of his last school could explain why his contract was not renewed.

If the teachers and Principal did not understand his concern for appreciation and sophisticated standards, Earnest knew how to teach in a way that was sure to win their approval. There was, after all, a long tradition of children's art for him to draw on. Earnest began to encourage students to write the same way they talked. At first he tried to cover the grammar lessons in their texts, but found that he was using those lessons as a way of defining the overly sophisticated style that they were to avoid. Finally, he gave up the grammar lessons as a distraction from the students' own writing. He had them write on a different subject each day so that their writing would be fresh. He rejected the formal spelling lessons and weekly tests in favor of individualized spelling challenges. When he visited each student, he underlined words that were misspelled and challenged students to look them up in the dictionary and learn them. He motivated students by first requiring them to write with a pen so that they would have to complete their thoughts without making corrections. Then he took students to the computer lab and let them compose directly on the computer. The computer made endless corrections possible. At the end of each period, Earnest asked students to take their papers home.

The students responded well to Earnest's approach to writing instruction. During the periods for writing, they worked quietly. When Earnest talked with them individually, they listened to the good things that he said about their writing. The students were happy to escape the regimentation of spelling tests and grammar tests, and they quickly learned that when they carried their papers home there was no threat of a grade.

Then one day Earnest received a note from the office that that Mrs. Wrath, mother of one of his students wanted to meet with Earnest and the Principal. Earnest used his grade book to identify Angelica Wrath as the girl who sat near the windows and was especially well behaved, though she sometimes looked out the windows. Earnest had once approached her and said that when she looked away from her writing she must be thinking about what she wanted to write and that was important, because writers think a lot.

Earnest walked to the meeting confident that this time he would not face charges of plagiarism or forcing students to write with unseemly sophistication. Earnest and the Principal sat on one side of a large table as they waited for Mrs. Wrath. When she came in she introduced herself and held out her hand. As Earnest stood to shake her hand, he realized that with heels she was over six feet tall. Her formal black suit suggested to Earnest that she was a well-educated professional who would quickly understand his educational program.

Mrs. Wrath sat down and pulled a handful of papers from her brief case. "I found these papers waded up in the bottom of Angelica's back pack. Are these the papers that Angelica has been writing in your class?" she asked.

Earnest straightened the papers enough to identify them as work done in his class. "Yes," he answered. "Angelica is a free spirit. She is expressing herself in a way that is appropriate for her age."

Mrs. Wrath pointed to some underlined words. "Are these the only corrections that you made on her papers?"

Earnest agreed, "The underlined words are my only written corrections. They are part of my individualized spelling program.

Mrs. Wrath was not impressed, "Angelica continues to misspell the same words. Is there no follow-up in your program?" When Earnest did not answer, she pointed to several problems of verb agreement. "Does your writing program include a concern for grammar?' she asked.

Earnest explained, "Modern approaches to grammar are more flexible than traditional approaches. The literature is full of examples of unique grammatical constructions. Allowances must be made for the natural language. I encourage children to write the way they speak."

"How unfortunate," Mrs. Wrath replied. "I would have thought that writing would be a place to learn how to construct ones thoughts, so that oral discourse might become clearer. Can you clarify what Angelica might have meant when she wrote this sentence?

Earnest studied what appeared to be a sentence—at least it started with a capital and ended with a period. He continued to study the sentence in silence until the Principal, sensed that Earnest needed help and that he might need to defend his school.

Mr. Frank addressed Mrs. Wrath, "You seem to be expecting a lot from a girl as young as Angelica. It is not realistic to expect that all children will become published authors. However, we can expect Angelica's writing to become more sophisticated as she matures. Children develop naturally if we do not inhibit them with burdensome expectations."

Earnest, happy for the Principal's support added, "My writing program encourages Angelica's natural freedom. I am helping Angelica to be her own person."

Mrs. Wrath straightened her back as she responded. "Your program of low expectations is depriving Angelica of her freedom. She is not free to do anything that she does not know how to do. An educational program that rewards Angelica for being childish is a program designed to retard her development. Not all children may choose writing as their life work, but you are depriving children of the skills they will need to exercise their freedom of expression in our great

country. You are depriving Angelica of the ability to write a coherent letter to her senator. You are not supporting Angelica's freedom you are taking it away.

Mr. Frank did not like the way the conversation was going, so he tried a new tactic. He said that they fully understood Mrs. Wrath's position and then he dismissed Earnest, so that he could speak to Mrs. Wrath alone.

"Angelica's current English teacher is a substitute, and her regular teacher will soon return. I am certain that you will find her writing program more to your liking. The substitute teacher is an art specialist, and some may consider his approach to education more suited to that subject."

Mrs. Wrath replied, "I am disappointed that, as the leader of the school, you do not have the authority to bring more timely relief for my daughter. And I doubt that your substitute can teach art any better than he teaches English. Is teaching expression with words so different from teaching expression with colors and lines? Is there not a visual grammar to be learned? Are there no skills to be mastered? If he teaches art the way he teaches writing, I pity his students."

Questions

What kinds of things are art teachers likely to do that may seem strange to teachers of other subjects? How is art taught differently from other subjects? Are those differences justified by the uniqueness of art?

What kinds of things do teachers of other subjects do that might enhance the teaching of art? Is there an academic component to art learning—or is art only a manual process? How do academic teachers teach their content?

How might students' freedom be impaired by a lack of adequate skills in art? Are students free to do the things that they don't know how to do? What artistic skills are likely to be required of adults—even if they do not grow up to be artists? Is there a visual grammar that students should learn?

If students copy drawings of fine artists, and the teacher exhibits them, are the student drawings counterfeit art? After students successfully copy a fine art drawing, what might they do that would be real art?

6

A Dickens of a Christmas Carol

An art teacher is haunted by the ghosts of history, criticism and aesthetics.

Although his full name was Ebenezer, his art students called him "Mr. Ebb." Even the Faculty called him "Ebb." He used to have an art room with a skylight on the third floor of the main building, but when the science department needed space for a computer lab, the Principal moved Ebb to an annex some distance from the main building. Ebb missed the skylight in his old art room, but he enjoyed being separated from the other teachers who seldom valued what he did.

On the last day before the Winter Break—that was the politically correct term for what everyone thought of as the Christmas Vacation—Ebb sat straightening his desk. Buried beneath a pile of memos he found a letter from the Principal that he had forgotten to deal with. The letter, quoted the new State Regulations mandating that all art courses include history, aesthetics and criticism, as well as studio. The regulations required a written plan for infusing these new areas into the art curriculum. At the bottom of the letter was a personal note from the Principal, "Implementing these changes will make art more like other school subjects, so that you can better defend the place of art in our school." The report was due the very next day.

Ebb was annoyed at another attempt by the State to legislate good teaching. He knew that good teachers are the source of good teaching. Besides, he needed to go home and pack for his trip to Europe. He planned to revisit his favorite galleries in London, Paris and Florence, and his plane would leave early the next morning. Still, it was unwise to ignore his Principal; so he walked to the main building, climbed the stairs to the computer room and began to type the required plan:

> *The new regulations will require me to make no changes in my art program; for I have always integrated history, criticism and aesthetics with studio instruction.*
>
> *I use several historic exemplars at the beginning of each assignment. Students practice criticism during critiques at the end of each assignment. And, the experience of making art increases aesthetic sensitivity to materials.*
>
> *No new means of assessment are necessary, as the students' achievements in history, criticism and aesthetics are evident in their artworks.*

At the bottom of his plan he wrote a note addressed to the Principal.

> *Art deserves a place in the school, because of its distinct nature. Making art more like other subjects would minimize its value. I hope you will help me defend the little time that students now have for studio.*

Ebb dropped his plan in the faculty mailbox and hurried to his second floor apartment where he lived alone. There were large windows on the north end of his living room that he had converted to a studio. But tonight he had no thought of painting. His thoughts were on the galleries in Paris—the first stop on his tour. Since it was winter, he packed his corduroy pants and his fleece pullovers. He slipped a raincoat into an external pouch on his carry-on bag and put his tickets and passport it the coat he would wear. The last thing he did was put his digital SLR on top of his coat—he did not want to forget that, for he planned to share his trip with his students. It was late when he finished, so he set his alarm, and went to sleep.

When he awoke it was not to the sound of the alarm, but to the sound of chains dragging across his floor. Rolling over, he saw the silhouette of a Giant—an old man with a full beard and a large straw hat. Chains draped about his double-breasted white coat and onto the floor. The chains rattled as the Giant approached Ebb's bed.

"Who are you?" Ebb asked, trying to control the tremor in his voice.

"I am not surprised that you do not recognize me," the Giant replied. "But, come with me and you will discover who I am."

Ebb tried to pull away when the Giant grabbed his hand. But it was no use. The Giant pulled Ebb through an open window and together they flew above the snow covered streets that led to Ebb's school. Ebb feared that he might fall, but the Giant held his hand tightly.

When they landed they were in Ebb's annex. To Ebb's surprise the annex was full of students. "What are they doing here at night?" he thought. Although Ebb could see the students, they did not seem to see him or the Giant.

The students were painting freely as they used broad strokes with bright colors to suggest water lilies in the style of the Monet reproductions that were about the art room. When the Giant stood beside a photograph of Monet, Ebb noticed that they both had white suits, straw hats and full beards.

Before Ebb could comment on the similarity the Giant snarled, "Even a casual acquaintance with my history would have revealed that I worked from nature, not reproductions of another painter. While I studied light and reflections, your students are merely emulating my style. Moreover, their emulations are superficial, for they have none of the under painting that I used. If their paintings are the measure of their art history learning, their learning is filled with inaccuracies."

When Ebb realized that the old Giant was Monet he pleaded with him, "Let me introduce you to the class so that you can tell them how you worked."

But, the Giant refused, "Your false teaching has chained Monet to oblivion—your students will never know Monet.

Ebb argued that his students would be able to recognize Monet's style, but the Giant responded: "Your students know only enough to become easy prey for those who would forge my style. The ultimate goal of art history is not to become familiar with styles, the goal it is to make attributions and establish authenticity."

Fearing that anything he might say would further anger the ghost of Monet, Ebb meekly followed as the Giant led him back to his bed. The Giant disappeared and Ebb tried to comfort himself that he knew three other teachers who taught Monet lessons exactly as he did. "It was unfair of Monet to criticize

the historic content of his lesson when he was teaching studio. But if his studio lesson on Monet was not consistent with the way Monet worked, was he teaching studio correctly?" These thoughts troubled Ebb, but when the clock chimed one a.m. he realized that he must get back to sleep, or he would have difficulty getting to the plane in the morning.

Ebb slept until he was awakened by the smell of popcorn. Opening one eye he saw the clock; it was not yet two. Ebb wondered who in his building would be popping corn at this hour. When he opened his other eye a Ghost appeared and offered popcorn to Ebb. Ebb tried to focus his eyes, but the image of the Ghost flickered on and off, as in an old movie. With a hesitant voice Ebb asked, "Should I know you?"

"Not unless you watch my show on TV. I'm a movie critic." replied the Ghost who seemed to continually go in and out of focus. Again the ghostly critic offered Ebb popcorn. When Ebb reached for the popcorn the ghostly critic grabbed Ebb's arm and pulled him out the window. Because Ebb had survived the previous flight with the Giant he was not afraid of falling, but he feared what the Ghost might say about his teaching. Their flight ended at a cinema.

Inside the cinema the Ghost said nothing as they sat eating popcorn and watched movies. The movies might have been interesting, but they were all shown backwards. There were westerns that started with the shooting of the villain and ended with the villain stealing cattle. Mysteries started with the capture of the criminal and ended with the discovery of the victim. Love stories started with the couple getting married and ended with their chance meeting.

Finally Ebb could stand it no longer. "These movies are dreadfully boring when you know from the start how they will end. Why are doing this to me?"

The ghostly critic smiled, discarded the empty popcorn bag, and explained:

"Viewing movies backwards is no more boring than your critiques of student artworks. When you make assignments you define the ending of the story. The real function of your critiques is not to teach students criticism, but to justify your grades.

"Real criticism is a drama that unfolds, as you try to discover what a movie or artwork is all about, and then seeks to describe the criteria that support that discovery. The only drama in your critiques is the suspense about the grades you will assign."

Ebb complained that the critic was unfairly judging his critiques, but the critic would hear none of it. Instead he magically transported them to an all-night restaurant where several of his students were gathered around a table. One student was pretending to be Mr. Ebb. The students giggled as Mr. Ebb spoke:

"As you know—because I have defined it in handouts, written it on the board and told you a hundred times—this assignment is all about Cokeness. I want you to line up your cans in the center of the table so we can have a critique. Now who can recall the first criteria? That's right, color. Bill, is Claire's can the appropriate red color? You are right, it appears to be. Sam, what is the second criterion for Cokeness? That's right, curvilinear lettering. Sam, does Claire's can have curvilinear lettering? Yes, it

does. Tina, what was the third criterion? That's right, cylindrical form. And does Claire's, can have a cylindrical form? That's right, it does. So Claire will get a grade of *A*.

"Now let's look at Bill's? Is it the appropriate red color? Will no one answer? Can no one see that his is green? Bill has not achieved the first criteria for Cokeness. Now does his can have curvilinear lettering? Still no one wants to answer? No, the lettering is not curvilinear. Fortunately Bill's can does have a cylindrical form, so his grade will be *C*."

The students giggled, knowing that Bill's can was Seven-Up. Bill protested that he preferred Seven-Upness to Cokeness, but Mr. Ebb pointed out that since most people preferred Cokeness, there must be something wrong with Bill's taste.

Ebb watched in disbelief as the students mocked him. "What is wrong?" he asked. "What should I do?"

The Ghost answered as he flew Ebb back to his room: "You should restore the drama to criticism. Your critiques of student work would be more dramatic if students defined their own aesthetic problems, so that their classmates would need to discover what their artworks were about."

"But I will still need to grade their art," Ebb protested.

The Critic answered, "I have to grade movies too. I record my grades by the number of stars that I award, while you use letter grades. Criticism identifies quality, but you base your grades on pedagogical standards. Pedagogical standards are confused with concerns for process, progress, development, attitudes and whether students followed your rules. Because you do not base your grades on the same standards as critics, your critiques give students an inaccurate idea of what critics do."

Ebb said nothing as the ghostly critic flew him back to his bed, but his mind was racing. "What could a TV critic know about teaching art? Critiques are a traditional part of teaching studio." But the memory of his students' Cokeness critique troubled him. "If students were not learning to criticize art by participating in critiques, what were they learning?"

Back in his bed Ebb was alarmed to see that it was already half-passed three. So he turned his thoughts form teaching criticism to the wonderful galleries in Paris and he fell asleep. But a cool breeze on his face awakened him. The breeze was not like a steady wind that might be coming from a window. Instead it came and went as though wings were fanning it. Ebb turned toward the breeze and saw a winged figure dressed in glowing robes. Sensing that the figure must be an Angel, Ebb asked, "Am I in heaven?"

"Not yet," the Angel answered. "And whether or not you will get to heaven depends on you. Will you confess the inadequacies of the way you teach? Or will you be a hypocrite who only pretends to teach while performing classroom rituals? Will you teach the way you would want to be taught?"

Ebb recognized the source of the winged figure's questions and he was troubled by the application of Biblical ideas to teaching, "Did the Angel not know about the separation of Church and State?" Ebb only thought this. What he said

was, "I suppose that you are going to fly me someplace, let's do it quickly, so I can get back to sleep."

And fly they did—straight to Ebb's school—and they soared over the place where his annex should have been. "Where is my art room now?" Ebb asked.

"It was torn down during the summer after the new State Curriculum eliminated studio art," the Angel answered.

"How could the State eliminate studio?" Ebb asked.

The Angel did not answer, but led Ebb to the third floor room with the skylight. The room was converted to a lecture hall and a teacher was commencing a class:

> "Welcome to the new course, *Aesthetic Values*. I am not an art teacher, I am a philosopher. As you know, this aesthetically oriented class has replaced the required class in studio art. Since you are the first students to benefit from this change, I would like to explain the why the State has mandated the study of aesthetics
>
> "First, studio art—as it was typically taught—enforced some questionable values. Typical assignments were short, compared with the time artists spend on artworks. In addition studio teachers tended to motivate student by teaching that art was easy. Thus, studio teachers unwittingly taught students to value art that was quick and easy. Of course, not all students were convinced, for our society tends to respect feats that are difficult and require time to master. It is true that some artists may seem to work quickly, but years of practice are required to achieve quality quickly. Moreover, it is impossible to justify time in school for learning things that are quick and easy. Those things might just as well be learned at home."

Ebb did not like what he was hearing. He whispered to the Angel, "Studio projects had to be fast because the class periods were so short. How can you motivate students, if art is hard?"

The Angel rebuffed him. "**Do you refuse to confess the inadequacies of your old ways**? Now listen and learn."

The lecturer continued:

> "Second, studio art was based on the questionable assumption that making art leads to the appreciation of art. This assumption is questionable since we have already observed that studio assignments taught students to work quickly and not to work hard. Thus, it was unlikely that students produced good art—some did, of course; but most did not. It is unlikely that students making bad art learned to appreciate good art. In any case, studio art teachers failed to provide experimental evidence to support their claim."

Ebb did not like the lecturer's inference that his students made bad art. "My students did art that was as good as any teacher's in the city," he whispered to the winged figure.

Again the Angel rebuffed him, "When you and your colleagues **pretend to teach by using the same ritualistic lessons** the student work should look the same. Those other art teachers were dismissed at the same time you were. Now listen to the lecturer!"

"Third, studio art, tended to de-emphasize the value of many art forms. The demand for studio time restricted the opportunities to study any art form other than the fine art created by European males. This emphasis unwittingly taught that some kinds of art were important while other kinds were not worth mentioning. African Americans, Native Americans, Asian Americans, Spanish Americans and American girls were all taught that their aesthetic heritage was not worth dealing with. When art of other cultures was considered it was demeaned by labeling it: primitive art, folk art, ethnic art, native art, or women's art—all these communicate that their art is less than *fine*.

"Your new course, Aesthetic Values, will correct the deficiencies of studio art by considering the arguments for different values in art, and examining the criteria that critics use to make their judgments about art. Thus this course will prepare you to form your own preferences in art based on the best professional understandings of art."

"Unfair," Ebb whispered. "As an art teacher I am more qualified to judge art than my students. When I teach I emphasize high art rather than low art—the noblest art rather than genre art. If fine art is difficult to approach because of ethnic or gender differences, all the more reason for it in schools. Students can learn things that are easy on their own."

The Angel rebuked him a third time, "I understand that you want to continue teaching as you always have, but that is not the issue. The issue is, **how would you want to be taught** if you were not a white American male?"

This final rebuke left Ebb speechless. He had noticed that each of the Angel's rebukes corresponded to the three questions about reaching heaven. The Angel had, in effect, called him, "**Unrepentant, hypocritical and unwilling to live by the golden rule.**" Unable to deal with issues that might affect his afterlife, Ebb asked a more immediate question, "What will happen to me after studio art is eliminated."

The Angel did not answer until they were back in Ebb's room. "If you are lucky," the Angel said, "you might substitute in music or gym."

The thought of substituting was not comforting, for Ebb had sold his piano years ago and he felt too old to start doing calisthenics. Ebb wanted to ask the Angel how he could prevent this awful future, but the Angel disappeared.

It seemed that he had only fallen asleep when the alarm rang. Ebb woke with a start. Was there another visitor? No. It was time to dress and go to the airport. But he could not take his mind off his three ghosts.

As he waited for the taxi that would take him to the airport, he reflected on the three ghosts. He feared that the way he taught studio could not include history criticism and aesthetics in a meaningful way. Worse, because he was not dealing adequately with history, criticism and aesthetics; was he compromising the quality of studio?

In a state of panic he recalled the plan that he had left for the Principal. He feared that the Principal might judge it as harshly as his three ghosts had judged him. So he quickly penned a new note to the Principal:

I am committed to the full integration of history, criticism and aesthetics with studio art. Integration, however, means more than simply adding some experiences for these new disciplines. Because the new disciplines interact with the process of making art, their proper inclusion will make it necessary to change the way I teach studio art. Because of the extensive task of curriculum revision that I envision, I respectfully request an extension of your deadline.

On the way to the airport he had the taxi stop at his school, so that he could exchange his new note for the old plan.

Fortunately, Ebb's first flight was delayed and he got on board just before the gate was closed; and Ebb's overnight flight to Paris was uneventful. In Paris Ebb enjoyed a different gallery each day, but at night he was haunted by the memory of his three ghosts.

On Christmas day he was in London and the galleries were closed. He stood looking out the window in his hotel and reflected on the similarity of his ghosts and the ghosts who visited Scrooge. "My ghosts gave me the dickens," he thought. He moved closer to the window and watched the snowflakes slowly covering the pavement. He wished that a small boy would appear, so that he could give him a coin and send him to purchase a new studio curriculum. Designing a studio curriculum that would not accidentally teach bad history, bad criticism and bad aesthetics was going to be a challenge. And if he did not get that right, would he be teaching bad studio? "Scrooge had it easy." Ebb thought, "All he had to do was pay for Christmas dinner."

Questions

How might teaching art history inadvertently distract from the quality of studio learning? Have you experienced studio lessons based on limited information about how artists actually worked? How much information about how artists used materials do photographs and reproductions hide? What role do materials and artistic processes play in understanding how art objects came to be as they are? How may studio lessons risk giving students superficial understandings of artists?

Have you experienced critiques that seem more interested in justifying grades than in teaching criticism? Should grades in studio art be based on the same standards that critics use? If criticism is more than justifying grades, or arguing for grades; how might critiques become more like what critics do?

Is it possible to teach a studio lesson that has no aesthetic values imbedded in it? If studio lessons have the potential to teach aesthetic values, what aesthetic values should studio teach? What kinds of studio lessons would support the values that you advocate?

What are possible problems in trying to grade learning in history, criticism, or aesthetics by evaluating success in studio assignments? For example: if students efforts are to be compared with the work of critics, do critics make artworks?

How might you design the curriculum that Ebb envisions—one that uses art history, criticism and aesthetics to strengthen studio instruction? Does the absence of such a curriculum make it more likely that students will make art that is less than real?

7

The Art of Discipline and the Discipline of Art

A magic pencil comes to the aid of a student teacher.

Because Joan lived on the same block with her aunt, Joan had been permitted to walk there since she was four. When she arrived her aunt always brewed tea—she described it as magic tea. As Joan grew older she began to doubt whether the tea was magical, but when she visited her aunt and drank the tea she always felt better.

Joan did not see her aunt often while she was in college studying art. But, when she received her student teaching assignment; she was anxious to see her aunt, for Joan was going to a school where she heard that there were often discipline problems. Now, as Joan approached her aunt's house, she wished for the magic tea to work again.

After her aunt had served tea and listened to Joan's fears of rebellious students, Joan did begin to feel better. Whether it was the tea, or the sympathetic attitude of her aunt; seemed of little importance. On the chance that it was the tea, Joan asked her aunt for some of the tea to take to college. Her aunt refused, saying that for the troubles of student teaching she would need something even stronger than the tea.

Her aunt took a pencil, dipped it in the teapot and had Joan kneel before her. As she ceremoniously touched the pencil to each of Joan's shoulders, her aunt said, "I dub you Joan of Art, and with this pencil you will be able to overcome all those who will take up swords against you." After Joan stood up her aunt explained that the pencil would only work if Joan used it each day to record her feelings in a journal.

When Joan left her Aunt's home she felt more confident. She walked with her head held high, as she clutched the pencil and swung it in menacing arcs. "I am," she thought, "as brave as that French girl, Joan of Arc." She was certain that, with her Aunt's magic pencil, she would be able to overcome the armies of students that awaited her.

Back at college, Joan put the pencil in a safe place. She fully intended to write with it, as her Aunt had told her. But, when she went to the school where she would student teach, the demands of writing lesson plans, making visuals and finding reproductions were so overwhelming that she had no time for her journal—thoughts of the magic pencil were crowded out of her mind.

After a week of observing the cooperating art teacher, Joan was to have full responsibility for one class. While her cooperating teacher and college supervisor watched, the students came into the classroom pushing and shoving one another. After the cooperating teacher calmed them, Joan started to explain her rules for the classroom—she had the rules listed on a brightly painted poster. But, when her cooperating teacher stepped out of the room a boy interrupted her

by walking to the pencil sharpener and sharpened his pencil. While Joan was wondering what she should do the boy asked, "Do you have a rule against sharpening pencils?" All the students laughed. When the cooperating teacher came back the students grew quiet and Joan started her lesson.

She showed them reproductions of Monet's garden paintings and explained that the garden was his favorite place and asked the students to make drawings of their favorite places. As Joan passed out crayons and paper the students began to talk. Their talk grew louder while Joan was helping individual students. When Joan had difficulty hearing what one soft-spoken girl was saying, Joan went to the front of the room and turned off the lights—it was something that her cooperating teacher did—and, for a moment, it seemed to work. The students got quiet, and Joan pointed to her poster and said that they were violating her third rule. But, when Joan turned the lights on the students were as loud as before. She turned off the lights again, but the students were not quiet long enough for Joan to talk about her rules.

Joan walked around the outside of the room wondering what to do. Girls were combing their hair. One boy seemed to be doing his social studies homework. The noise of students talking echoed through the room. She thought about closing the door to hide their noise, but decided that her best hope was for the principal to come and discipline the students. She thought about her college supervisor watching her and decided that no matter how bad the students were, she would continue to be good.

When it was time to cleanup few students could hear Joan's instructions. Finally the bell rang and the students ran out of the room.

As Joan picked up the crayons strewn across the tables and the floor she asked her cooperating teacher and college supervisor, "What was wrong with the students today?"

Ignoring her question, her cooperating teacher said, "Sometimes you have to be mean to students." And, her college supervisor told her that her body language told students that she was afraid of them.

Joan held back her tears until she could telephone her aunt. She sobbed as she described what had happened. Finally she asked her aunt, "How can they be so bad when I am so good to them? Her aunt said that she should write in her journal about why she wanted to be so good, and that she might start with her seventh birthday party.

Joan did not understand what good that might do, but she found the pencil that her Aunt had dipped in the tea and started to write. She recalled her anticipation of that birthday party. She had invited all the girls from her class and her mother made a lovely cake and party favors. When she was showing the girls her room one girl took Joan's favorite doll and began to rearrange its hair. Joan asked her to quit and reached for the doll, but Joan got only a lock of hair that stayed in her hand as the girl ran away with the doll. Joan screamed and chased her—first down the back stairs and then up the front stairs—with all the girls following. Joan's mother tried, without success, to stop them by announcing that it was time for cake. The chase ended when the girl with the doll fell and sprained her wrist. She cried until Joan's mother called the girl's parents who came and

took her to the emergency room. Then Joan's mother called the parents of all the other girls and apologized that the party had been canceled. The girls left, taking large pieces of the birthday cake with them. Joan refused to eat any of the cake and ran to her aunt's house.

"Why would her aunt want her to recall such an unhappy and unfair time?" She wrote. As she bit down on the pencil she thought she tasted the tea. "Could it be," she thought, "that I want to be so nice to my students, because when I tried to stand up for my rights at the party, so many bad things happened?" She recalled how mad she was when the girl seemed to steal her doll. She realized that the reward for her anger was that she lost her party. Then she realized that her students were stealing more than her doll. They were stealing her chance for recommendations that would lead to a teaching job. The more she wrote, the angrier she became. Finally she resolved, "The mark of a true lady is not being polite—no matter what—but demanding the respect a lady deserves." And, the very next day she screamed at her students.

At first, screaming seemed to work. It startled the students and they were good for a time and screaming made Joan feel better. But, by the time her college supervisor visited again, student behavior was so bad that she had to scream many times each period. She screamed at students who pushed and shoved as they came in the room. She screamed at the girl who rudely complained that Joan had mispronounced her name. She screamed at a boy who left his seat to adjust the blinds while she was presenting the lesson. When the class was making too much noise she screamed. Each time she screamed students were good for a few minutes; but they were soon bad again, so she had to scream again and again Students were so bad during cleanup that she screamed continuously.

When the students were gone her cooperating teacher complimented her for her ability to get mean. Joan responded that being mean so often required too much emotional energy. Her cooperating teacher suggested that if she merely acted mean at the little things, students would behave before Joan got really mad and screamed.

Joan's college supervisor made two observations: "The students may be playing a game with you—they win the game when they make you scream. Or students may simply want your attention. What you pay attention to is bad behavior, so the students are bad to get your attention. It is not happy attention, but any kind of attention is better than being ignored. I wish you had paid more attention to the students who were good."

Joan wanted to scream at the two of them. They were telling her to do different things. How could she act mean and pay attention to good kids at the same time? How could she, a student teacher, know what to do when experts can't agree? But she bit her tongue and said that she would try harder.

Joan did scream, and then sob, as she telephoned her aunt to complain about the conflicting advice she was getting. Her aunt listened and then told her to look in a mirror and write about what she saw.

It seemed like strange advice, but Joan sat in front of her mirror and began to write. First she described the details of her face. "This is like doing a self-portrait," she thought, but she questioned how looking in a mirror was like teaching. She looked at the pencil and wondered how a real Joan of Arc would respond to her desperate situation. As she sat, she envisioned herself entering the classroom in full body armor. "Armor will protect me from their jabs and insults," she thought. She stood ready for battle, as an army of students advancing toward her. The students had only short swords, but they all looked mean and ready to fight. As Joan advanced toward them, she was startled to realize that what she thought were their angry faces were reflections of her own face in their gleaming shields.

Joan looked at her face in her mirror and saw her own anger. She tried to make her face look happy, but could not. "If I am to look happy, I must have something to be happy about," she thought. She wrote a list of all the things that students might do that would make her happy. Next she wrote a list of what she could say to show her happiness.

The next day she used the two lists as her lesson plan. She told students what she wanted, and, when they responded, she immediately complimented them. As she concentrated on complimenting students who were working hard she tended not to notice those were not working.

By the time her college supervisor visited again, her classes were transformed. Joan met the students at the door and said that she was certain that they remembered how to enter the room. She praised them for entering quietly and quickly giving her their attention, so they could start the new lesson. She called students, table by table, to come to a demonstration in the center of the room. As they came she complimented the students. She asked students to look closely, as she showed them how to make coil pots and then praised students for their attentiveness. (Not all the students had been attentive, but Joan assumed that they already knew how to work with clay.) She directed the students back to their seats, and instructed helpers to distribute balls of clay. Many students were slow to start to work, but she praised those who started quickly. When she saw a boy throwing a clay tool she asked him to show her the safe way to pass the tool to another student. Then she complimented him. She rewarded the class for talking softly by playing music and turned it off two times when they got too loud. Even cleanup went well, as Joan alternated instructions with praise. Before the bell students were quietly sitting up straight hoping that they could lineup first. Joan praised them for working hard even though she knew that several students had not.

After the students left the cooperating teacher complimented Joan for remaining positive the whole period and noted that the students behaved better than when she screamed at them. But her college supervisor was less enthusiastic. He conceded that the students were quieter, but he wondered whether they were learning discipline or art. He had counted the number of Joan's statements that dealt with classroom management. There were 76; while he had had counted 17 statements about art. He suggested that his simple interaction analysis might account for the minimal progress students had made on their pots.

The cooperating teacher siding with Joan and argued, "You have to establish discipline before you can teach."

But the college supervisor retorted, "Students are unlikely to work hard until you start teaching."

The disagreement of the cooperating teacher and the college supervisor left Joan confused. She was also upset that she had done what the college supervisor wanted; yet he was not pleased. When Joan called her Aunt, she described what had happened and asked whose recommendation might be most important for job applications. After listening to Joan's story, her aunt suggested two questions for her to write about in her journal: "Do you really want to be an art teacher," and, "What have you become?

Joan had long wanted to be an art teacher, so that was easy to write about—though, recent events made her question whether she still wanted to teach. Writing about what she had become seemed impossible. As she sat, twisting the pencil in her fingers, she had a vision of herself as a prison guard. Not just an ordinary prison guard—she was receiving an award for outstanding work with prisoners. Her special commendation noted her pioneering efforts in the use of positive reinforcement to modify inmates' behaviors.

Joan wondered how many students thought of schools as prisons. Did they see themselves serving 12-year terms with no time off for good behavior? Did they see teachers as jailors who forced them to exercise and threatened to extend their term if they did not behave? As Joan wrote about her recent preoccupation with discipline, she decided that she wanted to be more than a prison guard. She realized that her focus had been all wrong. She now realized, "Teaching students to be good will not indicate teaching success, if students make bad art."

Next she wrote about her fear of what the cooperating teacher might do if Joan appeared to side with her college supervisor. She twisted the pencil and asked, "Who is it most important to please?" The answer, at first, surprised her, "I must make student art learning a higher priority than what anyone thinks I should do. The measure of my success depends, not on what I do to look like a teacher, but on what students learn about art."

Joan began to do more research for her lessons. By the time her college supervisor returned she had a ten-minute introduction to a lesson that she would have formerly thought of as simply a "work day." She was also spending more time observing how students were working on their art. As students started to work she quickly identified potential problems and brought them to the attention of the whole class. When she worked with individuals the issue of whether to be mean or positive had disappeared. Now she showed her disapproval of activities that were likely to hinder their artworks and praised those activities that were more like what artists do. Since artists sometimes concentrate intently on their work, Joan had introduced the practice of a "Five-minute Focus." For five minutes students worked without talking and without asking the teacher for help. She reminded them that if they talked, she would add time. They did not talk. As the students finished, Joan helped them hang their paintings. And then students wrote critiques of their paintings using Joan's new worksheet. Cleanup went

quickly, though students were noisy, because they were eager to play the art games that Joan now used to determine who would lineup first.

After the students left the cooperating teacher noted how much the students had accomplished during the period. Joan agreed and then showed the College Supervisor the students' worksheets. As the three of them analyzed student performance and speculated about what might help students on future lessons, no one talked about discipline.

At the end of the term Joan visited her Aunt. As they sipped tea, Joan showed her Aunt copies of her strong recommends and she thanked her aunt for the pencil that had had made those recommendations possible. At first she had hoped that the pencil would tell her how to attack her enemies, but the pencil had seemed more like a sword cutting away the defective parts of her own personality. She was embarrassed by her initial inability to assume personal responsibility for the behavior of her students. She regretted the self-centeredness that had prevented her from emphasizing with her students. And she was happy that she had overcome her fear of disapproval of her supervisors, so that she could concentrate on student learning.

As she showed her aunt that only a stub of the magic pencil remained, she asked for a new pencil to take to her teaching job. Her aunt replied, "**The magic is not in the pencil, but in your own metaphoric thinking as you reflect on your teaching.**"

Questions

Is it reasonable to wish for a single idea that will be like a magic wand and cause your students to behave? Will simply applying the correct techniques lead to teaching success, or is success dependent on personality changes?

Must all art teachers learn from the school of hard knocks? Must all beginning teachers personally experience the inadequacy of their ideas before they can improve, or can they learn by the experiences of others?

Can Individual teachers make a difference in discipline? Is student behavior the result of parents, violence on TV, the school, and the cooperating teacher; or can individual teachers make significant improvements in student behavior?

What metaphor best describes your emerging sense of the kind of art teacher you want to be: Art teachers are like prison guards? Art teachers are like physicians diagnosing and prescribing for their students' aesthetic health? Art Teachers are like gardeners—students are like flowers? Art teachers are like fountains of knowledge? Art teachers are like The Queen Mother and students should bow to her authority? Does another metaphor best describe the teacher you want to be?

Which is true: you cannot start to teach until students have learned to behave, or students will not behave until you start to teach? Should teachers start with strict discipline and then loosen up? Are undisciplined students likely to learn? Are students likely to resent strong disciplinarians? Are students who are really involved in making art likely to misbehave? Are involved students more likely to make real art?

8

Prescription for Teaching Art

A medical doctor confronts his daughter's ideas about teaching art.

Florence could not recall when she first started to paint. It seemed to her that she had always painted. But Florence did recall the joy she felt when she received her first box of oil paints. She also recalled the injustice she felt, when her Father insisted that she finish her homework before she could start to paint. His requirement was senseless, because she was smart enough to make good grades on tests without doing the busy work that homework required.

When Florence went to college she preferred the studio art classes where her professors encouraged her to be true to herself. Academic courses, it seemed, were designed to make her think like the professors. Yet, because she wanted to share her joy of painting with others, she was planning to become an art teacher. So she quietly conformed to the requirements of her art education classes. She was quick to figure out what the professors expected and she was able to deliver it with a minimum of effort, so that she could return to the studio and paint. She got through student teaching by imitating what her cooperating teacher did and she received good recommendations. Still, she knew that when she had her own art room she would want to do things her own way. She was certain that her way would lead students to love art, just as she did.

Florence did not search for a teaching job after she graduated. Instead her plans called for graduate school. She had found a program with a lot of studio and a minimum of theory. But, first she was going to tour Europe. Her Father had promised her the trip as his graduation gift and she was finally going to enjoy being away from home.

As she flew to London, she almost forgot about the large Victorian home where her Father's medical offices occupied most of the first floor. Gone was the memory of using the back stairs to get to her room so that she would not disturb his patients in the waiting room that was once a parlor.

Once in London, Florence enjoyed the freedom to roam through the art museums. She could have stayed forever. But, she received an urgent message from her Father. Because of an auto accident, he would require several operations and a long hospital stay.

When Florence reached her Father's side she learned that his condition was worse than she feared. Although he was barely 50, he would never be able to practice medicine again. Still, her Father's spirits seemed better than Florence's. The daily routine of hospital visits left little energy for her own life. For the first time in her life she did not want to paint. Moreover the insurance company was slow in making payments, so that there was no money to pay her graduate tuition for the fall semester. Finally, her Father urged her to escape the depressing routine of the hospital by taking a teaching job.

Florence sought a teaching position in the city, so that she could be close to her Father. But, the only job she could find was as a substitute. On the first day she substituted she found students in the midst of a lesson on perspective. She continued the lesson using the methods that she had most enjoyed as a student. That is, she encouraged students to find their own way of representing things—ways that were natural for them. She praised their hard work and assured them that, if they persisted, they would find sophisticated solutions to their assignment. Because her students worked quietly, she assumed that she would get a compliment from the Vice Principal, who everyone addressed as "B. F."—no one used his last name. But after observing her, B. F. noted that the perspective drawings looked better when the regular teacher was there. As he was leaving, he asked Florence whether she really expected students to discover in one period ideas about perspective that it had taken artists centuries to invent. This criticism stunned Florence; but because she was well brought up, she resisted the urge to argue with the Vice Principal.

When Florence visited her Father that evening she described her disappointment at the Vice Principal's remarks. She feared that a bad recommendation might effect future employment. She was certain that the Vice Principal was unfair because she had used perfectly good teaching techniques. Her Father, however, wondered whether her technique would be equally good for all lessons. He suggested that he would likely be sued for malpractice, if he prescribed an antihistamine for a patient suffering from diabetes. Florence responded that her students were not sick and that she hoped that her own Father would be more sympathetic. Moreover, she was certain that if she could have the same students for several weeks they would adjust to her methods and produce good drawings.

The next day, as she entered a new art room, she was pleased to see that the blackboards had been washed. But after she looked at the open plan book on the desk she turned to discover a note scrawled on the blackboard.

> *Florence,*
> *If you want children to learn naturally, you must remember that children naturally learn by copying. The teacher's job is to provide good models to copy.*
> *Bret*

Florence looked quickly to the door and then down the hall to see who might have left her the note, but she saw no one. As Florence returned to study the black board, she considered whether the message offered supernatural guidance, until she recognized the idea as one her methods professor had discussed. She decided that if, freedom and self-discovery had gotten her into trouble yesterday, then copying and control should be better today. Whether or not Bret was a deity, she was not going to make the same mistake twice.

The plan book called for the students to do expressive self-portraits, so when the first class came in Florence showed them a self-portrait by Van Gogh and demonstrated step-by-step how to achieve the expressive qualities that Van Gogh had used. First she laid out the features of her face in pencil, and then she drew contours around the features. Finally she used a loaded brush to make wiggly lines that followed the pencil lines. As students worked, she insisted that they clean their brushes before using new colors and avoid letting the brush strokes touch, so that the

strokes would not blend together. When children had difficulty she sent them to look at her example so that they could see what to do.

At first Florence felt guilty for using techniques that she did not believe in. But after teaching several classes she comforted herself with the thought that her directed teaching should earn her praise.

When the Art Supervisor, Mr. Sigmund, came to visit, Florence proudly showed him her students' self-expressive portraits. Mr. Sigmund, however, was not impressed. He noted that while the influence of Van Gogh was obvious, all the paintings had a sameness that made any personal expression unlikely.

Florence was crushed. She busied herself with cleaning the blackboard, so that she would not cry. But then, as she went to the closet to get her coat, she saw a new note on the black board.

Florence,
Protect children from adult influences. Give them the freedom to be themselves.
Victor

Florence looked again for someone who might have written the note, but she saw no one. She studied the writing on the board. "Even the gods of theory," she thought, "can't make up their minds. Every administrator wants something different. How am I to know what to do?"

At the hospital that evening Florence did not tell her Father about the notes on the black board, for fear that he would send her to a psychiatrist. Instead, she complained about the unfair remarks of the Art Supervisor, who had standards that were dramatically opposed to those of the Vice Principal. "How could she please both of them? How could she ever get to teach the way she wanted to teach?"

Her Father listened patiently and then replied, "Medicine men at side shows used to peddle bottles of snake oil that were guaranteed to cure all ailments. Doctors today, however, know that different symptoms require different prescriptions." What would happen," he asked, "if I treated patients the way I wanted without regard to medical books?

Florence did not answer, so her Father continued, "Diagnosis of student learning needs would seem to be necessary before prescribing instruction. Art teachers should be accountable for the artistic health of students."

Florence responded, "There is no relationship between the rigors of medicine and the freedom of art."

But her Father was unmoved, "Is it fair to select teaching techniques on the basis of personal preference, even though the way you teach will affect the artistic health of so many children?"

Florence did not want to fight with her Father, so she tried to leave; but her Father took her by the arm and suggested, "Since you do not value my medical analogies, you should visit your high school art teacher. You always trusted him."

The next morning there were no calls to substitute, so Florence drove to her old school. After visiting in the office she climbed the stairs to the art room. Her old

art teacher was just introducing a lesson on shading. To Florence's surprise he gave step-by-step directions as he demonstrated, and showed examples that students were to emulate. When the class started to work, he confronted students and made them do the assignment his way. "Where was the freedom that she remembered? How could her ideal teacher do this to students? How could she know how she ought to teach?" Florence's world was spinning out of control and she fainted.

The school nurse revived Florence with smelling salts and took Florence to a lounge where she rested on a couch. When her art teacher had a free period he joined her and Florence tried to explain why she had fainted.

"In college, I dreamed of being able to give students the freedom that I thought I experienced in your classes. I wanted students to profit from the same experiences that had helped me to develop as an artist. But when I taught with freedom the Vice Principal criticized me. When I sacrificed my principles and taught in a directed way the Art Supervisor criticized me. Today I saw you teaching in a directed way and my faith in the value of freedom was crushed. Now I don't know what to believe."

Her art teacher answered: "I came to your school when you were a junior, so you never experienced one of my introductory classes. I have always given introductory students more direction than advanced students, but that is not the whole answer. In your painting class I gave you the freedom to pursue your self-expressive style. Other students in your class sought artistic control, rather than freedom. I worked with these students in a more directed way. Hasn't your Father, the doctor, told you that different sores require different salves? When the bell rings you can watch how I still deal with the students in my painting class."

She watched the painting class and saw that he did, indeed, teach different students differently. Then she began to observe connections between the style of students' work and the kinds of teaching they received.

The next time Florence was called to substitute she made careful notes about the way she taught and the kind of learning that occurred. She looked at typical student performance and she also looked at individual differences. When she shared her notes with her Father he said they looked like the first systematic medical studies that made medicine a discipline—back when Napoleon forced military physicians to start keeping records. He was surprised that she could not go to reference manuals to look up what kind of instruction was best for different kinds of art learning. Florence did not know whether such reference manuals might exist. She did not recall anything like that from her educational methods class, but as a student she only paid attention to theories that supported the way she intended to teach.

Because her Father received an unexpectedly good insurance settlement, Florence was able to enroll in graduate program that would start in January. As January approached, Florence realized that she was looking forward to the required education courses. She already knew how to paint, what she wanted was insight into the discipline of teaching art. She longed to understand the relationship of teaching methods to learning outcomes just as her Father understood the effects of the medicines he prescribed.

When Florence's attended her first education class, the professor was a scholarly looking fellow who spoke with a seriousness that was appealing. The

professor described a new theory for teaching art that promised to avoid the shortcomings of older theories. The theory was advocated by a well-regarded author and promised to be a universal theory that would encourage art learning for all students. The professor predicted that the new theory would revolutionize the methods for teaching art.

Florence listened for some time; trying to process the professor's ideas in a way that would provide insight into the discipline of teaching. Finally, Florence held up her hand. When the professor recognized her she said, "I understand that you passionately believe in your new theory that promises to avoid the evils of old theories. But, I fear that art education is unlikely to be regarded as a discipline, if art teachers selected theories or methods on the basis of preference or newness. Such a practice in a discipline like medicine would be ludicrous.

The professor, sensing that he was losing control of the situation, waved his hand in a way that would have quieted any other student. But Florence would not be deterred. She raised her voice and challenged the professor to be more specific:

Exactly what kind of art learning does this theory claim to facilitate? I have no faith in cure-all snake-oils.

Exactly what methods does the theory advocate and what kind of evidence supports their effectiveness for learning? Some patients improve on a placebo.

What evidence supports this theory and its methods for learning in art? Is the evidence specific to certain kinds of students? One patient's medicine may be another person's poison?

If the methods are successful, what kind of aesthetic development can we expect? Will one lesson provide a miracle cure or should we look for improvement over time?

Are there side effects—what can go wrong? Will the cure for one aesthetic illness kill another essential ability?

The professor rebuked Florence, "Are you too conventional to try a new theory?"

In a voice that was now calm, Florence replied, "I fear your theory, for the same reason I would fear to take medicine from an unlabeled bottle. I don't have the information to argue that your theory and its methods are good-for-nothing, but I doubt that your theory is good for everything. Something good might happen if I try your theory, but my Father has taught me that an accidental cure is not the same as a remedy. If we are to be regarded as a discipline," she continued, "we must be able to select methods with predictable affects, just as doctors prescribe medicine."

The professor would have argued more, but he sensed that the other students were agreeing with Florence, so he conceded: "Our literature seldom has the specificity that you request; but if the class agrees, we can use your five questions to analyze each of the authors that we study this term. Such an analysis will be difficult; perhaps even painful if we discover that our favorite theories do not have universal value."

Florence added, "The pain may cure our discipline,"

Questions

Why may students be unlikely to apply theories from their art education classes when they start to teach? Is there a spirit of independence peculiar to art students that makes them want to do their own thing when they become teachers? Is it likely that some students see advice from their professors as an extension of parental control?

Do you wish that professors, and the literature of art education, would stop giving alternatives—some of which are contradictory—and simply tell us the best way to teach? Is longing for a single ideal way to teach art like wishing for a cure-all snake oil? Are different kinds of theories best for different kinds of art learning? Will misaligning instructional methods with aesthetic goals likely produce art that is less real?

What are the characteristics of a discipline? How might art education become more like a discipline?

Can you apply Florence's questions to an article on how to teach art? Exactly what kind of art learning does this theory claim to facilitate? Exactly what methods does the theory advocate? What evidence supports this theory and its methods for learning in art? If the methods are successful, what kind of aesthetic development can we expect? Are there side effects—what can go wrong?

9

First reported in a newspaper, this story tells what happened when an art teacher, who resembled a Greek Philosopher, challenged the politics of assessment.

Popular Art Teacher Fired by Board

United Press International

Athens, USA — Despite a resolution from over fifty students supporting their art teacher, the District School Board voted to deny the art teacher's bid for tenure and fired him. In reporting the Board's decision, the Superintendent said, "The safety of our students will no longer be jeopardized by this teacher's unauthorized field trips. The teacher's insubordination, unprofessional behavior, and failure to follow State Guide Lines left the Board no choice."

Students picketing outside the School Board offices praised their teacher for challenging them to excel. One girl said, "He lets us see him being an artist—he sets a high standard for us to aspire to." Another girl said, "We respect him because, we know his artwork and because he shares his thinking process as he works. Through his example, we understand the dedication that artwork requires." A boy added, "He respects and encourages our ideas, yet argues with us about what we are doing—he expects us to be sophisticated, rather than naive."

The President of the Teacher's Union said that the School Board's action was retaliation for a previous grievance that the teacher had filed against the school. "His grievance grew out of the Vice Principal's announcement that the faculty would serve as lunchroom monitors. The art teacher challenged the policy and the school sought to discipline him, but the arbitrator ruled in the teacher's favor."

The art teacher, who goes by the name Mr. Sock, gave his account of the incident with the Vice Principal. "I asked him whether he was ashamed that he hired us to be teachers, but now expected us to be police in the cafeteria. The VP turned red, as I explained that such a misappropriation of professionals should outrage taxpayers. It was not only a misuse of professional time; it threatened to create tensions between pupils and teachers that would make teaching more difficult. The VP, however, was more mad than ashamed. He thought he was all-powerful, but he should have known that his power was limited by the Union Contract."

Questioned about other teachers' reaction to the incident, Mr. Sock explained, "When I challenged the VP several teachers at the meeting whispered, 'sock it to him.' So, teachers began to call me *Sock*—it was easier to pronounce than my real name. Eventually the name stuck. I accepted the new name, because *Sock* sounded more heroic than my Greek name that translates to *Dog*."

Art teacher, Sock, described as unconventional

A teacher who taught across the hall from Sock described him as unconventional. "Older than most new teachers, his head was half-shaved and

tanned the same color as his chest, which often showed through his unbuttoned shirt. He always wore sandals, except when he went barefoot in the snow. Whenever he left the art room he carried his knapsack. On dress-down Fridays he usually wore a T-shirt with a picture of a Greek philosopher carrying a lantern. I often overheard his students talking about trips to museums. Because my aunt is the School Secretary, I know that he never applied for field trips. I also heard students say they visited his studio where he worked from nude models."

The Art Supervisor described how he became aware of Sock's unprofessional behavior. "Sock and several other teachers were assigned to a committee to work on assessment procedures required by the new State guidelines. While the other teachers came to the first meeting with examples of student art and their rubrics, Sock came with a chip on his shoulder. He refused to participate in the process and insulted some of the teachers. He told an experienced teacher that she might be able to cook beans but she did not know beans about art."

"I have been misquoted about the beans incident," Sock retorted. "When a teacher complained that the many varieties of art made it difficult to judge art, I asked her whether there were varieties of beans. She agreed that there were different varieties of beans. So I asked her whether she could judge their quality. She observed that she would judge dried beans differently from green beans, and described the best green beans in terms of their color and texture. Then I said that, if she knew as much about art as she knew about beans, she would be able to judge art."

Sock angered teachers over assessment

An art teacher, who wants to remain anonymous, said that Sock had angered teachers at the meeting on assessment. "He insisted that they were going about assessment backwards—they were trying to define how to assess art by looking at school art, rather than professional art." Sock argued, "Art teachers' assignments have a predictable appearance that is distinct from art outside schools." Teachers were upset at the implication that their students were not making art, but they conceded that students might be doing exercises. Exercises, after all, were important, because they developed abilities that artists need. When the teachers presented their rubrics for grading their exercises, Sock accused them of confusing requirements with criteria. Sock said that their requirements were only rules and sequences of steps, not standards of quality. Even an exercise, he argued, needed some way of determining quality, and the standard ought to be whether the exercise is like art.

When asked about the assessment committee, Sock said that he had not wanted to be on the committee, but the Art Supervisor had insisted. Sock described a Saturday meeting of the committee. "The meeting," he said, "was on portfolios. The teachers brought sample portfolios with collections of art assignments and student writings. As they struggled to find some way to judge whether students were improving, I pointed out that that, while they now looked for improvement, they had only taught students to do things differently. What they were doing was like trying to determine whether athletes were improving at baseball by watching them pole-vault. Typical diversified art programs, however,

make it hard to assess improvement; not only because there is no constant basis for comparison, but also because the improvement that teachers hope for is seldom there."

Several teachers reported that Sock had been more concerned with changing the way they taught, than in completing the assessment project. Sock, however, explained that his concern for instruction grew logically from the need to assess artistic learning. "There must be a natural connection between instruction and assessment," he argued. "*Ex post facto* assessment is unjust to students and comes too late to guide instruction."

Sock refused to use District Plan

According to the Superintendent, "When the Art Supervisor presented the art teacher's assessment plan, Mr. Sock wanted the record to show that the plan was not consistent with his philosophy and that he could not in good conscience use it. The Art Supervisor said that Mr. Sock had ample opportunities to contribute to the assessment plan that he now refused to use. Instead of contributing to the work of the committee, Mr. Sock had disrupted the meetings and had finally walked out. Thus, he had forfeited his opportunity to shape the plan to fit his philosophy."

"It is not true," Sock asserted, "I did not walk out of the meeting. Rather, I suggested that our meeting would be more profitable, if we moved to a near-by art gallery where the artwork would stimulate our discussion and then I walked to the gallery—they did not follow me."

Sock also claimed that the Superintendent misrepresented what happened at that meeting. Sock explained, "I asked whether the Super [Art Supervisor] was not ashamed that he was presenting a plan that illogically confused **what is** with **what ought to be**. The plan from his teachers subverted the efforts of the State to improve art education. The purpose of the State Assessment Project was to cause teachers to rethink what they are doing, yet the Super has endorsed a system that merely ensures the status quo."

When the Superintendent asked whether Sock was ashamed of his impudent behavior he answered, "Pride in being an art teacher comes from success with students, rather than appeasing teachers who teach less well than I do. If art teachers continue to teach, as they have, they can expect the public to continue to hold school art in low esteem. Moreover, art assessment scores rendered by teachers who have a vested interest in showing that their students are learning will not sway public opinion. True respect is not won by avoiding difficult questions. Would teachers who have always lived in a cave respect the questions of one who has been outside the cave? Or preferring the comfort of their familiar shadows, will they reject the outsider? I believe the Super recognized my reference to Socrates [*The Allegory of the Cave*]. But his provincial teachers did not understand. Their fixation on shadowy assessment standards is the predictable result of pedagogical inbreeding that is more concerned with a stable workforce than quality education."

Sock also asked the Superintendent, "Are you not ashamed that your assessment document is motivated by political protectionism, rather than a desire for authentic assessment? Is it more concerned with justifying the retention of art

teachers than in improving art education? Are you not embarrassed to be protecting mediocre teachers while pretending to reward student achievement?" The Superintendent took offense and asked Sock to leave.

When asked whether he had anticipated that his manner would irritate his superiors, Sock replied, "Should I be governed by those who are less able than I? If those who govern are not led by right reason, they must be led with halters. I have realized the importance of exposing pretentious behavior since college introduced me to the Greek philosophers."

Professor defends Sock

Sock's college Philosophy Professor—who had unsuccessfully tried to be a character witness for Sock—described an incident in his Philosophy class. "One day Sock came to class wearing a T-shirt depicting a Greek carrying a lamp. In the middle of my lecture Sock stood up and asked me whether I was not ashamed that I pretended to teach philosophy while only teaching literature. He followed his question by asserting that reading what philosophers have written and answering questions about their writings on tests in more like studying literature than learning to do what philosophers do. After class students who had never paid attention to Sock pointed at his shirt and called him Socrates—I thought that incident was the origin of Sock's name. But, I was embarrassed at my student's ignorance. They should have known that Diogenes was the one who went about with a lantern looking for an honest man." The professor added that, because of Sock, he had changed the way he taught.

Sock refused to comment on any similarity between himself and Diogenes. He did, however, say that his Diogenes T-shirt had disappeared just before the hearing. So, he had worn his Socrates shirt. On the shirt's front was a single branch of hemlock. Sock explained that the shirt was appropriate, because it was unlikely that the School Board would be more reasonable than the Superintendent hired by the Board.

Sock's professionalism challenged

A teacher, who said that she had testified at Socks hearing, reported, "The school was not paying us for working on Saturday. It was unprofessional for Mr. Sock to obstruct our progress. Sock came in with a high-and-mighty attitude because his kids win competitions. Talented kids win competitions, not teachers. Moreover, in pushing kids toward pseudo-sophistication, he is ignoring the basics required by the standards."

Sock retorted, "If that teacher really believes that talent alone accounts for the quality of student artwork, she should in good conscience resign. It is surely a waste of taxpayer's money to pay her to teach something over which she has no influence." Sock dismissed the claim that he was ignoring the basics. "If I were a winning football coach, I would not be accused of ignoring the basics. It would be assumed that players who win have a better grasp of the basics than those who lose. The real issue is not that I ignored basics, but that my basics are different from those of my colleagues. Because my colleagues sought to require me to

evaluate my students by their basics, they threaten to undermine the learning that made my students successful."

After teachers claimed that Sock had behaved unprofessionally, Sock responded. "Those teachers testified that I had behaved unprofessionally with my students, in that I had invited them to my studio. While the latter is true, it does not prove the former. If teachers have studied art, is it professional to hide their skills from students? We should not be afraid that students may copy teacher's work—if teachers do good work—rather, we should fear naive students copying one another."

Sock answered the accusation that he took students on unauthorized field trips with the explanation that he had no car. Students had taken him. He justified the trips as a way for students to learn, "the history of art, rather than the history of reproductions."

Sock concluded his defense

At the hearing, Sock concluded his defense with the following observation: "The fact that I am on trial for my good works indicated how desperately art teachers in this school district need better supervision. Therefore, I am available to replace the current Art Supervisor."

After the hearing, still wearing the shirt with the branch of hemlock; Sock admitted that his arguments had fared no better than those of Socrates. He regretted that, while he had sought to guide his colleagues through philosophical inquiry, they had conspired to muzzle his right to free speech. Then, he recalled that after Socrates drank the hemlock—something he freely did as a matter of principle—the citizens of ancient Athens repented and honored him.

The missing T-shirt explained

Outside the building where the hearing was held there were a group of students wearing T-shirts that looked like the one Sock used to wear. One of the students explained how Sock's familiar T-shirt, with a picture of a Greek philosopher carrying a lantern, disappeared. "We borrowed it," the student said, "so we could make more. After we scanned it, printed inkjet transfers, and ironed them on shirts; we couldn't tell which the original was. Still, we returned one to Mr. Sock's studio. Now we wear the shirts so we will be more like Mr. Sock."

Questions

Is conflict between old teachers and talented new teachers inevitable?
How might the potential for conflict be minimized? How can artists deal with educators without sacrificing their integrity? What is the difference between a healthy skepticism and a threatening cynicism?

What are Sock's principles for assessment? What is the starting point for assessment? What is the difference between criteria and rules? How are exercises to be graded? What conditions are necessary to evaluate growth? What should be the relationship between assessment and instruction? If winning competitions is a form of assessment, what kind of basics will enable students to win?

How might art assessment be consistent with both the demands of art and the expectations of education? How will the nature of assessment change depending on the goal of assessment: rewarding achievement, diagnosis of learning needs, defending the art program?

What should be the source of our standards for assessing art learning? Should standards be based on an understanding of what artists do? If norms are based on what students naturally do, will their artworks be more or less real? Will politically motivated standards tend to defend programs as they are and thwart program improvement? What kind of standards will encourage real art?

Do art teachers have a responsibility that goes beyond their own classroom? How could Sock have worked with the other teachers to improve the learning of all the students? Did he have a responsibility to do so?

10

Winning the Accountability Game

A superintendent, who was once a winning football coach, imposes athletic standards of success on the art program.

It should have been a joyous occasion, the band was playing, and others in the line before her were jubilant. But Hope only managed a tired smile, as she stood on the platform and her professor congratulated her. She felt only a little better, as she made her way back to her chair and searched for her Mother and Son in the audience. Teaching art five periods each day, preparing lessons, driving to the college to attend evening classes, and working on her Masters Thesis after her son was in bed had been a heavy responsibility.

Hope was relieved when the ceremony was finally over and she was able to join the recessional. After three years of juggling teaching and graduate school, she had finally completed the last requirement for her degree and for tenure.

Hope pushed through the crowd until she reached her Mother and her son, Able. Hope held Able close to her and told him, "Now—after years of evening classes and summer school—I can spend more time with you."

Their time together, however, was threatened when they arrived home and Hope listened to her answering machine. The message was from Hope's Principal. He wanted her to become the Chair of the Art Department in her district. Her duties would start tomorrow by attending an important meeting of the School Board. Able overheard the answering machine and asked, "Will you leave me and go to the meeting?" Hope replied that she did not like to make important decisions until she listened to her inner voice.

After Able was in bed, Hope sat in her chair waiting for her inner voice to tell her what to do. The Principal's request was a surprise, for Hope had assumed that one of the older art teachers would become chair. She wondered whether the older teachers did not want the extra work—or perhaps they had such large salaries that the chair's stipend seemed insignificant. She wondered whether the extra money would be worth the extra work and, "How would the work affect Able?"

Although she listened quietly for her inner voice she heard nothing. So, she turned her attention to the mail beside her chair. In addition to the usual bills—including the education loan for her undergraduate degree—she found an advertisement for summer camp. Hope wanted Able to go but did not know how she could afford to send him. The chair's stipend, she realized, was enough to send him; and camp and would keep Able safely away for the neighborhood boys who played in the street.

The next morning she telephoned the Principal to tell him that she would be chair and that she would attend the School Board meeting. Then she telephoned her mother and asked her to stay with Able.

When Hope attended the Board meeting she heard the new Superintendent, Dr. Win, address the Board. He told of the necessary expenses to achieve the new State Standards for Math and English. And he suggested that savings for those expenses could be found by replacing elective courses with study halls. Dr. Win proposed that, "If electives are to be retained, the teachers of those courses should have to defend their worth." Several Board members voiced their concern that students might lose something important if electives were eliminated, but they hesitated to propose a tax increase in order to meet the State Standards. In the end the Board scheduled hearings for each of the areas with elective courses. The hearing for art would be on the first Monday in November.

As Hope drove home she thought of the two new art teachers in the district. The possibility of eliminating electives threatened their jobs. Hope's position seemed secure. With her Masters and three years of experience she had tenure, but she dreaded the possibility of teaching five sections of the only required art course.

At home, and in her chair, Hope considered what to do. She wished for her inner voice. She felt responsible for her new art teachers, but she felt alone and helpless against the Superintendent and the Board. Then Hope's mother telephoned. She wanted to know the times that she would be watching Able. Hope gave her the times and told her mother that she did not know what she would do without her help.

After she hung up Hope realized that, if she was going to fight, she needed help. She recalled that there were teachers at the Board meeting from other departments. Those departments might also lose their electives. Perhaps she could unite with those teachers, and they could fight the superintendent together.

The next day she studied the list of the departments with electives and decided that the most vulnerable departments were music and physical education. So she made appointments to see new teachers in both departments.

Hope's first appointment was on the archery range with Miss Zen. Hope asked her how she had reacted to Superintendent Win's threat to replace electives with study halls. Miss Zen replied, "Some departments might feel vulnerable, but the teachers in physical education feel secure."

Hope observed that Miss Zen did not yet have tenure and that some people might feel that archery is a frill subject that could be safely eliminated. Miss Zen answered, "After only two years coaching archery, my team has placed second in the State." Hope wondered how the varsity team, which met after school, justified the elective archery class. Miss Zen's explained, "My success with the archery team validates the quality of my teaching, and the elective course is a place to recruit for the varsity. Don't you have something like a varsity program in art?" When Hope told her that they had no varsity in art Miss Zen observed, "It must be difficult to challenge and develop your best students in art without competition and without the example of other students succeeding."

Hope said that varsity sports seemed to be about competitions and she feared that the desire to win would distract students from the process of making art. Miss Zen pointed to some students who were shooting arrows, but they were not using targets. "Those students," she said, "are practicing the process of a

proper release. An improper release will cause the arrow to go array. Students practice without a target so that their concentration will not be distracted by where the arrow goes. In addition to learning proper processes, archers must learn proper concentration and how to analyze their own performance. My athletes practice these processes because they believe that proper processes will help them shoot winning scores. If your art students are really practicing correct processes, they should produce artworks good enough to win."

Hope replied that she did not think that her art students would enjoy the rigor of repeated practice. "Competition," Miss Zen answered, "motivates my athletes to practice." Then she added, "Don't artists have competitions?"

Hope replied that she taught art so that students could experience the joy of making art, without regard to public acclaim.

"Archers know the joy that comes from exercise and the magic of the arrow's flight," Miss Zen observed. But she quickly added, "I suspect that those athletes who say that they are not interested in winning do so, because they know they have no chance of winning. The goal of teachers is to prepare students so that they can reasonably expect to win."

Hope speculated that it must be easier to teach students to win at archery when students have only one sport to learn. She explained that art exposes students to diverse mediums—a new one every week—so that students can find a medium that is right for them. We want every individual to find a medium that they can feel personal about."

Miss Zen replied, "Archers' bodies are so different that the coach must help each archer make adjustments. Thus, an extended period of time is required to truly individualize the sport. There would be no time to individualize instruction, if I introduced a new sport every week. A week on volleyball, a week on basketball, and a week on field hockey is a schedule more likely to convince students that they are not athletes rather than to develop individual abilities."

Hope thought about the large number of her students who did not think of themselves as artists, but she did not voice the comparison. She could see that she was not going to find an ally in the physical education department, so she excused herself saying, "I need to pick up my son at his grandmother's."

Her son, Able, greeted her with the news that he wanted to play hockey. Hope's mother explained that the novice hockey program emphasized skating skills and that it was not until the Bugs Bunny Tournament at the end of the season that they would play a game. Able added that he thought the tournament was a really big deal.

As they drove home, Hope told Able, "I do not want you to play in organized sports. I would worry too much about your safety." When Hope's mother telephoned that evening, Hope told her of her decision. Hope's mother noted that she had made the decision without waiting for her inner voice. Hope responded that she needed all the resources of her inner voice to deal with problems at school.

As Hope sat in her chair she wondered at the value of her inner voice. She had found no help from Miss Zen—only criticisms of her art program. She hoped that the School Board had no ex-jocks who would think art should be taught like

athletics. Still, she hoped for an alliance with the music department. Music, after all was another art form.

The next day Hope met with Mr. Note in the rehearsal room. Hope asked him if he felt threatened by Superintendent Win's proposal to eliminate electives. Mr. Note responded, "The students in his performance groups tend to make higher grades in English and Math, so rather than being a frill, music seems to support the academics."

Mr. Note added, "I should be able to justify my electives, because my students have done well in the County Music Competitions. Moreover, several of my graduates have received scholarships to music schools." Hope asked whether competition distracted from the learning processes. "On the contrary," Mr. Note responded, "Sight reading is such an important process that it is a regular part of our competitions."

Mr. Note pointed to photographs on the wall, "My performance groups received frequent invitations for concerts." As Hope looked at the photographs, she noted that the students looked very nice in their tuxedos and long black dresses. She observed that the clothing and musical instruments must be very expensive and asked how he got support for his groups? Mr. Note answered, "The school pays for little more than some new sheet music each year. The students sell grapefruit to help pay for their clothing, and bus trips to out-of-town performances. Still, we are dependent on parental support. Support is better now that the performance groups are more visible."

Then Mr. Note asked, "What does the art department do for fundraising?" Hope replied that they managed with the materials that the school gave them, but she dearly wished that her painting class could work with acrylics rather than watercolors. Mr. Note added, "Some thicker matte Board might enhance the artworks that you exhibit during the Winter and Spring Concerts."

Hope asked whether it was possible to train students to perform, because they had private music lessons outside of school. Dr. Note answered, "We encourage students to get experiences in music beyond what the school provides, but few students in my glee club have outside instruction." What really helps," he said, "is the strong foundation that they receive in elementary and middle school. We are fortunate to have teachers that move students well beyond lyrics and pitch. So that when I get them, they understand following the director to achieve a consistent interpretation. Since this is the case, I am able to work with individuals to develop solo quality voices."

"Doesn't competing for vocal solos, or for seats in the orchestra, distract students from the real joy of music?" asked Hope.

"Not at all," Dr. Note answered. "Students know that solos and chairs are earned by dedication and practice. Moreover, there are no unimportant parts in music. It is the conductor's responsibility to assign individuals to parts that they can best perform. The final performance depends on a quality performance from each part. So, everyone feels a loyalty to the group. That loyalty is similar to what you have on an athletic team."

Since even the music teacher was using athletics to explain his program, Hope concluded that Mr. Note would not be her ally. So, Hope wished him well and drove to her mother's home to pick up her son.

Able greeted Hope with a hug and showed her a brightly colored flyer from a fast food chain. As Hope read the flyer announcing a drawing completion, Able said that he wanted to enter. Hope complained to her mother, "Competitions like this are designed to promote greasy fast food rather than children's art. If children lose, they are disappointed and if they win, the prize is likely to ruin their health."

Looking disappointed, Able sobbed; "You teach art but you don't let me do art."

That night Hope sat for a long time in her chair wishing for her inner voice to tell her what to do. She had no allies and the hearing with the Board and the Superintendent was fast approaching. After a long while she heard nothing so she started flipping channels on the TV. When she came to a boxing match she watched for a while. As she watched, she wondered why this match fascinated her. Normally she detested violent sports. Finally she realized that it was one man fighting one man. Why should she take on the whole Board and the Superintendent as the same time, if she could arrange a one-on-one fight?

So the next day she telephoned the Superintendent's secretary for an appointment. And then she went through her files searching for things that might impress the Superintendent. She found her assessment rubrics and an article from the State Art Teacher's Newsletter reporting that students' Math and Verbal scores on the SAT correlated with the number of arts courses that students took. The last thing she did was download photos of student artwork to her laptop. With these in her briefcase she felt more confident.

Hope's confidence, however, was tested; as she entered the Superintendent's office and saw that his walls were covered with trophies. Dr. Win explained, "Before earning my Doctorate in Educational Administration, I coached football. I had two state championships. Now I intended to coach the district to a position of national recognition." Hope replied that she preferred to think that he would achieve his goals through coaching faculty rather than cutting them. "That," he answered, "is the reason that I agreed for this meeting. Now, show me what you have brought."

Hope opened her briefcase and showed him the article about the SAT scores. "I am aware of that report," he said. "Those correlations are impressive, but they group all the arts together—music, dance and theater, as well as visual art. Moreover, correlations do not show cause and effect. The SAT study was on a national scale, so there may be some schools where the correlation existed and some where it did not. The results may simply indicate that students in culturally privileged communities are more likely to take arts courses. What I wish for is statistical evidence specific to our school district and specific to visual art."

Hope did not know how to respond, so she opened her laptop and showed him photos of student artwork. "I am impressed with the quality of your

photographs," he said, "but I wish for some sense of organization that would show that students are improving in art. For example, English students write an essay at the start of the term and another at the end of the term. Improvements in the essays are evidence of learning and teaching. I wish you could show me similar evidence of improvement on a single art task." Hope pointed out that their art programs emphasize a diversity of experiences that sensitize students to a broad range of assignments with the intent of improving their appreciation rather than making them professional artists.

"If appreciation is your goal," Dr. Win responded, "it is curious that you spend so much effort having students make things. Certainly English teachers have the goal of teaching appreciation of great literature, but they also expect their students to learn to write. In addition they expect everyone to write after they graduate. Whether they write scientific reports, advertising copy, newsletters or simply letters; their writing will be better if they learn the skills that the professionals use. They are preparing writers as well as avid readers. The same is true in athletics. The goal of athletic programs is not solely to produce spectators. Coaches intend to train people for a lifetime of physical activity whether it is for a professional contract or the joy of recreation. Moreover, the teaching of appreciation cannot be separated from the teaching of making. It is impossible to imagine that you might teach children to appreciate great art by permitting them to make half-hearted art."

Hope responded that her rubrics documented student achievement that was more than, "half-hearted." Hope showed Dr. Win examples of her rubrics and the multiple scores that they yielded for each student.

Dr. Win praised the rubrics for their value as feedback to the students, but dismissed their value as evidence of accountability. "Your rubrics have no more value than training statistics for coaches. What I want to see is a list of your wins and losses. What competitions have your students entered? What awards did they receive? Did they get scholarships in art? Were students admitted to prestigious art schools? Or, can you compare your students' achievement with some national or state standard. Without these kinds of external validation there is no evidence that what your rubrics measure is worthwhile."

Hope replied that the teacher who taught the senior studios was now retired, so she had no record of what happened to last year's graduates. Hope knew that the State was working on portfolio assessment, but it is still in the early trial stages. As for exhibiting student artwork, Hope explained, "We have the custom of having major exhibitions that coincide with the Spring and Winter Concerts. We put up the best work from every student. That way no student is embarrassed."

"I saw your exhibition when I was interviewing for this job, "Dr. Win replied. "The exhibition seemed to contribute to the importance of the musical event, but I saw few visitors paying attention to the artwork. Were there any news articles about the art exhibition? There were several about the concert."

"Your assessment of the evening makes it sound as though the music department is in competition with the art department," Hope responded.

"The real world is competitive and on that evening music got more points," Dr. Win replied.

"Instruction in art requires an environment that is different from your concept of the competitive world," Hope argued. "Art learning requires a supportive environment that is free of the stresses of competition, if students are to creatively fulfill themselves."

"Students are tougher than you believe them to be," Dr. Win answered. "Teachers should prepare students to deal with the competitive aspects of life. I fear that you are teaching like an overly protective parent and I believe you could teach better if you taught more like a coach."

Hope thought that his reference to motherhood was inappropriate, but before she could respond the secretary opened the door and ushered in the President of the School Board. So, Hope thanked the superintendent for his time and she left.

That evening, while Hope was preparing dinner, Able came to her and asked her to take him to the store. Hope said that she could not go with him now, because she was cooking. Able argued that he could go alone, "Grandmother lets me go alone."

Hope answered, "Grandmother lives closer to the store than we do. I do not want you to go alone."

Able cried, "You don't let me do anything. I can't play hockey, I can't be an artist, and I can't go to the store. Will you ever let me grow up?" Then he ran to his room and slammed the door.

Hope turned off the stove and sat down in her chair. "Why, she thought, "must I compete with my mother for my son's affection?" But when the telephone rang her inner voice suggested a new question; "Mother," she asked, "Am I an overly protective parent?"

Her mother hesitated then said, "Yes, and I should know one because I used to be one."

"When did you quit?" asked Hope.

"I quit when I realized that it made you resent me. Why do you ask?"

"I'll explain later," Hope answered, "Able needs me now."

Hope went to Able's room and told him that he could take her to the store and, if he showed her how safely he could do it, he could go alone tomorrow. Able proudly led his mother to the store and told her all the safety rules as they walked.

That evening in her chair Hope pondered the relationship between teaching and parenting. "Was she an overly protective teacher?" She feared that some students might resent her just as Able did. She thought about the students who never seemed involved in their work and wondered whether some competition might motivate them. Her inner voice asked, "What would art teaching be like, if she were more like a coach?" After she thought a while she began to make notes.

The next morning she called an emergency meeting of all the art teachers in the district. At the meeting she told them about the impending Board meeting when they must defend their electives. She told them that since she had met with

teachers in other departments and with Superintendent Win, she now understood the rules that they must play by, if they were to save their electives and prevent the dismissal of any art teachers:

1. Art teachers must be able to show that students improve in art—randomly administered rubrics, and randomly selected artworks are of no use.
2. Validity of internal grades is established by external judges and competitions.
3. SAT results need to be replicated on the local level with visual art classes.
4. Scholarships, awards and publicity count as measures of external validity."

Her teachers responded to her list of rules with the same arguments she had tried with Miss Zen, Mr. Note, and Dr. Win:

"Competitions will distract from the joy of art."
"Competition will distract from learning processes."
"It is harder to make art students competitive, because we have to cover a diverse curriculum, and because our students have inferior materials."
"We are preparing students to appreciate art, not to be artists."

Hope listened to all their arguments and then replied, "**Your line of reasoning would make no sense to anyone but art teachers.** What is at stake is not whether we will conform to the rules, but whether the rules will motivate us to teach art better."

"Too many of our students respond to us as though we are overly protective parents. Protecting students from outside assessment makes us the sole judges of our students. Thus, we make students dependent on us. Students do not like dependence, so they grudgingly go through the motions of completing our assignments. We try to motivate them by making art fun, but aside from their initial response to new materials, there is little joy in their art."

Hope sensed that several of the teachers wanted to interrupt, so she talked faster.

"I wish our students worked as hard for us as athletes work for their coaches. Athletes train hard because the coaches are not their judges, but mentors preparing them for outside competitions.

"Coaches organize their curriculum into seasons so that athletes have time to excel in one sport at a time, while we teach a diversified curriculum that permits students little time to become good at anything. So, our claim that we do not intend to teach students to become professional artists is likely to become a reality. Even the best program is not likely to make all students become professional artists, but to perpetuate a curriculum that would not help those who

might become professionals seems unfair. If we think of artists as more than fine artists, there are certainly a lot of jobs in our society that benefit from art skills."

"But," said a teacher, "We do more than teach studio—there's history and criticism and appreciation..."

The teacher might have gone on, but Hope interrupted in an even stronger voice, "We claim that we teach a Discipline-Based Art Curriculum that includes the discipline of art. **The studio component of our discipline should teach our students to be more like artists. Artists submit their art to competitions and subject themselves to the judgments of critics.** Artists compete with other artists for their share of the art market. Part of the art process is exhibiting and competing.

"Moreover, students who do not become professionals are likely to make art as adults. Every K-Mart sells art supplies—lots of people must be using them. Virtually everyone takes photographs with their cellphones. The advent of computers and desktop publishing means that anyone in business can be called on to design materials where visual appeal is important. **The things people make should be more aesthetically appealing, because they have had art classes.**

"We cannot hide our concern for the quality of our students' artworks by claiming that we are teaching process rather than products. Processes are inexorably connected to products. If the products do not look good, it means that the students are not learning good processes.

"What really bothers me is my new found fear that our diversified studio program may limit our success in teaching appreciation. As we quickly move from project to project, we try to convince ourselves that making art enjoyable is more important than helping students achieve sophistication in their artworks. Thus we contrive to make art quick and easy. **But students would be more likely to respect art, if making art was really hard.**

Hope paused and looked about the room; she could sense the teachers discomfort with her arguments, so she tried to soften her voice.

"We make excuses for our students' performances by complaining about short periods, and inadequate budgets for supplies. Thus, we try to shift the responsibility to the administration. Now, however, the School Board and the Superintendent are holding us personally accountable.

"The question is not whether we will play their accountability game. We must if we are to survive. The real question is will we change the way we teach so that our students can reasonably expect to win?"

Hope closed the meeting by challenging each of her teachers to prepare individual written plans that would establish accountability and ensure student success. Hope would assemble the plans and present them at the Board meeting.

For her own part Hope planned to start each grading period with assignments that would be repeated at the end of the term and use them as pre-tests and post-tests. Improvement would give evidence of learning. She would also use the pre-test post-test model for criticism and history with assignments to write about art. She would limit students to one medium during the marking period so that they could develop some proficiency. Since students would need less help with the medium, she would assign a number of artworks to be

completed outside of class. More class time would be spent on critiques. She would use guest critics so that she could begin to escape her role as sole judge. She would also encourage students to enter competitions.

In addition Hope wrote proposals for an Advanced Placement Art Class and a competitive student exhibition to be held outside the school. The opening of the exhibition would be enriched by a string quartet provided by the music department. To deal with increased expense she proposed publishing greeting cards that would feature the artwork of local artists. Interviewing the artists would require students to behave as historians and their best writings would be printed on the back of the cards.

Three weeks before the November meeting the two new teachers came to Hope. One teacher said that he had talked with his thesis advisor about studying the relationship of SAT scores to art instruction at their school. "If he could get the records, the professor would help with the statistics." The other new teacher, who had the same thesis advisor; wanted to do a follow up study of recent graduates by telephoning them, "Can the school release the student's telephone numbers?" Hope promised to take both requests to the Principal. And she prayed that they could have data in time for the Board meeting.

On the first Monday in November the School Board convened its meeting in the gymnasium. All the art teachers were there to support Hope. As Hope looked around the gym she was disappointed that so few people from the community were there. "Doesn't anyone care about the future of art?" she thought. While Hope waited for her turn, she listened to the glowing reports of student accomplishments from the music department. Applause from the audience indicated that most of the people in the audience were there to support music.

When it was her turn Hope argued that it would be unreasonable to eliminate art in order to fund programs for math and English. To support her argument she presented new data showing that students who take visual art classes are more likely to score higher on the SAT. This was true nationally and at their school.

"In addition to supporting the academic program, art provided career opportunities for students. Two of their students had gone on to art schools, one with a scholarship, and three other students had jobs that were art related. She conceded that these numbers were small, but hoped that art electives would continue to make art careers possible for the most talented students."

She reported that since she had become chair in June the art faculty had prepared plans designed to nurture talent and ensure accountability in each art class. She started to outline her own plan and the plans of the other teachers. But, before she could finish, a Board member with a stopwatch said that her time was up. So Hope thanked the Board and gave them the plans from all her art teachers.

As Hope went back to her chair, Dr. Win excused all the guests, so that the Board might deliberate privately.

Outside the gym Hope saw the Principal leaning against the trophy case. "You and your teachers are to be commended for your quick work on the studies of the SAT and the recent graduates," He said.

"Our two new teachers deserve all the credit," Hope answered and then she asked, "How is the Board likely to respond to our plans for accountability?"

The Principal answered, "Your plans represent a dramatic improvement. But I am afraid that the Board would be more impressed, if the plans had been implemented last year, so that you could have reported on the positive results."

"It would be unfair," Hope said "for the new teachers to lose their jobs, because of what older teachers failed to do last year. Besides, doing their studies of the SAT and the graduates required them to work harder than the older teachers."

"If they must seek new jobs," the Principal answered, "their experience this year will prepare them to make art positions more secure at their new schools."

Questions

What attitudes in school and society indicate that art teachers must be accountable? Will parents and the public judge your students artworks by the teacher's rubrics or by comparison to familiar artworks? What evidences of student achievement are most likely to sway the opinion of policy makers?

What aspects of coaching are like teaching art? If there are differences between coaching and teaching art, which of these differences suggest ways to improve the teaching of art? Will it help to have competitions in art? Do students already compete for grades? Will it help if the teacher, like the coach, is a mentor rather than the sole judge of success?

What conditions will enable students to excel? How might direct contact with art, rather than reproductions, improve students' standards for art quality? How might we provide safe periods to practice, as well as competitions for grades? How might teachers overcome the limitations of short periods, and inadequate supplies so that students can excel? How might the tradition of a diverse curriculum be reconciled with the need to work in depth so that students may excel?

Susan Langer has written that there is no cooperation among the arts, only successful rape—in what ways are the other arts likely to abuse the visual arts in the schools? How might the visual arts use the other arts to their advantage?

What kind of evidence will enable art teachers to defend their programs? Will public relations suffice, or must students do really good artworks—artworks that are not counterfeit? Is it sufficient to exhibit only the artwork of talented students? How can you document that all students actually improve? What kinds of student achievements will document their learning in art history and criticism?

How should you respond to each of the following? Competition will distract from the joy of art. Students should focus on process rather than products. Short periods and inadequate materials limit students' ability to do significant artwork. Students need to experience a wide range of materials. The purpose of school art is to teach appreciation of art.

11

Heroes and Heroines

This is not another story; instead, it is a challenge for you to become a hero or a heroine. Rather than something that is learned in four years of college and then simply repeated for the next forty years, becoming an art teacher is like going on a quest.

The first story in this book was an allegory about an art teacher named Joseph. You will recall that Joseph dreamed that he was a knight on a quest to return real art to the castle. Joseph's story illustrates the typical sequence of a quest—or a hero's journey as described by Joseph Campbell (1973):

- **The ordinary world**. The hero is introduced leading an ordinary life—a life that is somehow impoverished.
- **The call to adventure**. The hero receives a call to adventure—typically the hero refuses the call until circumstances compel him to accept the call.
- **The land of adventure**. In the land of adventure the hero experiences a series of tests. He must distinguish true mentors from false mentors, and he confronts dragons that require him to overcome weakness within himself. This internal growth is viewed as a gift that transforms the hero.
- **Hero's return**. The return to the ordinary world is filled with an increased awareness of the gift and a willingness to share the gift with others.

My other stories also have heroes or heroines, though I may have taken liberties with some of the steps. And some heroes and heroines do not answer the call until the end of the story.

Because you have worked through the questions at the end of each story, you have examined assumptions about teaching art that were likely to inhibit your choices, as you design your art program. Thus, **you are now able to think more clearly about art and learning.** Your thinking will now be more concerned with rightness than with rationalizing current practices. **Clear thinking will enable you to plan lessons and design programs that will move closer to an ideal**—an ideal that is more consistent with your concept of real art than with what is typical.

Implementing your program, however, is likely to become a new adventure. Your clear thinking may be little valued if it collides with the traditions and self-interests of colleagues, administrators and parents. Even students may at first perceive you as a dragon blocking their quest for fun and graduation. You will recall that Socrates, the father of clear thinking, was forced to drink hemlock—a poison that caused his agonizing death. So, winning support for ideas that deviate from the norm may require heroic effort.

Given what happened to Socrates, the shortest course to job security may seem to be sacrificing your ideals and conforming. But this course is unimaginable, since the tradition in art is just the opposite: faithfulness to ones convictions. Even though you might try to conform, circumstances such as new

state requirements, poor student performance on national assessments in art, and dwindling public support for art in schools are likely to serve as wakeup calls for you to be become a hero or a heroine. You will want to answer the call. When you do, what can you expect?

- **Ordinary World**. Ordinary art programs, as suggested in my stories, are likely to perpetuate **counterfeit art**, if they:

 Stress appreciation or creativity rather than quality student artworks,
 Emphasize working with a wide variety of materials and subjects rather than working in depth,
 Teach quick and easy ways to make art rather than traditional craftsmanship,
 View art as a respite from the rigors of academic study,
 Believe that student success in art results solely from talent rather than work,
 Discipline students who challenge the teacher's authority,
 Have students emulate historic exemplars, rather than teaching students to work the way artist work,
 Teach criticism only through critiques of student artworks,
 Support only aesthetic values based on European male artists,
 Defend art in schools for its ability to support academic learning,
 Justify the need for art teachers by painting signs and lettering awards,
 Seldom participate in art competitions,
 Display only exceptional artworks as evidence of successful teaching, rather than documenting improvement of all students.
 Have no external standards to validate the art teacher's judgments of quality, and
 Favor approaches to assessment that will defend the current art program.

If your colleagues have ordinary art programs, you are likely to feel pressure to conform—pressure that threatens to inhibit your individuality.

- **Call to adventure.** Your call to adventure may come from external sources such as new State Regulations, the results of National Assessments, or threats of local program elimination. But, what should compel you to accept the call, will be concern for your students—a concern, I hope, that was heightened by the stories in this book.

- **The land of adventure.** As you intentionally use your new ideas in order to escape the ordinary and move toward the ideal, you will confront pupils who perceive you as a dragon, because they expect art to be quick and easy. Your principal may become a dragon, if he, or she, values school art more for its political value than for its aesthetic value. Other art teachers may believe that you are a dragon, when you do things differently from the way they do them. Thus, you may seem to threaten the "correctness" of their programs. Because you have worked your way through this book, you will be able to think more clearly as you confront these adversaries. When you challenge the ideas of your students and

colleagues, carefully framed arguments may be less persuasive than metaphors and allegories. You have my permission to build on the allegories in this book.

- **Hero's return.** The inner growth that enables you to deal with students, principals and colleagues is the self-confidence that results when you base your actions on ideas that you have carefully examined, rather than personal intuition. Back in the ordinary world, your students are the immediate beneficiaries of your gift. You may also report on what you have accomplished at a professional conference. If enough teachers do, ideal art programs may become ordinary.

Will you accept the challenge to enter the land of adventure and go on a quest?

The stories in my book are a call to adventure—an invitation to escape the ordinary and journey toward the ideal—an invitation to turn away from counterfeit art and journey toward real art. You will want to answer the call and become a hero or a heroine.

Reference

Campbell, Joseph (1973). *The Hero with A Thousand Faces*. Princeton University Press. Princeton, NJ.

Notes on the Stories

These notes contain the autobiographical inspirations for my stories. They are a record of how I tried to teach using some of the prevailing ideas of my time, and how I came to question those ideas. Thus, my notes are a record of my personal quest to become a better art teacher.

Writing about my experiences was difficult, for not every experience was a happy one. That is, I often got in trouble when I based my methods on my taken-for-granted assumptions. Because my assumptions were based on ideas that I had internalized from my culture and my memory of how I was taught, I initially assumed that my troubles were caused by some inadequacy in my students. Reluctantly, I began to admit that my ideas were inadequate.

My notes are an unreliable place for you to search for answers to the questions that I list at the end of each chapter, for your circumstances may not be the same as mine. As I have tried to find my own way in teaching art, I have experienced some personal success. But, I can offer little assurance that my own experiences will transfer directly to different communities, new times, new students, and new art movements. Often my experiences lead to more questions than answers. Still, my reflections may alert you to some possible mistakes, so that you will not repeat them. **What I hope for is that my reflections will serve as a model for your reflections, so that you will make conscious choices about teaching art—choices that will prevent your students from making counterfeit art.**

1. Hero's Journey

When I shared an early draft of Joseph's adventures with my college students, their immediate response was to launch into an intense discussion of, "What is art, really?" Their involvement in the question pleased me for a time, but (as I listened) I began to fear that they were motivated less by a desire for philosophical inquiry than by a desire to defend their own positions. When they turned their questions on me, I feared that, if I could not solve the problem, "What is Art?" my students would feel justified in doing whatever they wanted as teachers.

In case my fear was accurate, I made several changes in the version of Joseph's story printed here. I hope that my changes are sufficient to show that the real reason for the story is not to motivate a search for the ultimate definition of art, but to explore the chasm between art in the real world and art in schools. I am not worried that teachers may have a definition of art different from mine. My real concern is with teachers who seem to divorce their own beliefs about the true nature of art from what is proper art instruction. I often see student teachers who are talented artists; yet they teach lessons that have little to do with their own artwork. Other student teachers seem to mimic the lessons that they had as

students—lessons that seem familiar in schools, but produce results which look quite different from the art outside schools.

My experiences, as I began to teach art, were like those in the story of Joseph.

The call to teach

My mother did not suggested that I should study to become an art teacher. She wanted me to become a surgeon. At least that was what she said after she became ill. I don't know if she thought I might have been qualified for the medical profession. Perhaps she wanted a financially secure profession for me, and doctors made more money than anyone she knew. I never sensed that she involved me in activities that would make me want to be a surgeon. What she did was send me for lessons in tap dancing and piano.

Several years after my mother's death, I received my first invitation to teach. The invitation came during my senior year at Central High School in Tulsa, Oklahoma. The Principal summoned me to his office and told me that one of the art teachers was ill and that I was to take her classes for the day. He assured me that another art teacher was in an adjoining room and would look in to help, if I needed it. I don't recall that the other teacher looked in often. I do recall feeling a strong sense of importance as I helped individual students.

Professor Harry Broad, who first enrolled me at the University of Tulsa, suggested the idea that I should major in art education. Dr. Broad said that, if I majored in art education, teaching would provide a secure future. As it turned out he was the only advisor for art education majors, so I always suspected that he wanted me, a scholarship student, as one of his own advisees. I agreed to his suggestion, but I hope that my response was not motivated solely by a desire for finical security.

Impersonal Art

As it turned out, I began to teach art before I had college classes on how to teach. I started teaching Saturday classes at the Philbrook Art Museum in Tulsa, Oklahoma during my sophomore year at Tulsa University. The offer to teach came after one of my paintings received the first prize in a competition at the Museum held during the spring of my freshman year. To get first prize in a competition with my own professors was a big event in my life. I fear that my professors recovered from my receiving the award faster than I did. I don't recall learning too much in my art classes for the rest of the term.

When I began teaching younger children on Saturday Mornings at Philbrook my lessons were based on the ones that I had experienced as a student. This seemed like a natural thing to do. It was, after all, the only example of art teaching that I knew. Thus, my first curriculum was built on a diversity of mediums and subjects that I had experienced as a student.

My students—except for one five year-old boy who cried each time that his big sister was not with him—responded well to my lessons. That is, they did what I asked them to do. But the art that they produced seemed uninspired and superficial—as though they were not really involved in art. At the time I assumed that deficiencies in their artwork must have meant that the students were inadequate in some way. Now that assumption seems hard to justify, because the

students were volunteers in a museum program—a place where I should have expected to find the most talented students in the city. It is more probable that the deficiency was in my diversified curriculum. For, while the art activities I had experienced in school had contributed to my success in art; they were not the whole of my experience in art. I had overlooked what I had learned at home.

When I was thirteen I began to make pen and ink enlargements of photographs—one was 32 by 40 inches. My favorite photographs were of rodeo events. My rodeo subjects recalled an earlier time in Drumright, Oklahoma when I had my own horse and my father was President of the Roundup Club. I rendered the enlargements in pen and ink trying to apply techniques from a book. I did several of these pen and ink drawings over a period of months. I also copied from how-to-draw books, repeating the drawing until I had memorized them. I chose the books myself. One was on trees, others were on faces, the human figure, and dogs—I still had a dog, although the horse was sold when we moved to Tulsa.

I often reworked ideas in successive printings. For example, after one of my teachers required me to compose figures inside geometric shapes, I did several similar compositions on my own. During my senior year of high school I did an oil painting of wrestlers neatly compressed into a rectangle the size of the canvas. I worked at my dresser using myself as a model for both figures. Wrestling was important to me then, because I had not yet suffered a disappointing defeat in the first round of an intramural tournament. The painting, however, won a purchase award offered by the Carnage Institute as part of the Scholastic Art Competition.

I had also reworked the painting that won a purchase award during my freshman year of college. It was based on paintings that I had done over the past year and a half. The first was a watercolor that I did during the Mid-Western Art Camp for high school students at the University of Kansas. My watercolor was of one wall of the theater building. That wall had no windows and its aging stucco was interrupted only by a haunting steel fire escape. I recall wanting to put on heavier color while my painting teacher advised me to paint in tints so that the color would look right when I got out of the sun. Although I was drawn to the subject I never liked the color. It looked too thin to be a real wall. My second version of the painting was in tempera. The opacity of the medium helped make the wall solid, but my paper was too small to convey the scope of the wall. The final version in oil was as wide as my dresser that I was using as an easel.

My memories of my independent art experiences contrast sharply with my early experiences in school. My elementary school memories include a soap carving of a dog, a weaving of string and raffia that I sewed into a purse for my mother, a tooled copper relief, and tempera painted designs. My junior high school experiences included making a color wheel, enlarging a comic strip with a 6-B pencil, perspective drawings of boxes, and a monochromatic painting of a landscape. My first year of high school introduced me to pastels, charcoal, collage, and still life painting. The usual still life contained an assortment of kitchen utensils and liquor bottles. Thus, my school curriculum consisted of a wide range of materials and assigned subjects with few opportunities to rework ideas. In addition, my teachers discouraged copying.

While my early school experiences had consisted of learning about different mediums, my personal experience led me to work with a single medium over an extended period of time. Thus, the quality of my school art was tentative

compared to the confidence I portrayed in my independent artwork. While school art moved me from one subject to another, my own experience was more likely to include practice on the same subject and reworking ideas. I could see improvement in my independent work, while at school I sensed only change. Moreover, school art narrowed my choices of subjects so that I seldom worked with the subjects that were personally meaningful.

While school taught me valuable skills, the exercises that taught me those skills were not real art. School art lacked reality for me, because it was not as meaningful as my own art. I also suspect that continually switching mediums and subjects tended to make my school art look amateurish in comparison with my personal work that evolved over a period of time. Still, as I began to teach, I repeated the examples of my schoolteachers. I assigned subjects and often changed mediums. When my students did work that seemed uninspired and unsophisticated I did not know why. Now I know that I had been asking the wrong question about how to teach art. **I had been asking, "How was I taught?" I should have asked the larger question, "How did I learn to be an artist?"**

Untrue Art

When I student taught in a junior high school I enjoyed working with individuals and small groups, but I had a problem with the first lesson that I taught to the whole class. My lesson was on color theory. I lectured on primary, secondary and tertiary colors. I drew diagrams of complementariness and split-complementariness. I was completely confident; because I had heard the same lecture in junior high school, high school, and college. But the students asked questions that seemed to test my authority as a new teacher. "Why are there only three primaries, while there are eight colors in our watercolor boxes?" "Why is yellow and violet a better harmony than yellow and blue?" "Why aren't white and black on the color wheel?" As the class was about to get out of control, I asserted my authority and gave them a test over my lecture. The students understood the threat of a grade and quietly took the test that I dictated to them. When I looked at the papers, my suspicion that they were not listening to me was confirmed. I did not want to grade the papers, but my cooperating teacher, John Berland, said that I must. The students meekly accepted their grades and they listened as I gave them the proper answers. I had based my lecture on the color theory that I knew. It was years later that I learned of alternative color theories—theories that would have helped me deal with the student's questions.

Because I did not know of alternative color theories, I believed that I was teaching truth. Thus, I confused truth with theory. I did not know that soon after Ives published the red-yellow-blue theory for pigments, he published a magenta-yellow-cyan theory for dyes. I did not know that the primary colors of light that we see on television are red-blue-green. Despite the fact that I had not even seen color television, I should have remembered about red-blue-green theory from a stagecraft class that I had in college.

Gambling on Art

I have often observed coil pot lessons that were intended to introduce students to the art of Native Americans. These lessons typically had students

working with coils the size of their finger, dampening surface of the coils and working them together with a wooden tool. I became suspicious of these lessons when I saw a Navajo potter demonstrate how he worked. He used very soft coils the thickness of his arm and worked new coils into old coils with his hands, while pressing the coils to the desired thickness for his pot. As the pot gained height, he sat it in a bowl so that it would not collapse. The next day, after the clay was leather hard, he cradled the pot in his arm and turned the pot as he burnished the surface with a wooden tool. His finished pot was surprisingly symmetrical. As I compared the Navajo potter's techniques to the typical methods taught in school, I feared that art teachers risk conveying inaccurate cultural ideas.

I had long observed that my best art students seemed to exude self-confidence. But it was one of my graduate students who reminded me that self-confidence is more likely to result from hard work and achievement than from permissiveness and praise. My graduate student introduced his class of developmentally challenged students to computer graphics with a series of skill building lessons. Before he started the computer unit and after he finished the unit, the resource room teacher administered a personality test to the students. Statistical analysis showed that the students' self-confidence improved significantly.

Recently I visited an exhibition documenting students' writings that had been inspired by their use of a camera. As I compared the photographs to the writings, it seemed that students had made snapshots to remind them of how things looked, so they could better describe them in their writing. It reminded me of something I had once read: Vacationers take photographs to remind themselves of things they have seen, while photographers strive to describe things for people who have not seen them. I feared that this multidisciplinary unit had reduced the art of photography to the vacationer's technique of point-and-shoot.

Thus, while I often observed art students who were self-confident, tolerant of different cultures, and academically gifted; I could not be certain that art was the cause. I also fear that focusing on supporting academics, cultural goals and self-development may distract students from really making art.

Corrupted Portfolio

While visiting my father's farm I discovered where he had stored my high school portfolio—the one that had earned me a full tuition scholarship. I looked at the paintings and saw them as weakly inspired by social realism—a movement that was now clearly out of style and of no current interest to me. There was also a newspaper photograph of my painting of wrestlers—the one that had won a purchase award. As I looked at the photograph I realized that something was wrong. The two wrestlers had three left hands—a mistake I had made as I posed in front of my mirror.

Looking at what I had done as a student made me less sure of my own judgments of student work. I knew what I liked, but was that what my students should like now? I felt unqualified to look into the personalities of students and tell them how they ought to work. In addition, I was aware that new styles of art were becoming fashionable in New York and I wondered at the lasting value of my judgments. Could what I rejected become stylish in the future?

Creativity as a Goal

As a graduate student at Penn State I watched Dr. Robert Burkhart and two graduate students, Gloria Bernheim and Earl Nitschke sorting through huge piles of student artworks, trying to identify qualities that indicated student's creative processes. As I watched, I began to contribute ideas and the next term I was assigned to work with them. The four of us worked in a dimly lit observation room under the leadership of **Kenneth Beittel** (1964). Thus, I participated in the Self-reflective Studies that identified the spontaneous and divergent processes of creativity and a third academic strategy. **Spontaneous** students started their drawings with a light overall structure and flexibly made changes as they added details. **Divergent** students started with a detail and flexibly discovered a structure. **Academic** students followed a predictable plan, making few changes. Gloria reported our findings at The National Art Education Convention that year in St. Louis.

These creative strategies became the criteria for an experiment that measured the effects of two different variables;
- Self-reflection augmented by a teacher vs. independent self-reflection
- Teacher assigned criteria vs. student defined criteria.

The students in the experiment were divided into four groups and each group received a different combination of the instructional variables. All students worked from the same still life and I photographed the students' drawings while they worked. These photographs were the stimulus for students' reflections on their working process.

While the experiment was in progress Gloria, Earl and I resolved to use one combination of the experimental variables with a class of college students during the studio portion of their appreciation class. The variables we chose were the ones that we believed that most art teachers used. That is, the teachers assigned the criteria and then encouraged the students to work independently. So we made the assignment, told the students the qualities that they were to work for in their paintings, and encouraged them to work independently. We responded to students' questions with encouragement to find their own way to do things, for that is what artists do. The students, however, did not respond favorable to this treatment. Somehow, they believed that three teachers in the room should contribute more than encouragement. They simmered near the point of revolt, yet we remained committed to our approach. In the end, the work that our students did fell far short of the criteria that we had assigned.

The findings of the self-reflective experiment confirmed our experience with our studio appreciation class. Students working with assigned criteria and reflecting alone had the least creative growth. **The best combination was student defined criteria and self-reflection guided by a teacher.**

After Penn State I went to the University of Tulsa to teach sculpture where I attempted to use ideas from Penn State. My life modeling class was small and the subject was constant so it was easy to apply the notions from the Self-Reflective Experiment. In this class I was able to talk with students individually, ask them to reflect on their work and to formulate their individual goals. They became very involved and their work became individualized. In a similar way I

worked with the Sculpture class, here I had some graduates as well as undergraduates. In both classes I worked on my own sculpture, along with my students. Thus I had no way of knowing whether my students' success resulted from my creative teaching techniques or from my own example of being an artist.

In a large three-dimensional design class, where students did not see me doing my own artwork, I tried to instruct students in the spontaneous and divergent strategies of creativity. My students, however, could not apply these ideas to my assignments because my assignments emphasized using specified processes to reach predetermined ends. When I realized that I was teaching them to be academic, I hoped that there was still a place for the tradition of the academy in art. I reasoned that **not all of artistic achievement is explained by creativity. Artistic skill also contributes to aesthetic quality.**

Praising Process

While I began to teach at Buffalo State College I returned to my interest in psychological approaches to art. I used **Guilford's** (1971) **Structure of the Intellect** as a way to deal with the artistic process. I identified art reproductions that were similar to Guilford's definition of the kind of thinking in each cell of his Structure of the Intellect, and I verbally defined the kind of artistic thinking that seemed appropriate for each cell. Thus I created a map of 48 different kinds of artistic thinking and I made slides of artworks that seemed to illustrate each kind of artistic thinking. I presented my findings at a symposium at the University of Illinois at Urbana.

The next fall I used the Guilford paradigm to structure a class that I taught to Canadian art teachers in Burlington, Ontario. I showed them the same slides that I had presented in Illinois and asked them to agree to define the problems that they would undertake in terms of the thinking skills within the Guilford structure. They agreed. So, each new assignment included a review of one domain of the Guilford paradigm and gave students the choice of working with several kinds of thinking in that domain. The variety of work my students produced was astonishing. It seemed that the structure helped students identify ideas for their work. The actual quality of the work, however, was disappointing. Only those students who had done good work the previous term seemed to have the technical skill and the internalized standards to take good ideas to a fulfilling conclusion. That is, several students had good ideas that were crudely executed. Perhaps if I saw the work again today—in the knowledge of the Neo-Expressionism—their work might seem less disagreeable or even stylish. At any rate I feared that in working for diversity of ideas I had sacrificed excellence for the students who were less mature in their own work.

When I next taught studio in Buffalo, I did not teach in such a structured way. Rather than teaching a succession of skills, I hoped to help students develop their own ideas. When I looked at their initial efforts I was able to point out that virtually anything they might do approximated one section of the Guilford Structure. Thus I affirmed the value of their approach and its potential for creativity. The students responded well to this treatment on a personal level. They liked me, because I saw value in their work. But their art was still disappointing. True, everyone did something different, so their work seemed personal; but these qualities seemed insufficient to make their art real.

About that time I attended a creativity conference and heard **Edward deBono** lecture on his theories about "**lateral thinking**." He had the idea that too many people behave as though they are searching for buried treasure by digging holes. They keep digging their holes deeper and deeper, even though they find nothing. What they ought to do is dig in new places. That is, they should think laterally. It seemed to me that my students had been digging themselves into aesthetic holes with their artwork. So I purchased deBono's book (1974), hoping to find ideas that would help me teach students where to dig.

I was delighted to find that one section of his book dealt with making art. But when I read that section, deBono's ideas were discomforting. He argued that many artists today confuse art process with solutions to art problems. They execute different techniques, rather than working to solve artistic problems. Their artwork looks complex and confusing, because it is not a real solution to a problem. Solutions have clarity and simplicity. **If deBono was right, it meant that my students did unsatisfying work because I had been teaching methods, rather than focusing on problems or goals.**

Beittel, K. R. (1964). *Effect of Self-Reflective Training in art on Capacity for Creative Action*: US Office of Education Cooperative Research Project No. 1870. Washington, DC: Office of Education, U. S. Department of Health, Education, and Welfare.
DeBono, Edward, (1974). *The use of lateral thinking*, Penguin Books Ltd, Harmondswworth, Middlesex, England.
Guilford, J. P. (1971). *The analysis of the intellect*, Mc Graw-Hill, NY.

2. The Apprentice

Vanity's story is set in Siena, Italy where I was, for a year, Co-Director of Buffalo State's Semester in Siena Program. While I was there I observed teachers acting like masters in a way that contrasted sharply with my notions of teaching for creativity.

At the Art Institute in Siena I observed a ceramics class where the instructor was like a master who had full responsibility for the pottery that the students produced. I watched as the instructor went from student to student and worked on their pots. If students could not do the work to his standards, he did it for them.

In the sculpture studio I saw a teacher criticize a student's work as, "not the way the professor would have done it." Later I asked the teacher how students would learn to do their own work if he insisted that students work his way. He replied that students came to his classes to learn to work as he worked—if students wanted to do their own work they could do it at home. This display of authority was a surprise to my notions of instruction designed to foster creativity. Yet, **I reasoned that masters training apprentices had produced great artists for a long time in Italy.**

My First Apprenticeship

I was first apprenticed to my mother. She had mastered the art of embroider and I wanted to learn. She taught me backstitches, chain stitches and French knots; but what I wanted most to learn was the satin stitch. Mother, however, insisted that I first improve my other stitches. I remember my futile efforts to try the satin stitch on my own.

I often sat and watched my mother embroider. One of her projects, that I was especially interested in, was to become a quilt for my bed. She did the individual blocks with airplanes in patchwork with embroidered details. Then she surprised me by taking the blocks to ladies of the church who assembled the blocks into the quilt face. Next they stretched the quilt face along with filler and backing over a large frame. Finally the church ladies laid the frame over the back of the pews and quilted intricate designs. Thus, I became aware that artmaking could be a group activity where assistants supported the work of the designer.

In college I was able to observe only one of my professors actually working. My sculpture professor, **Duayne Hatchett**, had not yet built his own studio, so he worked on his sculpture at college. At that time he was using a welding torch to fabricate small abstract figures. I observed in his work habits the same concern for craftsmanship that I had seen at my mother's side. When he needed parts for his sculpture that he did not have the tools to fabricate, he had the parts made at a local firm. Occasionally I felt that I was participating in his sculpting, as he asked me what I thought about different possibilities for some of his pieces. Once he even used my suggestion. But when I tried to brag about his use of my idea, he pointed out that he had not used the idea because I had suggested it, but because it was the right thing to do—moreover, he would have eventually come to that idea himself.

The riddle that Vanity had to solve has its parallels in the development of my artistic thinking.

Mixing Artmaking with Passion

While in college I used the promise of portraits to lure girls to my apartment. Although the girls seemed pleased to take their portraits home, none of the girls gave me more than a kiss in appreciation. I have since wondered whether they had seen something in me, as I painted, that made me seem less attractive. Could it have been that I was more interested in the painting then in them? Freud may have accurately identified my motives for doing those portraits. (I have heard others quote him as saying that artists paint in order to secure the love of women.) But identifying the motivation leaves a lot of the artistic process unexplained.

Drugs as a Stimulus for Artist Thinking

While I was renting a studio from a local artist—and before I was 21—I began to try to combine drinking and painting. The combination intrigued me, as I learned of the high-spirited parties in the other studios. My attempts at mixing paint with alcohol, however, were not successful, for I could not escape the pangs of guilt that came with my heritage that included a grandmother who was a

member of the Women's Christian Temperance Union. Moreover, when I stopped painting and started to drink, I never seemed to get back to work.

After I had taught for several years I was offered a joint of marijuana. The offer came while I was visiting a young couple in their loft in New York City. I declined their offer, but watched with interest, as they smoked several joints. After they extinguished their last joint they invited me into their studio to see their paintings. They turned on their special museum quality lights and proudly showed me their newest work. With each new painting they marveled at optical effects that I could not see. Although they saw vibrant colors, I saw only muted grays. I concluded that only those who smoked marijuana could properly appreciate their artwork. And I resolved to let others paint for that audience.

Becoming Aware of My Artistic Thinking

I had experienced developing an idea over time, as I reworked old ideas in new paintings. But, it was not until my senior year that I recall being able to fully think through an artwork before I started it. I had made a sketch the previous summer of sunbathers that I wanted to translate into a silkscreen print. As I walked to the campus on a Saturday morning I envisioned rendering my sketch as a line drawing to be printed first on brown paper, and then overprinting with a series of translucent pinks and oranges. What I hoped to achieve was a vision of the tanned bathers, and vivid swimsuits sparkling in the summer sun. I executed the print exactly as I had planned it. But I made one mistake: I should have made twice as many prints, for it sold better than any of my previous prints.

Judging When My Artwork was Finished

As an elementary student I was dependent on the judgments of my teachers to tell me when a printing was finished. When I began to work at home I had to rely on my own resources. Because I seldom reworked areas of my early paintings, I suspect that deciding whether the painting was finished was as simple as seeing whether all of the canvas board was covered.

Unlike Vanity, I had several teachers who suggested that the way to determine when a painting is finished is by comparing it with other artworks. While I was in junior high school I attended Saturday morning classes at Phillbrook Art Museum. My Painting teacher there, **Rexford Garey**, first compared my artwork to that of a professional. He took me to a painting by Feininger and challenged me to make my paint more like his. My high school teacher, **Gibson Bird,** regularly looked at my painting, and then went to the bookshelf and returned with a reproduction that illustrated a quality that he hoped that I would develop in my painting. Thus, they were judging my work by professional standards—standards that were external to themselves. In college my professor, **Duayne Hatchett**, encouraged me to enter the same regional competitions that he entered. I do not recall him ever saying that I should strive to be better than other artists, I simply wanted to.

But, when I began to teach, I judged student artwork on the basis of what I liked. I, after all, was the expert and I had a record in competitions to prove it. But I became tired of students who continually asked me whether they were finished. I recall a crafts class where it seemed that I could not turn around without two students asking me whether something was finished. I began to long for standards

of finishedness that were outside of myself—standards that students could apply for themselves.

Now I fear that unless art teachers guide students to think about their processes of art making and evaluation, their art experience will be less than genuine.

3. Art Trickery and Magic Witchery

The King and Allure believed in magic. Did I also think that art was magical?

The Magic of Talent

My personal belief in my talent was fueled by scholarships, acceptance in exhibitions and awards. As I began to teach, some of my students did better than others. Was the difference in achievement caused by differences in talent? Talent seemed like an in-born quality that I, or any teacher, had little chance of influencing. If some students did well because of the magic of talent, should I be excused for the poor work of untalented students? Could I claim responsibility for the work of good students, if good work was the result of talent?

While visiting my father's farm I discovered where he stored the paintings that I had done at home while I was in high school. There were two piles of canvas boards. Each pile was over two feet tall. In my mind I compared my level of productivity with the small number of paintings required in high school painting classes. As I looked at my early paintings I saw the simple-minded subjects and the lack of sophistication in the handling of paint that I was concerned about in my seemingly untalented students. They were struggling now with problems that I had struggled with years earlier. **Was talent in art only an indication of how much and how long I had worked?**

The Magic of Tricks

Drawing with a stick dipped in ink was a popular art assignment when I was a student teacher. The activity was popularized by magazine illustrations of student drawings that seemed to have the quality German Expressionism. Because the stick and ink were harder to control than pen and ink, the students' drawings had a predictable crudeness that made them appear expressive. Thus the lesson seemed successful. Now that German Expressionism is less in vogue it is easy to see that the activity was a trick. A trick that forced the students to work crudely, even though they might have wanted neatness, and even though their feelings toward their subjects would have been better expressed by neatness.

It is harder to recognize trickery today, because art lessons often include a component of art history and because the students are likely to do something that resembles an art style that is currently fashionable. But, I recently saw a student teacher's lesson that tricked students into mimicking Impressionism. The student teacher introduced the lesson with several slides and she pointed out that the artists painted with dots of color. Next the student teacher showed the pupils an "impressionistic tree" that she had made. The trunk and branches of the tree were made of twisted black coat hangers. The leaves were squares of yellow, green, and blue construction paper. The assignment was to use yellow, green, and blue

felt tip markers to make a drawing of the tree. Students were to avoid overlapping dots in a way that might mix colors.

All the students produced a mass of colored dots that looked impressionistic, so the student teacher did not understand why I was disappointed in the lesson. I was disappointed because the students had not worked as the Impressionists worked. The Impressionists worked from nature, not manufactured imitations of nature. The Impressionists would have studied the color of real leaves on the topside and the underside of trees. They would have studied the color of a tree trunk to see what different bits of colors are optically mixed to give the illusion of a single color. **I should have told her that her students' artworks looked counterfeit,** but I was afraid of being too confrontational.

My student teacher did not understand my criticism. She argued that the intent of the lesson was to introduce Impressionism and the students had all achieved her criteria of working with colored dots like the impressionists used. She argued that studio activities should not be criticized in a lesson geared toward appreciation. Moreover, she argued, the studio methods had insured that all students succeeded and student success was more likely to give students good associations with Impressionism than failures. I had no immediate answer. My student's magic was too strong for me—so I turned our conversation to another topic.

Now I wish that I had unmasked the trickery involved in the appreciation part of that lesson. The cruel trick was that that those students were taught to believe that making Impressionistic paintings involves nothing more complex than making arbitrary dots with colors supplied by manufacturers. Impressionism was presented as something so simple that anyone can learn to do it in 45 minutes. **It is hard to imagine that teaching students that something is ridiculously easy will result in real appreciation**. In life outside the art room we appreciate those things that are the most difficult. Now I am suspicious of trickery whenever students seem to succeed with minimal effort.

I became aware of another kind of trickery in the pages of *Studies in Art Education.* An article there by **Arthur Efland** (1976) suggests that art teachers control student art for their personal advantage, rather than for the good of the students. Efland argued that even though schools are largely authoritarian and regimented, administrators try to maintain an image that is humanistic and individualized. Student art that is free, happy, individualized, and requiring little skill supports the image favored by administrators. Clever art teachers know how to please their administrators by tricking students into producing those qualities. Large brushes ensure freedom, requirements to clean their brush before dipping it into a new color ensure happy colors, requiring each student to work with a different subject insures individuality, and working with lots of different materials ensures that students have no time to develop skill with any medium. **The irony is that teachers use strict controls to force students to produce propaganda that will show that the school is a free and happy place. In the process, students work in a "School Art Style" that is unique to the schools and has little relationship to art outside the schools.**

Black Magic

I learned about the game of black magic when I attended my older cousin's birthday party. My cousin and her friends sent me out of the room while they selected one object. My problem was to guess which object they had chosen. When I returned my cousin pointed to objects in the room and asked. "Is it the chair, is it the fireplace, is it the plant?" I always guessed wrong. My cousin's friends however always guessed right. They knew that the correct object was always the one after my cousin pointed to a black object. My cousin did not explain the trick to me until several weeks later.

Some adults defend the place of art in schools as though art is magical. They ascribe magical powers to the learning of art—that is, they make claims for art that are beyond the realm of art and difficult to defend, either by research or by logic. Art, they claim, promotes creativity that readily transfers to other subjects. Art improves social skills such as sharing and respect for other cultures. Art improves students' self-images by promoting self-confidence. Art makes people moral. Art differentiates people from mere animals. Art promotes appreciation for nature. Art improves academic skills such as reading.

While art teachers can point to some of their students that are creative, do well in other subjects, have well-adjusted personalities, have a reverence for nature and do well academically; there is little evidence that taking art classes is the reason.

It is illogical to expect that making torn paper collages or doing contour line drawings of hands will increase verbal scores. Yet some art teachers may teach skills that will transfer to higher verbal abilities. I became aware of this possibility when I looked at sample questions of a standardized verbal examination that my granddaughter brought home from school. The questions that seemed to get the most credit were those that dealt with metaphorical thought and the ability to make interpretations. These, of course, are mental skills that have their equivalents in criticizing art and in getting ideas for making art. Creating visual symbols requires metaphorical thought, and making interpretations of art works requires critics to see meanings beyond the physical qualities of the artist's medium. If my granddaughter's art teacher, or her English teacher, had required sufficient practice in these skills; my granddaughter would have scored higher. There may well be room for meaningful cooperation in teaching such skills. The motivation for making magical claims, however, seems to stem from competition between the disciplines for status within the schools.

The Magic of Faith

Does art come from God? An affirmative answer would emphasize the importance of faith, yet would compromise the position of art in public schools where Church and State must be separated. A negative answer would seem to minimize the importance of the close association of religion with the history of art, yet would make art teachable. That is, if God guides the painter's brush, there is little that art teachers can do to change God's will. Students who are guided by God will do good work, while heathens will not.

While I was a member of a suburban church in Buffalo the pastor asked me to design a new cover for the order of service. As I sat in church wondering what I might do I raised my eyes from the pastor to the cross that was suspended

from the ceiling in the front of the church. It seemed to me to be a special cross—precisely executed in pristine white and gleaming gold leaf. I recalled conversations with members of the church who told me that they also thought the cross was special. Bright lights from either side of altar illuminated the cross. I had often thought that the lights were so bright that they distracted from the pastor at the pulpit. But now I looked at the shadows that they cast and realized that, if I exaggerated those shadows, I could suggest the crosses where the two thieves were crucified beside Christ. I went home and did preliminary sketches based on my memory of the cross, but they were awful—uninteresting, unimaginative, and unaesthetic. So I arranged to photograph the cross on a weekday. Because I did not have a telephoto lens, I was forced to get up close, actually behind the pulpit. From that vantage point I was forced to look up at the cross. I realized that under the cross was a more intimate viewpoint, a viewpoint appropriate for worshipers and a viewpoint that would give members of the congregation a fresh perspective of a familiar symbol. From a graphics viewpoint the perspective was far more dramatic.

Back home I processed the photos and tried to render the cross in pen and ink. Nothing I tried conveyed the preciseness and vibrancy that seemed appropriate for my subject. I discarded my graphics pens and tried my ruling pen, but the result was a mechanical drawing that looked like it belonged in a coloring book. Desperate for a solution, I looked at some early pen and ink reproductions for inspiration. I observed that those crafty draftsmen often used crosshatching that was vibrant because it produced a moiré pattern. I knew about moiré patterns in optical art, but I was surprised to find them in traditional pen and ink drawings. I took my ruling pen and straight edge and played with the angles in my crosshatching until I could dependably produce moiré patterns. Because I could now work with vibrant tones I did not need to enclose my drawing of the cross in lines that would make it like a coloring book rendering. After two weeks of struggling and false starts, I completed the final drawing in two hours. The new viewpoint and vibrant tones came together at last. My drawing appeared on the order of service for several years. If God is responsible for quality in art, and I have no personal responsibility, why do I make so many mistakes? Is it that I am not Godly enough?

As I have reflected on my own experience, **I conclude that the proper question is not whether God is responsible for quality in art, but whether artists work as though God is watching.** My notion is similar to that of the **Shakers** who inspired their Brethren to make rockers as though Angels would use them. Those 19th century Shakers (Sprigg & Larkin, 1987) believed that work was a form of worship. Today the shakers are remembered more for their rockers of unadorned beauty than for their religious dances that gave them their name. Whenever I set in a Shaker rocker I experience a sense of rightness in its design and craftsmanship. I also feel enthroned, as though I were an Angel.

Efland, A. D. (1976). The school art style: a functional analysis, *Studies in Art Education*, vol.17 no. 2, 37-44.
Sprigg, June & Larkin, David. (1987). *Shaker—Life, Work, and Art.* New york: Workman Publishing

4. Art and Alienation

A full appreciation of my story, "Art and Alienation," requires a familiarity with some ideas from our literature. The following is a list of the literary inspiration for each of the characters:
- Students of Philosophy will recognize **Carl** the **Crow** as a reincarnation, not only of Michael's brother, but also of **Karl Marx** (1904). Marx formulated his ideas in a political context, but philosophers have since applied his ideas to different contexts.
- **Mach's** views, though typical advice for new teachers, bears a striking similarity to **Niccolo Machiavelli's** (1962) ethical system. Writing during the Renaissance, Machiavelli was a student of how rulers were able to gain and retain power. Retention of power, according to Machiavelli, was the moral responsibility of rulers and justified any means. Politicians who are caught following his principles today are described as Machiavellian.
- One of Niccolo Machiavelli's books was entitled *The Prince*. Machiavelli's advice was directed to the prince. Thus, **Mrs. Prince** is the recipient of Machiavellian advice.
- **C. J.** is based on Brent Wilson's (1974) case study of **J. C. Holtz** who did artwork based on comics. He did not simply copy comics; he adapted familiar images to fit new situations. Wilson made the point that. J. C.'s natural art work was very different from school art.
- **Yoni** is based on *Wang Yani: Pictures by a young Chinese girl.* (Yang, 1987) **Yani** was a prodigy. Working in her father's studio she achieved amazing sophistication in her paintings and had exhibitions of her work by the age of five.
- **Nodia** is based on Lorna Selfe's (1977) *Nadia a case study of extraordinary drawing ability of an autistic child.* Nadia's favorite subject was horses. She rendered them with free and energetic contour lines.
- **Michael** is inspired by a **composite of 25 accomplished sculptors** studied by Kathryn D. Sloan and Lauren A. Sosniak (1985). Their report is included in Benjamin S. Bloom's *Developing talent in young people*. Several of the sculptors had difficulties at school that required parental intervention.

How are my experiences similar to those of the students in my story?

Personal Alienation

The summer after I finished the third grade my family moved from Drumright, Oklahoma to Tulsa. My new home separated me from my old friends and I had to leave my horse behind. Our new house was some distance from other houses—it was on land owned by the Texas Oil Company that included warehouses and was next to a railway. I literally lived on the wrong side of the tracks.

In Tulsa I attended Whittier Elementary where the social hierarchy of my class was already established. I was an outsider. When I tried to challenge what I thought was an unfair application of the rules during a game of softball, the class bully took it as a personal challenge and chased me from the playground. Our

classroom teacher heard of the incident and held what amounted to a kangaroo court where all the students in the class sided with the bully.

My mother tried to help by inviting my whole class to my birthday party. Much of the Texas Company property where we lived was maintained like a park, so it seemed a perfect place for a party. Toward the end of the party I showed my classmates a place that was special to me. It was a pond where my dad had helped me construct a small boat house and raft. The raft was constructed from two wooden barrels connected by a platform. It enabled me to pole across the pond and catch crawdads with a piece of bacon tied to a string. It was a place where I could imagine that I was the ruler of my own universe.

It was a mistake to have shared something so personal; within a week I discovered that someone had destroyed my raft. Because of my own experience, I am sympathetic to students who may feel alienated at school.

Fortunately I did not feel alienated in my art class. My art teacher, Ms. Nickels, even chose me to wash the brushes at the conclusion of a painting lesson. Now I often hear art teachers say that their art room is a place where students can find shelter.

Alienation in Schools

Is it just me, or do others feel a sense of alienation? When I visit with teachers in school lunchrooms I often hear them complain of conditions that are likely to alienate students: busses that separate students from their own neighborhoods, students who are separated from their own families because of divorce, TV and computers that replace activities with friends, public address systems that replace student assemblies and pep rallies, cafeterias where noise level is deafening, and rules so oppressive that they even limit student access to toilets. These complaints seemed to describe, not only, the conditions in the inner city; but also, the conditions that my sons experienced in their suburban schools.

Some art teachers that I visit also seem alienated. Several elementary art teachers eat their lunch in their art rooms and feel that they have little in common with the other teachers in their schools. Over the door of a high school teacher's supply room is a sign that reads, "**The best three things about teaching are June, July and August**." Teachers complain about unending wage disputes between their unions and the administration, principals that interrupt their lessons with PA announcements that seem to do more for the principals ego than to promote learning, the need to discipline students who have not learned discipline at home, monitoring study halls, buss duty, collecting money, painting signs and a **hundred other things that distract them from their real role as art teachers.**

The notion that schools might not be a happy place was suggested by **Arthur Efland's** (1976) article, "The School Art Style." **Efland argued that next to prisons and the army, schools are the most oppressive institution in our society.** At the end of the article Efland laments that after years of trying to change art in schools we should have worked to change the schools.

Alternatives to Alienation

As I have visited schools here and abroad I have seen some examples of what schools might become, or even go back to. In England I saw that all the students in the primary school had recess at the same time. One teacher went outdoors with the students; the other teachers went to tea—not a hurried 10-minute break. When I expressed concern for the students' safety, I was told that when there are not so many adults to watch over them, children learn to look out for themselves; moreover, the exercise was good for them. I remember that in my elementary school in Drumright, Oklahoma all the students went to the playground for recess. I don't recall any injuries. Teatime, I discovered, was also a time for the headmaster to contact teachers—there was no PA system and there were no telephones in the classrooms.

When I went to lunch with the teachers in England I discovered that they ate in the same room with their students. Teachers sat at tables with students from different grades. The students from each grade had a different responsibility: some went for bowls of food that were served family style, some returned dishes at the end of the meal. The oldest students were responsible for demonstrating good manners for the younger students. **Manners were an important part of the school curriculum.** One principal complained about teachers from America who ate with his students and held their forks in the wrong hand. (I knew that he was talking about me, but I had thought that I was a cultural resource showing how we ate in America.)

After I returned from England I heard reports of health benefits of drinking tea. But I suspect that the benefits may come as much from the respite and the collegiality that come with teatime. American teachers, of course, have their respites from students. Their respites are called planning time. **In one high school that I visit, the principal transformed planning time into an opportunity for collegiality by assigning all the art teachers the same planning period.** The teachers loved it and they discovered that their planning time tended to focus more on what was good for the whole school art curriculum.

Efland, A. D. (1976). The school art style: a functional analysis, *Studies in Art Education*, vol.17 no. 2, 37-44.

Marx, Karl. (1904). A contribution to the critique of political economy. (N. I. Stone,Trans.) Chicago: Charles H. Kerr & Co.

Machiavelli, Niccolo (1962) The Prince in W. T. Jones, *Approaches to Ethics*. Mc Graw-Hill Book Co. New York. 16-167

Selfe, Lorna (1977) *Nadia a case study of extraordinary drawing ability of an autistic child.* Academic Press, New York

Sloan, Kathryn D. and Sosniak, Lauren A.. (1985) 25 accomplished sculptors in Benjamin S. Bloom's *Developing talent in young people.* Ballantine Books, New York.

Wang Yani (1987) Wang Yani: *Pictures by a young Chinese girl*, Prestel Munich.

Wilson, Brent. (1974)The superheroes of J. C. Holz: plus an outline of a theory of child art. *Art Education*, November 2-7

5. The English of Art

My step daughter, Risa, went to a new open plan school that boasted an innovative curriculum. But Risa's Mother, Dianne, became concerned when Risa did not bring papers home. Dianne insisted that she must see the papers and eventually Risa complied. When Dianne saw the papers she knew why Risa had not wanted to bring them home and she knew that the school's writing program was not working for her daughter. So she requested a meeting with Risa's teacher and the principal.

When Dianne got to the meeting, she found that the social studies teacher and math teacher were also there, for the school used team teaching. Dianne was seated on one side of a large table with the four professionals on the other side. She suspected that the seating arrangement was designed to intimidate her. Rather than being intimidated, she became more determined. Dianne began by showing Risa's papers to the teachers. She used the papers to document what seemed to be the schools failure to help her daughter learn to write. The teachers responded by questioning Dianne's motives, "You seem to believe that we don't care about your daughter."

Dianne responded, "I know the teachers in this building care. I see your cars here early in the morning and late in the evening. But, you don't care about what I care about. You want my daughter to enjoy freedom now, so that she will learn to be creative. I want my daughter to develop the skills now, so that as an adult she will have the freedom and the ability to write a coherent letter to her senator. You are depriving her of that freedom."

Soon after that meeting, a member of the City Council, who lived on Dianne's street, told her, "I heard about your meeting with the school."

"You did." Dianne responded. "How many people know about the meeting?"

"Lots of people know," And I want you to know that you made an impression on the school and things have changed."

I don't believe that Risa has ever written a letter to her senator, but because her elementary teachers changed the way they taught writing, she is now a college graduate and she has the ability to exercise that freedom if she wants.

My story of Earnest was, of course, inspired by Dianne's confrontation with the faculty at Risa's school.

Earnest got into trouble when he substituted in English classes even though he knew a lot about English. Can art teachers who know how to make art also get into trouble?

Necessity for Art Teacher Training

If you can make art, what can go wrong as you try to teach students to make art? That is the question that I forced upon my methods students, and then I challenged them to teach me to stand up from a seated position. I argued that they all knew how to stand up, so they should be able to teach me. Besides, standing up must be easier to learn than learning how to make art.

I sat on a chair in the center of the room and had volunteers try to teach me. As each volunteer tried to instruct me, I did my best to follow their directions.

Although I used the lesson for a number of years, none of my students ever successfully got me into a standing position. Some students failed because of problems with terminology. For example, my response to the directive, "Put your feet firmly on the ground," was to roll out of my chair and crawl along the floor toward the outside of the building so that I could put my feet on the "ground." Some students failed because they relied too much on language when what I needed was examples. Some failed because they tried to teach me a sequence of moves, when what I needed was to be able to do several things simultaneously. Others failed because they moved directly to the final task of standing up before teaching prerequisite skills. I concluded my stand-up lesson with the observation that physical therapists have extensive training to help stroke victims relearn how to stand. **Since making art is a more complex activity than standing up, art teachers are likely to need some training in how to tech art**

Knowing What Students Need to Know

About the same time that I was dealing with whether students who were able to make art could intuitively teach others to make art, the Elementary Education Department of my college was dealing with the same issue in reading. After years of assuming that teachers would be able to teach reading because they knew how to read, the college took a hard look at the reading scores of students and decided that it was time to require teacher candidates to take a course in how to teach reading. I became aware of how important the new requirement was when my first wife enrolled in the course and brought home her lessons on phonetics. Although, as a first-grader, I might have learned the phonetic rules to help sound out words, I had long ago forgotten them and, instead, used a more intuitive approach. If I wanted to teach reading I would have to relearn things that I had learned so long ago that I had forgotten them.

This realization of the importance of forgotten learning led me to tell my method students that the things that their students most needed to learn were probably things that they had learned so long ago that they had forgotten them. I reinforced the idea with the observation that one year after taking a college course; students are likely to recall only ten percent of the course content.

I feared what would happen, if student teachers presented lessons based on the ten percent they might recall, so I began to require them to show me the books they had used to refresh their memories as they planned their lessons. I also asked student teachers to do the lesson themselves; but not to prove that they could, or to have an example to show their students. I wanted student teachers to do the lessons, so that they could reflect on how they worked and to identify what students would need to know.

6. A Dickens of a Christmas Carol

Ebbs full name, Ebenezer, was, of course, the first name of Scrooge who was haunted by the ghosts of Christmas. Just as Ebb, resisted the idea of adding

history, criticism and aesthetics to studio, I also found the idea difficult to embrace.

The idea that art curricula should be based on the four disciplines of studio, art history, criticism and aesthetics was first proposed by **Manuel Barkan** (1966), in a symposium at Penn State, The Symposium was held while I was at Penn State, but I did not attend, as there was limited space for students. I did receive a copy of *the Red Book* that published the papers from that symposium. As a student, I had no idea of the importance of Barkan's paper. I cannot recall even reading it before the book *Beyond Creating* (Getty, 1985) popularized his ideas. If I had read Barkan's paper, I would have been amazed; for at that time studio activities completely dominated school art. Moreover, the dominant theories of art education emphasized creativity rather than the serious discipline that Barkan favored. I now realize that I should have been impressed with Barkan's ideas, for his ideas were closer to the way I had learned about art in college.

How had I experienced Barkan's four disciplines in college?

In college I was fortunate to have one professor who dealt with all those disciplines in his sculpture classes. My sculpture professor, **Duayne Hatchett**, kept an alphabetized file on sculptors. The file was composed of photographs and articles from magazines. He subscribed to several art journals and friends brought him articles from popular magazines. He placed the reproduction on the front of 8½ x 11 cards and the articles on the back. He typically used 10 or 12 reproductions to introduce each lesson. In an advanced class he required me to purchase a book on the history on twentieth century sculpture. Duayne did not give formal critiques. Instead, he talked with me individually about my work. For 20 or 30 minutes he considered different possible interpretations of my work and analyzed how qualities in my work added to, or distracted from, each interpretation. And he considered how people with different theoretical viewpoints would tend to judge my work. I don't recall him ever telling me to change a particular thing; instead he helped me to see my work more fully so that I could decide what changes were most appropriate. Because the studios were there hours long we took a break midway through each studio period. Duayne went with us for coffee at the student union where he raised issues that we argued about. He challenged our thinking by quoting from something that he had recently read. The discussions always lasted longer than the ten minutes that was officially scheduled and they seldom resolved the initial question; but we went back to the studio with a heightened awareness of the complexity of the issues.

Art History

While I was in college I traveled with other students to the Illinois Biennial at the University of Illinois where I saw paintings that had paint textures. Before that I had been painting with smooth surfaces—possibly inspired by smooth reproductions in magazines. When I returned home I began to use strong textures. After I had taught for several years I visited museums in Paris where I experienced a new understanding of texture. I became fascinated with a highly polished bronze head by Brancusi. It seemed to me that the ever-changing

reflections in that mirror-like metal surface produced even more interest than any paint could. Moreover, the highly finished form did not hide how the artist worked—a quality valued by critics at the time. On the contrary, it was clear that the artist had worked methodically and long to produce that surface. The experience with Brancusi motivated me to work with refined surfaces in my sculpture. Thus my artwork was influenced by direct contact with art in museums.

Thus, the formative history influences on my art were from museums, not art classrooms. I believe that this is only partially explained by the fact that few of my studio teachers dealt with history. I also believe that history, as it was conveyed by reproductions and slides had little information that would have been useful to me. At a symposium at the University of Illinois I heard **Brent Wilson** report on research that compared children's understanding of art based on studying a reproduction with their understanding based on studying an actual artwork. He found only one difference: **The students who studied the actual artwork had an understanding of how the artwork was formed, while students studying the reproductions did not.** Thus, showing students reproductions may not give students the information that they need for studio activities.

In college my art history class was equipped with 35-millimeter projectors for color slides. There is the potential for slides of paintings to convey information about the texture of a painting, but photographers, schooled in copy photography, persist in using flat lighting that obscures reflections and shadows that might describe the textures of the paint. While slide details could convey process information, slides of the whole artwork provide only a fuzzy reminder, so that students can identify the image when they see it again.

Criticism

My life-drawing instructor, **Alexander Hogue**, had a non-verbal method of criticism. At the end of each pose he quietly collected the drawings that were the best and pinned them to the bulletin board. After class Jim McCormick, a fellow student, and I often discussed the drawings on the bulletin board. Our conversations about the drawings were not centered on how to get our own drawings chosen, for they almost always were. What we sought was insights into what constituted quality so that we could improve as artists. We also went through our portfolios of drawings looking for evidence of progress and signs that we might be developing some individuality, while still following the assignments. I believe that the addition of Jim's viewpoints enriched my evaluations and hastened my development as an artist. After Jim graduated he had a long career teaching at the University of Nevada.

The absence of any formal instruction on how to criticize artworks did not prevent me from accepting an invitation to give a critique for an art society in Oklahoma City. The invitation came shortly after I received an award in a competition held in Oklahoma City. I recall how confident I was the morning of my trip, even after my landlady advised me to be a bit more humble when I approached the art of individuals old enough to be my parents. She was a strong willed individual who had owned a large restaurant, but now ran the boarding house where I lived. I ignored her advice—she might know about cooking, but I knew about art. That evening I criticized one painting severely, even though it

was by an officer of the society. It was, as I saw it, only a cartoon rendered in paint. I rejected the painting as being more appropriate for the Sunday funnies than as fine art. Fine art, I argued, ought to be serious rather than funny. Several years later I saw Red Grooms "Ruckus Manhattan" I liked it, it was funny, and it was in a museum. I had been wrong about humor. I wish I had followed my landlady's advice and been more humble. **Since then I have tried to be more open to innovations. When I critique student work I often point to qualities that are good, even though the qualities are inconsistent with the assignment.**

Aesthetics

I recall little that my teachers did that might be considered intentional training in aesthetics. But I vividly recall admonitions about what kind of art I ought to like. "Watercolor should not include opaque white paint or solid black paint. Informal balance is better than formal balance. Free art is better than tight art. Newer art is better than older art. Anything that is personal is better than a copy. Art should be permanent." Thus my studio teachers were conveying aesthetic standards.

Building on the notion that my teachers had imbedded aesthetic content into their lessons, I gave a paper at a New York State Art Teachers Conference. At the conference I argued that studio projects cannot avoid having imbedded aesthetic values:

- If we teach red-yellow-blue color theory, we teach that other colors are not worth mentioning—even though other cultures may prefer magenta and turquoise.
- If we have one-period-lessons and tell children that art is fun, we teach that art is fast and easy; while long challenging projects teach that art is the result of work and concentration.
- If we change the materials often, so that much of our instructions is about how to work with the new materials; students learn that art is mostly about the craft of working with materials.
- When we select the objects for a still life, we show children that some objects are worthy of art and that other objects are not.
- Even the layout of the studio can have implications for aesthetic values. Is making art a shared process—do students work at tables, or is art an independent process completed in separate desks?

Thus we inevitably convey aesthetic values as we teach studio—something that we have long claimed. **The problem is that, if we are not aware of these values, we may inadvertently teach values of questionable validity.** Moreover, we are unlikely to question these values if they are consistent with our own traditions and culture.

Aesthetic Values and Culture

When I visited The Strong Museum in Rochester, New York, I saw an exhibit that depicted the kinds of art associated with different levels of society. The upper class had original paintings (often in an avant-garde style), homes designed by architects, custom built furnishings, and real antiques. The middle class had reproductions of well-known artworks chosen for their subject matter,

builder homes, and mass-produced furnishings that imitated earlier periods. The lower class had sofa-size paintings purchased at fairs, crafts done by family members, throws to cover worn-out furniture, and rented dwellings. As I studied the exhibit I reflected on the painting that I loved as a child. It was of a waterwheel, painted on velvet, and it was probably purchased at a fair. Our home was rented from the Texas Oil Company where my father worked, and it was painted the same gray color that the Company used on its warehouses. My mother decorated the interior with her needlework. My reflections led me to the conclusion that on an aesthetic basis, at least, my heritage was lower class. The art that I had studied in my history classes, however, was that favored by the upper class. And I was teaching students who were largely from the middle class. **Was I a lower class professor teaching middle class students how to teach upper class art?** "Teaching," I thought, "requires me to overcome lots of cultural boundaries—even without considering race or gender."

For a long time I believed that it was my job to teach students what they ought to like. Just as my teachers had taught me, I wanted them to like the art of the upper class. Clearly original oil paintings were better than traditional needlework. But then the Whitney Museum of American Art had an exhibition of Amish Quilts. The needlework of the Amish women had many of the qualities of the then popular Hard Edge painting. But those Amish ladies had done it first and I liked their colors better. About the same time I discovered traditional Navajo Eye Dazzler Blankets. These blankets produced dazzling optical effects that rivaled contemporary Optical Art paintings. **These experiences led me to question whether I should teach students to favor the art of a particular segment of society.** Was I, in effect, teaching some students that their culture had no value?

Barkan, Manuel, 1966, Curriculum problems in art education. In Edward L. Mattil, *A seminar in art education for research and curriculum development*, [The Red Book] The Pennsylvania State University, University Park, PA. 240-255.
Getty Center (1985) *Beyond Creating: The place for art in America's schools.* Los Angeles: J. Paul Getty Trust.

7. The Art of Discipline and the Discipline of Art

As I reflected on my own experiences as a student teacher, I realized that I was initially pre-occupied with what I would do. My college supervisor had to point out that while I was making a presentation with a projector I stood facing the front of the room and never realized that the students behind me were talking. I have a small voice, so I don't scream well, but I was quick to punish students with a test when they were getting out of control. I learned that students may be doing the best they know how when I demanded that a fourth grader quit crawling around under a table and start picking up paper scraps the way I had told the class to do. When he came out from under the table his hands were full of paper scraps and his leg was in a long plaster cast, so his only way of reaching the floor was to

crawl. Thus I learned, by being negative, why it is better to be positive. I was fortunate that I had someone who promptly pointed out these problems. I did not like it at the time, for it meant that I had to assume responsibility for things that it would have been easier to blame on others.

Every part of the Joan of Art story is taken directly from my experiences with student teachers.
Joan's progression from a self-absorbed do-righter, to a screamer, to a positive-reinforce to a content-teacher is typical for many of my student teachers. True, some student teachers start at different levels, because of previous experience, and some do not progress as far. Still I observed the sequence so often that I began to wonder if everyone had to make the same mistakes before they could progress.

Self-Absorbed Do-Righter

I once had a student teacher assigned to a school in an upscale community not far from Buffalo. Because I had visited the school before I knew that the students were typically well mannered, so I was not prepared for how they responded to my student teacher. She was a mature and dignified individual—old enough to be the mother of the children in the fourth grade class that I was observing. As she started the class, I noted that her formal attire and her polite way of addressing the students should serve her well as a teacher. The children, however, thought differently. I wish I could recall what began to go wrong, but the final few minutes of the period were so astonishing that they have blotted out any recollection of the earlier part of the period. What I recall is that for the last five minutes of the class she stood by the door waiting for the bell. I was pleased that she was there guarding the door, for the class had become so rowdy that I feared students might escape. She stood with her arms crossed while she watched students as they noisily tossed paper airplanes about the room. I don't recall what her lesson was about, but I am certain that it had nothing to do with paper airplanes. She hardly flinched as the first airplane struck her. She seemed not to notice that some boys were beginning to take aim in her direction. I observed that they began to fold the airplanes more like darts, so that they would fly straighter. Increasingly the airplanes found their target. The bombardment might have lasted forever, but the bell finally sounded the "all clear" and the children rushed from the room.

After the children were gone I asked her how she felt while the children threw their planes at her. She replied that she was proud that she had remained calm even though the children had misbehaved. I did not try to understand the social or psychological influences that might have supported her belief that teachers ought to be calm no matter what happens. It was irrelevant that she might recall a favorite teacher who seemed always to be calm. It made no difference that in her drive to avoid being negative, students perceived her as indifferent. I was less than calm as I told her that I would have expected her to respond angrily to student behaviors that were so disgraceful. "Didn't she realize that they were making her look bad in front of me and that she would need a positive evaluation from me if she expected to get a teaching job? Didn't she realize that they were threatening her entry to a profession that she had spent three and a half years

studying for? Fortunately, she was strong enough to deal with my harsh criticism, so that she was able to turn the class around—no small accomplishment after starting badly. (Disciplinarians agree that it is easier to start with tight control and then loosen up.)

Content Centered Discipline

One of my student teachers started out as a **content-centered** teacher. When I visited her ageing brick school building for the first time I was directed to the second story where I found an oversize room with a door at the front and the back. It seemed that two rooms had been connected to make a larger classroom for art. This should have been an advantage, but while I approached, I saw three students run out the front door into the hallway. Before they disappeared into the back door, the art teacher appeared in hot pursuit. The teacher and students completed another circuit before I entered the room. As the teacher tried to present her lesson, the students were inattentive and noisy. Some were rude. The teacher dealt with each instance of bad behavior but was unable to establish any kind of order. I was concerned that the college had assigned a student teacher to work with such an inept art teacher, so I took my student teacher to the faculty room for coffee. Over coffee, I encouraged her to share her feelings about the school, and gave her several opportunities to ask for a new assignment. She was not interested in a new assignment, for she had already planned her first lesson. She invited me to observe it. I accepted the invitation, anticipating that she might need me to guard the back door of the art room.

When I arrived, I met her in the hallway. She said that she was glad that I was there because she was meeting her students in their classroom and then she was taking them outside. The word "*outside*" brought fear to my heart. If their regular teacher could not keep students inside the art room, how could a student teacher keep them under control in the great outdoors? I wondered who would be liable if we lost a student while I was supervising her. But I should not have been concerned.

I walked with my student teacher to an academic classroom. We went inside and while the students were still controlled by their teacher, my student teacher told the students that she had a special activity planned. They would go outside and draw. Because she knew that they wanted as much time to draw as possible, she expected them to follow a few simple procedures. She had everything they needed for their drawings arranged in piles on the counter that stretched between the two doors of the art room. As she led them through the art room, they should take one item from each pile.

When she led them to the art room, she complimented them for their quietness. As they entered the art room, she remedied them of what they should do. She collected all the students outside the art room and led them down the stairs and out the side door. When she reached the fence, she sat the first student down facing a line of Victorian houses across the street from the school and said, "Draw exactly what you see in front of you." Six feet further down the fence she sat the next student down and repeated her instructions. In less than a minute, she had all 24 students seated with their backs to the fence and drawing Victorian houses. As they drew, she worked with them individually and complimented their attention to details on the houses. At the end of the period, she efficiently led the

students back to the art room where they returned their drawing boards, pencils, erasers, and papers to appropriate piles—where they would be ready for her next class. When she had all the students back in their classroom, she told their teacher how responsibly they had behaved and how well they had drawn.

The next time I visited the school the cooperating teacher was presenting a lesson. The students were better behaved, because my student teacher was hovering about the periphery of the room directing wayward students to give their attention to the teacher. It seemed to me that the roles of the student teacher and the art teacher had become reversed. My student teacher was now the dominant force in the art room.

My experience with this student convinced me that student teachers could make a positive difference even in a bad school. I already knew that student teachers could let discipline deteriorate even in good schools. **The most successful student teachers seemed to focus on the content of art, rather than discipline. Really teaching art seemed to make the difference.**

8. Prescription for Teaching Art

Like Florence, I started painting at an early age. The idea of teaching art came later. I liked studio courses better than academic courses, though I made good grades in both. And, like Florence, I trusted my own instincts about teaching more than ideas from books.

Avoiding Theory

I first became suspicious of theories about art education when I tried to use advice from a professional journal that praised the virtues of finger painting. At that time I was teaching children's art class at the Philbrook Art Museum in Tulsa, Oklahoma. (I taught there on Saturday mornings during my sophomore year of college.) In addition to all the psychological benefits that the journal article claimed for finger paint, the illustrations of children's finger paintings looked like the abstract expressionism that was currently in vogue. So I carefully followed the author's directions for the preparation of finger paint. The recipe for finger paint called for liquid starch, which I purchased with money that I might have spent for lunch. (Lunch at that point of my college days was often a cup of chili in a diner. I preferred diners that left catsup and a basket of crackers on the counter. As I ate the chili, I kept adding catsup and crackers. By the time I was full there was only a faint reminder of the chili that I had started with.)

I prepared three colors of finger paint and spooned a bit of each color on the center of a large sheet of paper for each student. As my students started to work, I sensed none of the inhibitions that finger paint was supposed to overcome. Students were soon working with their hands and forearms as well as their fingers. Moreover, they worked with a creative energy that enabled them to finish paintings faster than I could rescue them and place them on newspapers to dry. The students reworked and overworked their paintings until their three colors were merged into muddy browns. When it seemed the end of the period would rescue me from my first experiment with printed advice on teaching, I realized that I had a serious crisis. The two five

gallon buckets of water at the edge of the room—the buckets that had been more than adequate when students only needed to wash their brushes, the buckets that had long substituted for the absence of a sink—those buckets were not adequate for 25 children to cleanse themselves of finger paint that was now up to their armpits. The water in the buckets immediately turned to the consistency of tomato soup. Students who had tried to wash in the buckets now stood dripping slightly diluted paint on the floor. Not knowing what else to do, I sent students up the stairs to the restrooms to wash their hands while I arranged the last of the muddy brown paintings on newspapers to dry.

When the students came down the stairs they looked reasonably clean to send home. But as soon as the children were gone, the Education Director confronted me and demanded that I inspect the boys' bathroom. On the way I observed the paint on the banister where the well-trained children had placed their hands for safety. The quantity of paint on the banister prepared me for the state of the bathroom. Of course I volunteered to clean it and the stairs. I hoped that the girls had been neater in their restroom. Modesty prevented me from finding out.

Thus, I learned that authors who theorize about teaching art might not understand the reality of what goes on in real art rooms—certainly not art rooms without sinks.

Florence avoided theory because she wanted to do her own thing. When I started to teach, I also avoided theory. But is this true of most teachers? Whether teachers use theory or don't use theory may not be the proper question. The question for **Eliot Eisner** is when do teachers use theory? Speaking at a National Art Education Convention, **Eisner observed that, "Most art teachers tend to fly by the seat of their pants until something goes wrong. And then they use theory to suggest alternatives."** Eisner's observation parallels my experience with student teachers. When something does not work my student teachers are anxious for me to remind them of theories they should have remembered from class.

This untimely use of theory is at odds with the medical analogy proposed by Florence's Father. **If art education is to be a discipline like medicine, we need to be able to confidently predict that what we do with students will achieve the desired result. We need to get it right the first time, rather than depending on theory to rescue us after we make mistakes.** Art teachers, it seems are willing to depend on trial and error to an extent that would not be tolerated in the practice of medicine.

Medical Metaphor

For several years at Buffalo State College, we based a requirement for student teachers on a medical metaphor. That is, we required student teachers to complete a diagnostic-prescriptive sequence of instruction. Student teachers first assigned an open-ended lesson as a kind of checkup to determine the extent of pupils' achievement in art. Next student teachers analyzed their pupils' artwork, identified areas where they wanted students to improve and prescribed a series of lessons to bring about that improvement. Finally the student teachers evaluated pupil artworks for criteria that indicated whether their pupils had improved. Under the leadership of **Robert Burkhart** we had every student teacher in the department teaching using the diagnostic-prescriptive model.

Eventually, however, our passion for the medical metaphor subsided. The student teachers' series of lessons took so long that Cooperating Teachers complained that there was no time left for their curriculum. I was also concerned that student teachers' diagnoses of their students' artworks were based on personal preference—preferences that were usually defined by the student teacher's own art style. It was as though physicians might use their own blood pressure and heart rate as a standard of health. Moreover, student teacher attempts to improve student performance were often discouraging, for their approach to instruction was dominated by their intuition and trial and error.

The spirits of "Bret" and "Victor"
The spirits of "Bret" and "Victor" tried to help Florence decide what kind of instruction to prescribe to her students. And I had my own experience with these spirits. But I had the advantage of recalling their last names—Brent Wilson and Victor Lowenfeld.

I first encountered **Victor Lowenfeld** as an undergraduate. His book, *Creative and Mental Growth (1952),* was the text in my methods class. My perception of the book was that after several chapters on the importance of creativity for children, he prescribed exactly what teachers should do in order to support the creative development of children. I was pained that there seemed to be no place for creativity for teachers. Still, the metaphor that seemed to underpin Lowenfeld's book was appealing: Students are like flowers and will develop naturally if their gardener/teachers merely water them. Apparently all I needed to do to be a successful teacher was avoid the temptation of imposing my own preferences on children—the metaphorical equivalent of trying to turn daises into violets. Still I suspected that an adequate gardening metaphor would specify cultivation and fertilizer, as well as water. Lowenfeld published his book while he chaired the department of art education at Penn State University.

The year after Lowenfeld's death I began my graduate work at Penn State. His death was a disappointment, for I had hoped to study with the man who had so dominated theoretical thinking about teaching art. If I had doubts about his theories, perhaps his latest work would resolve my questions.

Early that fall, Penn State hosted a presentation by **Manuel Barken** who had just returned from a sabbatical semester in France where he had photographed amazing examples of children's artwork. As he told us the ages of each of the child artists, it was clear that they were well beyond the expectations of Lowenfeld's developmental stages. Barkan argued that developmental stages define what children do naturally rather than what children can learn to do. He saw the stages as starting points, rather than goals.

Scarcely a week later, I eavesdropped on the methods class for art education majors taught by **George Papas**. I was astonished to realize that they were not using Lowenfeld's text. Instead they were using a list of readings that eventually became an anthology that Papas published, *Concepts in Art and Education* (1970). Curiously, I was required to use Lowenfeld's book with the course that I was teaching as part of my graduate assistantship. My course was for elementary education majors, so I concluded that Penn State believed that Lowenfeld was appropriate for classroom teachers, but art teachers needed something different.

Perhaps it was wise to teach classroom teachers to not impose their untutored art preferences on children, but trained art specialists ought not to withhold their preferences gained through years of instruction.

Several years later I heard **Brent** and **Marjorie Wilson** (1977) report on their work that challenged Lowwnfeld's assumptions. While Lowenfeld identified the "two eyed profile" as part of a natural developmental sequence, the Wilson's noted that the "two eyed profile" had disappeared from children's artwork when magazine illustrations that featured profiles were replaced by photographs. The Wilson's argued that children are naturally influenced by the images that surround them. Thus, teachers ought to provide good examples for students to emulate. Like **B.F. Skinner,** they believed that children learn by imitation, practice, and rewards. Brent Wilson was Chairman of the Art Education Department at Penn State when he and his wife first challenged Lowenfeld's theories. While I was moved by the Wilson's arguments, I wondered at so much opposition to Lowenfeld in the department that he had built.

So who is right, Lowenfeld or the Wilsons?

How could I decide? I did not trust my own preference, for my preferences seem to change. Moreover, a decision based on preference would be difficult to justify. I was tempted to use what seemed to be the newest theory, for it would have the advantage of not repeating the shortcoming's of the past theories. Moreover, my college tended to reward professors who required students to read newer references. Newness, however, was difficult to judge. For example, Wilson's writings advocating learning by copying appeared after Lowenfeld's publications discouraged copying. But learning by copying was also advocated by **Walter Smith** (1873) a century earlier. So, which idea is the new idea?

The conflict between theories of freedom and theories of copying are dramatized in my story about Florence. There on the side of copying are the vice principal **B. F**. (Skinner), the noted behaviorist; and **Brent** (Wilson), the spirit who placed the first note on the blackboard. Advocates for freedom were **Victor** (Lowenfeld), the crusader against coloring books, and the art supervisor, **Sigmund** (Freud), father of psychotherapy.

The medical analogy in my story suggested a way to avoid deciding whether freedom is better than copying. For Florence the final medical question was not which medicine is best, but which medicine is best for which ills? Thus, **exactly what kind of art learning does each theory claim to facilitate?** Teachers wanting to facilitate real artmaking will strive to match their instructional methods to their aesthetic goals.

Lowenfeld, V. (1952). *Creative and mental growth (revised ed.),* New York: Macmillan. 1-25.

Papas, George (1970). Concepts in Art and Education. London: Macmillan Company.

Smith, Walter. (1873), *Teachers Manual of Free Hand Drawing and Designing*. Boston: Charles Osgood and Co.

Wilson, B. & Wilson, M. (1977). An iconoclastic view of the imagery sources in the drawings of young children. *Art Education*. Jan. 5-11.

9. Popular Art Teacher Fired by Board

Sock is a reincarnation of the Greek Philosopher, Diogenes. A literal translation of *"Diogenes"* is *"Dog"*—the name that Sock no longer used. Sock's style of challenging authorities was inspired by records of the dialogues of Diogenes (1969).

Do contemporary art teachers dealt with administrators more successfully than Sock?

Irritating administrators

While I was a student teacher the art supervisor announced a meeting to be held at the Botanical Center. This seemed like an unlikely place to study art or teaching, but my cooperating teacher, John Berland, expected me to attend. Sitting in the back of the room we heard a lady speak on the virtues of a Japanese principle of arranging flowers that utilized three flowers of three different heights. Had I heard the lecture today, in the context of concerns for multiculturalism, and after my marriage to a lady who used to be a florist; I would likely have been more respectful. But at that time I had little interest in anything other than the newest fine art. As an outlet for my frustration with a lecture that I perceived as totally irrelevant to the needs of art teachers, I quietly tore up my napkin, used the pieces to sculpt three flowers, and planted the flowers in an ash tray; being careful to follow the principles that the lecturer advocated. When John saw what I had done he could hardly contain his impulse to laugh out loud. He took my arrangement and showed it to the teacher next to him and they both chuckled. I reached to reclaim my arrangement, but I was too late. The teachers passed it down the row. Each teacher giggled and could not wait to pass it on. For the rest of the lecture I watched the progress of my arrangement toward the front of the room. It was easy to tell where it was from the antics of the teachers trying to control their laughter. After the lecturer I saw my arrangement under the chair where the Art Supervisor had been seated. I don't know whether the supervisor ever found out who had disrupted her meeting, but while I was working on my Masters degree I applied to her office for a part time position and I never got a reply.

I once had a student teacher that I knew to be a strong artist, and since I believed him to be a clever student I assumed that he would show up at school dressed differently from the way I was accustomed to seeing him in studios at college. I was wrong. When I first visited him he was wearing a dress shirt open at the collar and his shirttail was hanging out. His baggy pants were rolled up to expose the tops of old fashioned green tennis shoes ornamented with freely painted designs. While my student prepared materials for his next lesson, the cooperating teacher took me to coffee and told me of her fears for our student teacher. It seamed that he had a way of saying things that upset other faculty members. For example when a young teacher announced her engagement and

showed off her ring my student teacher held her hand inspected her ring carefully, and exclaimed, "Wow! Your finance must be the king of the bubble gum machines." I agreed that events like these must have been upsetting.

On our way back to the art room we were joined by the Principal and a member of the School Board. They were going to observe my student teacher. As the four of us set at a table in the back of the art room preparing to take notes, I felt uncomfortable. I had never known an American principal to observe a student teacher. While I was in England I learned that principals, or headmasters as they call them there, do make all the observations. Thus they maintain an objective evaluation of the quality of instruction that their students receive. The principal could quickly discharge a student teacher, while a classroom teacher might be likely to try to retrain a helper. Now I feared that a principal and a board member were an omen that I would soon have to deal with a new placement for my student teacher. Just as I was about to be overcome with fears, the students came in. The student teacher became a pied piper leading students merrily through an intriguing presentation. His enthusiasm and smiles charmed them into doing his will. As students went promptly to work the principal and board member excused themselves. I had the feeling that they looked disappointed—as though they had not collected the evidence that they had expected. Although my student teacher had failed in the faculty room he excelled in the classroom. **Inaptness in the faculty room, however, is more like to be observed by teachers and administrators than competence in the art room**, so I feared for my student teacher's professional future.

There are, of course, some strong art teachers who seem to know intuitively how to get what they want from administrators. One young teacher, Bill Giles, was teaching from an art cart, because he did not have an art room. After Bill concluded each lesson he asked students if they would like to do more of this kind of work at home. If they did, they were to line up after school on the right hand side of the art supply room (which was near the front of the building) and he would give them materials to use at home. Often, as the children lined up, their line extended past the doorway to the school office. When the principal asked why the students were there, Bill explained that the length of the line showed that art was so important to his students that they wanted to get materials in order to work at home. **The principal was impressed that students would volunteer for homework** and the next year the principal found a room to dedicate to the art program. Bill's efforts were successful, because he demonstrated that his program had the quality to deserve a special room.

To Assess or not to Assess

A political victory that **Stanley Czurles** often bragged about was his role in the elimination of the test in art that New York State required until shortly before I arrived in Buffalo. His ally in bringing about this change was the New York State Art Teachers Association. At the time I believed that the elimination of the test was a good thing. I could not imagine how a typical multiple-choice test could measure much that was important for artmaking. Tempting teachers to teach to that kind of test must have distracted from worthwhile learning. Thirty years later the decision seemed less wise. Leaders in the New York State Teachers

Association who attended meetings on State wide curriculum reform began to sense that if art taught nothing that that we could measure, then its place in school was not secure. Art desperately needed a test if it was to have the status of other subjects in schools. While the decision to eliminate the test may have improved education, we had no way to prove it. **What art education leaders should have done was fight to improve the test.**

Art of Assessment

I once took a sabbatical for the purpose of dealing with assessment in art. What I intended to do was compare different aesthetic systems, so that I could specify criteria for judging art. As I looked at the problems in assessment, however, I realized that such criteria would be of little value unless art teachers first dealt with other problems. To illustrate these problems I wrote a story about an unemployed art teacher who was substituting in a math class (Jones 1995). The teacher got into trouble with the principal because he tried to teach math as though it were art. He made assignments that failed to define the problem that students were to solve. For example he had students working with pencils and wanted them to do something with even numbers. (Thus he had assigned the medium and the subject.) And then he complicated his grading problem by helping some students more than others and permitting students to take work home to finish. (So he failed to separate practicing and testing.) When students handed in their finished papers he did not know whether he was grading student work, his own teaching, or the assistance student got at home. When the teacher discussed the difficulty of grading with the principal the principal responded that if he taught art the way he taught math he would not be able to grade it either.

If we want to boldly measure what art students ought to be learning, and not deal with politics, how can we do it? **The answer, surprisingly, may lie more in how we teach than in how we judge success in art.** Let me explain. **Betty Edwards** (1989) impressed millions with the series of drawings that she published in the front of her book, *Drawing on the Right Side of the Brain*. These drawings dramatically illustrated the difference in portrait drawings made at the beginning and at the end of the term. At the beginning of the term her college students drew portraits that were crude and poorly proportioned, while the portraits from the end of the term were magnificently sophisticated. Because Betty Edwards had her students focus on the single task of drawing portraits for an entire term, it is easy for anyone to see the dramatic improvement. I have seen many teachers emulate Edwards' exercises designed to emphasize the importance of right brain functions such as drawing from an upside-down drawing by Picasso. I have not seen a single teacher require students to focus on a single subject for an entire grading period. My point here, however, is not about the value of depth education. The point I want to make here is that Edwards assessed her students with the same test at the beginning and at the end of the term—the test was to draw a portrait. Because she repeated the test, it is easy to judge whether the students improved. Knowing what the final test would be, Edwards taught for the test.

Betty Edwards teaches us that, if the task is held constant, it is easy to compare student work and judge quality.

A task that is gaining increasing popularity is to produce a portfolio. Advance Placement courses in art have long required a portfolio, and they have simplified the judging task by requiring specific elements in the portfolio. These elements can be judged independently. When one of my graduate students did a study on judging portfolios she found that when independent elements of portfolios are defined teachers agreed in their judgments of quality, even though there were no visual or verbal definitions for quality. Student judgments of the quality, however, were less likely to agree with teacher's judgments. This was particularly true for younger students. Thus, teachers may need to work on helping student to understand the criteria that they use to make their judgments.

Assessment and Politics

The questions that Sock dealt with was different from the question that his Art Supervisor wanted to deal with. The Supervisor wanted to use assessment to prove that the art program that he was responsible for was already good. **Thus, his concern was, "How can art programs survive the political threat of assessment? Sock, however, asked, "How can we assess what students ought to be learning?"** He was willing to risk exposing deficiencies for the sake of improvement; while the administrator feared that exposing deficiencies would leave art politically vulnerable.

The English department at Buff State must have felt politically vulnerable when they assessed student writing skills at the beginning and at the end of Freshman English. Using the best research procedures they had collected freshmen essays and selected papers that represented different levels of writing skill. These papers served as the criteria for judges to use as they evaluated papers written at the beginning and the end of Freshman English. The papers were coded and randomized, so that judges did not know whether they were reading papers from the beginning or the end of the course. As I listened to the head of the English Department report, I was stunned that he would announce to the college that they found no significant difference between papers at the beginning and at the end of the course. That kind of data, it seemed to me, might be devastating to a department; but the English faculty did something remarkable. They used their data to argue that writing was such a complex skill that many students needed more help than they could get in one course. They proposed the addition of another course for students who could not pass their writing assessment test. Although that additional course would be for no credit, the English Department would need a number of new faculty members to teach the course. A few weeks later their proposal for their new course was approved. Thus the English teachers had turned assessment that seemed to provide devastating news into a political advantage. Shortly after the new writing program was in place I observed an improvement in the writing of students in my methods classes.

Dealing with Administrators

While I was serving as acting chair of my department I was called to a meeting to consider whether the college's Performing Arts Center, should go ahead with a commitment to permit **Karen Finley** to perform. Since Karen Finley did her performance while she was completely naked, the new director of the Center did not want to take responsibility for a program that was scheduled before

she was hired. I was to attend the meeting because Dr. Parks, the Chair of our Department, had arranged for our department to sponsor the performance before he went on sabbatical. The other sponsor of the performance was Hallwalls, an avant-garde gallery in Buffalo where Dr. Parks was a member of the board. The new Director of the Performing Arts Center opened the meeting with the questions "Is the performance of Karen Finley art? And if it is art, is that kind of art appropriate for the Performing Arts Center at the College?"

The need for me to respond increased as the twelve administrators grouped about the conference table were silent. Finally I said, "I think the question is wrong. Karen Finley has already performed at the Contemporary Art Museum in Los Angeles. Do we want to set up ourselves for ridicule as being more authoritative judges of what is art than a noted museum? No one suggested that they wanted to open the college to that kind of ridicule. So the director asked whether the college was an appropriate place for nudity on the stage. I responded again that she was asking the wrong question, because student productions at the college had already included nudity. I reminded everyone of a scene from the student production of "Equis" that had included a nude scene. "The real question'" I asserted, "is not whether nudity is objectionable, but why do people object to Karen Finley? Could it be that people object to the message that her performance delivers?" At this point several people volunteered that her message was politically provocative. Then I asked whether we wanted to provide publicity for her by banning her at Buffalo State. "Would our ban be perceived as a form of censorship—an action that would be inappropriate for an institution of higher learning?

Because my question controlled the direction of our discussion, the general tenor of the meeting moved toward the decision to let Karen Finley perform. Our decision proved to be a fortunate one, as it resulted in a long column of praise from our local art critic. The performance was a sellout and there were no political repercussions. Thus, **one strategy for dealing with administrators is to change their questions to better questions— questions that do not start with the phrase, "aren't you embarrassed that..."**

Diogenes, L. (1969). *Lives of the Philosophers,* Henry, Regnery Company, Chicago. (pp.131-153)
Jones, L. (1995) An Assessment Adventure: What Arty learned about teaching art while grading arithmetic," *Journal of the Canadian Society for Education through Art*, October.
Long, A. A. (1996). "The Socratic Tradition: Diogenes and Hellenistic Ethics" in Branham, R. B., and Goulet-Cazé, Marie-Odile, Eds. *The Cynics*, University of California Press, Berkley.

10. Winning the Accountability Game

Forfeiting an Art Program

Not long after I came to Buff State, the Director of Art in the Buffalo Public Schools telephoned that he needed the support of faculty members in a Board of Education hearing. The Board was considering whether to eliminate art teachers for kindergarten through third grade. New York State mandates art instruction for elementary students, but does not require that art specialist teach art. Art teachers had believed that their positions were secure, because the Buffalo Teachers Union valued the free period that art classes gave to classroom teachers. Now, however, the jobs of nearly 20 art teachers were at risk.

I had assumed that the future of art education was so important that it would be the only subject that the Board would consider on that evening. I was wrong. The first item on the agenda was a report from an elementary music teacher. He reported on the success of a small grant for the music program in his school. The grant had supported a choral group's trip for a concert. According to the choral director, the concert had gone very well and he showed newspaper clippings reviewing the concert. The teacher played a tape of several songs from the performance. The Board members all listened with broad smiles on their faces. When the music ended there was scattered applause from the audience. I feared that those applauding had come to support the music program rather than to preserve the art program.

Finally the Board took up the question of eliminating art teachers in grades K-3. When my name was called I walked to the railing and stood behind a microphone. As I delivered my well-rehearsed arguments for retaining art specialists, I was aware that most of the Board members did not look at me. Some did look up as they turned the pages of the documents that were scattered about the top of their table. I hoped that the microphone was connected to a tape recorder so that the Board could study my ideas before reaching a decision. After I spoke, the other members of my department spoke, several of the teachers likely to lose their jobs spoke, and the art supervisor spoke. But a representative of the Teacher's Union did not speak—did they think that teaching art would not increase the work load of elementary teachers?

Suddenly the hearing was over. And the Board retired in order to privately consider their decision. I felt empty inside. The Board had devoted no more time to the question of the future of the art program and the jobs of 20 art teachers than they had spent listening to the choir of one music teacher.

The morning newspaper announced the Board's ruling. I felt deeply for the teachers who would lose their jobs, but I was also angry that they had trusted the Union to save them, while they should have realized that they were in a competition. **I realize now that no arguments we could have made before the Board would have altered the Board's decision. What they wanted was not words but results.**

How then, can art teachers achieve results that will impress school boards? How can they demonstrate that that they can do more than classroom teachers? Will SAT scores help?

Whether SAT scores might correlate positively with the number of **visual art** courses taken at a particular school district could be an important research project. But, even if the result is a positive correlation, it would not show cause and effect.

I believe that art teachers are more likely to achieve results that will justify their programs if they do what they are best prepared to do; that is to teach students to really make art—to move beyond traditional assignments and to deal with art in all its richness and complexity. But too often I observe teachers so preoccupied with the mechanics of managing the children and materials that they have little energy left for art—and no inclination to compete for publicity.

I was not fully aware of how much those problems might be minimized until I worked with a teacher who was recovering from cancer. While he was dealing with fatigue caused by chemotherapy, he decided to minimize the energy that he expended on materials. Rather than trying to work with several materials each day, he had all of his classes work with the same medium for several weeks. The materials that students used were always on the same table at the back of the room. I recall that after several weeks of painting with tempera the table looked more than a little messy. But that energy-conserving teacher cleaned it only when he changed to a new material. Student teachers who worked with him were challenged by this arrangement with materials. For, while they had fewer responsibilities for management, they were forced to plan for more than how to work with materials. They had to plan richer art content for their lessons. In dealing with that need for richness they began to separate themselves from what a classroom teacher would be likely to do.

To distract my student teachers from preoccupation with materials I began to ask them to define what it was not possible to teach with construction paper paste and crayons. What could students not learn about design, representation, or communication of ides? When they had difficulty thinking of anything, I suggested that their preoccupation with the need for a large variety of materials was the result of a successful advertising campaign carried out by manufacturers. **My argument was not that cheap materials are sufficient for a program, but that lots or materials are unnecessary and may be a distraction from significant art learning**.

Art and Competition

My own view of competition may be biased, for I had early success in competitions. When I was 13 my father encouraged me to enter an art contest that coincided with the release of Walt Disney's film, *Cinderella*. I painted a dreamy Cinderella in filmy white robes standing on a hill. My father framed it and the judges awarded me third prize. While I was first taking painting classes at the Philbrook Art Museum a classmate told me that it was possible to win prizes at the County Fair; so I entered several paintings in different categories. The prizes turned out to be only ribbons, but I was pleased. My first high school art teacher, **Opal Thorpe**, entered one of my paintings in a Scholastic Art Competition to be held in Oklahoma City. My father drove me to Oklahoma City to receive my award. My second high school art teacher, **Gibson Bird**, encouraged me to enter a professional competition and one of my watercolors was accepted in the Tulsa Annual Exhibition. In college **Duane Hatchet** encouraged me to enter regional

competitions. I recall that we both entered paintings in the Mid America Exhibition held in Kansas City—both of our paintings were accepted. Thus, the idea of art as a competitive activity was not a foreign idea to me.

In high school Mr. Bird arranged an exchange exhibition with another high school. The artworks for the exhibition were selected by a committee of art students. I do not recall art competitions at school during my elementary years—at least not competitions with a judge other than the teacher. The teacher gave grades and all students competed for those grades.

The realization that art teachers assign grades, changes the question that I have been dealing with. Since students already compete for grades, the question is not, "Should art students compete?" but "How should students compete?"

Competition between Disciplines

Although there is no formal competition acknowledged between art and music, I realized that, as a parent, I had made some unfavorable comparisons. When I attended my son's middle school spring concert I could tell that their school had a strong music program. Parents and other relatives of the performers were in the auditorium well before the scheduled performance. When I entered the auditorium, I received an impressive program with biographies of the conductors, notes on the selections for the evening and lists of the students' names in each musical group. Stagehands were busy making final adjustments on the lighting and sound equipment. When the orchestra filed in I tried to estimate the value of the instruments and sheet music that the students worked with. While they played I thought their music compared favorably with professional groups that I was familiar with. After accepting bows, the conductor gave credit to the individual instrument instructors at the school and to the number of private teachers who had contributed to the ability of his student musicians. When the boy's chorus sang, I immediately perceived that my son, who was a member of the group, had been learning more than lyrics. The conductor brought out tone and expressive qualities that would have done honor to a much older group. The conductor had the chorus demonstrate some of the exercises that he used in order to develop such skill.

Leaving the auditorium I was faced with crowds of parents waiting for their children. Behind the parents I caught a glimpse of student artwork. Working my way through the crowd I saw watercolors on thin paper that had wrinkled. The paintings were matted with a flimsy board. I seemed to be the only one who was looking at the artwork. I felt sorry for the art students trying to make do with inferior materials. I recalled what a difference it had made in my work when my high school teacher encouraged me to purchase some good watercolor paper. The paper stayed flat and the colors stayed on the surface and were more intense. The texture of the paper itself was beautiful. I thought how unfair it was for those students to work on cheep paper while the music students played on expensive instruments. I thought about our value system in this country that correlates importance with cost. **Could it be that the status of art in schools is diminished because art does not cost enough?**

Dan Teis was a teacher at the Philbrook Art Museum who had insisted that I work on larger canvases—large enough to seem important. Larger canvases were inconvenient, for I had been using canvases small enough to fit in my painting box. Transporting wet canvases on the bus ride home was a challenge, but I did like the larger size. While I was finished my masters degree, I worked for Dan in his Colonial Frame Shop. Dan taught me to understand how well cut mats and expensive frames enhance artwork. I was envious of one customer who purchased one of my larger prints and had me frame it. The gold leaf frame made my print look great, but the frame cost three times more than I had received for the print.

After Dan Teis became the Education Director of the Museum in Little Rock, Arkansas—and after I had taught for several years—he invited me to judge a statewide competition of student artwork. I don't think Dan invited me to be a judge because of my respect for frames—I believed that I was invited because an out-of-state judge would give the appearance of objectivity. It was difficult for me to be objective, however, for I dearly loved a series of paintings from the students of one kindergarten teacher. The paintings combined the freshness of children's expressions with the stature of professional materials. The teacher had her children working with oil on canvas. The work of older students executed in crayon on construction paper paled by comparison. **I fear that we make our art programs look cheap by using cheap materials.**

Competing and Coaching

I learned more about competition when I became a varsity rifle coach at my sons' high school. I became the coach after my older son, Jeffrey, announced that the coach was leaving and he doubted that they could find another one. I told Jeffrey not to worry; if no one else would take the team, I would. I knew that a losing season had discouraged the present coach who had little shooting experience and had only taken the job to keep the program alive. Because I had shot in an NRA program where I earned medals as a youth, and because I had earned an award for marksmanship while I was in the army, I felt qualified. I did not know that three schools in our league took turns winning the State Championship, so I had no idea of the competition I would face.

Anyhow, I assumed that the school would find another coach; there were, after all, several shooting leagues in our area. So I was surprised at how soon I got a call from the Athletic Director. (Several years later I learned that my son had volunteered me on the next day.) The Athletic Director urged me to take the team and said that **Vincent DeWind**, an elementary art teacher that I knew, would help me get started with the team.

I had confidence in Vincent's help on an important aspect of taking the team: safety. He was the only art teacher that I knew who had children working with X-acto knives. And they did it with no injuries. Because his students worked with appropriate cutting instruments, they were able to make surprisingly intricate stained glass designs from constructing paper. I knew that his students worked safely because they had earned the right to use knives by following the rules when they used small red sable brushes. And they earned the right to use the brushes that permitted small details by following the rules with larger cheap brushes. We applied the same principle on the rifle range. We required shooters to demonstrate

safe handling of rifles before we got out the ammunition. I did take the first-aid course required for all coaches, but the only injury that I treated was when a boy celebrated a good score by jumping up and hitting his hand against the concrete ceiling.

When I took the coaching position it seemed like the ideal teaching situation. All my students were volunteers. There were tryouts, so I would kept only talented shooters for the team. Each shooter practiced with a rifle and ammunition that would cost as much as the entire budget that an art teacher might receive. Because of the ideal conditions, I expected to have no difficulty with motivation, and initially I did not. The excitement of shooting, the thrill of the noise, and the magic of seeing holes appear on the paper targets 50 feet away sustained the shooters for about three weeks. But as their scores did not continue to improve as rapidly as they had at first, team members became discouraged. Some even started missing practices.

My difficulty motivating students made me rethink my ideas about motivation in the art room. No longer could I use the excuses that students were not interested because of some fault of their own; all my shooters were volunteers, and I had selected them for their potential. I could not blame a lean budget that prevented me from working with interesting materials. The responsibility for motivation was mine, and I believed that the same must be true in the art room. I began to suspect that the real reason that art teachers present new materials in rapid succession is that if students work too long with a medium they might discover that they are not making progress and become discouraged. I recalled that the Depth-Breadth studies at Penn State identified a low point in student moral after about six projects in the same medium. I thought about an elementary art teacher who also coached swimming. His projects typically lasted several weeks longer than those in any of the schools that I visited. His student's artworks looked exceptionally good and his swimmers regularly won awards. I wondered how he motivated his young artists and his athletes to work so long and so hard. How could I motivate my shooters to win?

When an experienced coach heard my question he told me, "**Everyone has the will to win; winners have the will to train**." So I tried to focus the team on training. I worked with my team on the importance of concentrating on process, rather than score. They shot at the back of targets so they could concentrate on smooth trigger release. I encouraged shooters to keep journals, so they could set personal goals and diagnose their own shooting problems. I tried to relieve the monotony of shooting with isometric exercises designed to increase strength. And we practiced relaxation. But motivation remained low. Then—using the idea from another coach—I introduced peer completion into the practice. I paired shooters according to their ability and had them shoot for score. Winners had their names read as part of the morning announcements for the whole school to hear. Motivation improved dramatically. Motivation remained high as members competed for places on the traveling team.

The sense of competition also motivated me—I wanted my team to win. I joined a shooting league, so that I could better understand what my team was experiencing. I studied manuals form the Army Marksmanship Unit. I read the account of the coach who had led the US team to Olympic championships. And I went to shooting coach schools at Olympic Training Centers at Lake Placid, New

York and Colorado Springs, Colorado. In the four years that I coached, the team had four winning seasons.

We were not successful, however, against the stronger teams. We might have been more successful, if I had done for all the team what I did for my sons. We had an air rifle range in our basement and in the off-season I took my sons to NRA matches. They also were members of a Civil Air Patrol rifle team that I took to a match against the freshman team at West Point. My older son, Jeffrey, went to the Air Force Academy, partly on the strength of his marksmanship. During his senior year there, he was named the most valuable athlete on the rifle team. Three years later he returned to the Academy to coach the rifle team.

I wish I had provided more opportunities for the other members of my team. I have since learned that the coaches with the strongest teams had off-season programs that benefited their whole teams. **I wonder whether the most successful art teaches might be the ones that figure out how to extend art practice for their students.** Does a competitive sense drive some art teachers to extend their own school day in order to keep their rooms open for students?

A Final Thought

My high School Art Teacher, Gibson Bird, once told me that a biography should be a record of evolving ideas. After reviewing my notes, it seems to me, that they are an autobiography that Mr. Bird would approve of.

About the Author

Layman H. Jones Jr. is Professor Emeritus in the Art Education Department at Buffalo State, State University of New York. During his tenure in Buffalo; he served as Chair of the Department and as Co-director of the College's program in Siena, Italy. He was also an exchange professor with Didsbury College in Manchester, England.

He holds a Doctorate in Art Education from Penn State, a Masters in Printmaking and Sculpture from Tulsa University, and a Bachelors in Art Education from Tulsa University.

Before coming to Buffalo he taught sculpture at the University of Tulsa, Oklahoma; worked as a Research Associate at Pennsylvania State University, and taught Printmaking and Crafts at Fort Hays Kansas State College. His teaching career started with Saturday Morning and Summer Classes at the Philbrook Art Museum in Tulsa, Oklahoma, where he taught kindergarteners through adolescents.

As he taught theory courses at Buff State, he discovered that students already knew how to teach art—that is, they knew how they were taught and it had worked for them. So he began to use stories like the ones in this book to challenge student's previously unexamined ideas about teaching art.

His publications include allegorical stories similar to the ones in this book: "Recipe for Assessment: How Arty Cooked His Goose while Grading Art," *Art Education*, March 1995; and "An Assessment Adventure: What Arty learned about teaching art while grading arithmetic," *Journal of the Canadian Society for Education through Art*, October 1995. He was also responsible for the publication of 15 issues of the *NYSATA News,* the Journal of the New York State Art Teachers Association.

His experiences as an art student and as a practicing artist underpin his ideas about teaching art. He came from a family of craftswomen and his mother taught him to embroidery. His father enrolled him in Saturday morning and Summer Art Classes at the Philbrook Art Museum and helped him enter his first art contest. At Philbrook and in high school he studied with a series of art teachers who went on to teach in college. He spent two summers at the Midwestern Art Camp at Kansas University. While he was still in high school his artwork was accepted in professional competitions. In a Scholastic Art Competition he received a Purchase Award from the Carnegie Institute and a Scholarship to the University of Tulsa. During college he worked as a production artist in at a silkscreen printing firm. As a practicing fine artist, he has exhibited in 31 competitions and received 18 awards. He has had 15 one-man exhibitions, and his artworks are now in nine public collections.

www.ingramcontent.com/pod-product-compliance
Lightning Source LLC
Chambersburg PA
CBHW062354220526
45472CB00008B/1796